W9-DEE-327

The Frozen Image

Scandinavian Photography

The sun begins to be dark; the continent falls fainting into the Ocean;
They disappear from the sky, the brilliant stars;
The smoke eddies around the destroying fire of the world;
The gigantic flame plays against heaven itself.

Eddaic poem, *Völuspâ*, 13th century

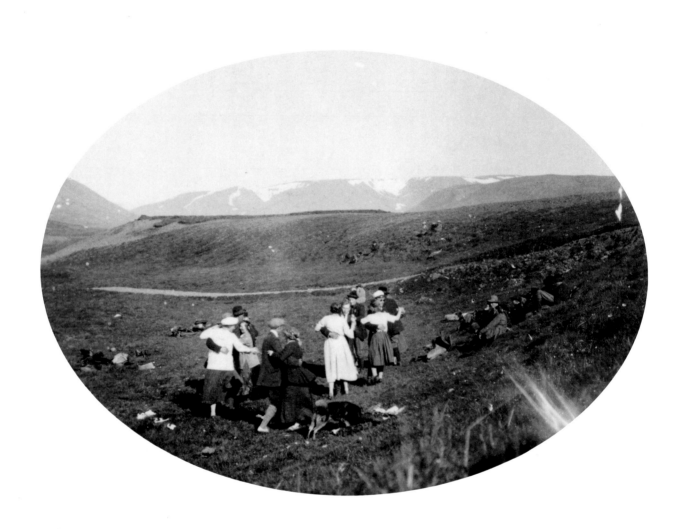

The Frozen Image

Scandinavian Photography

Introductory essays by Martin Friedman

With contributions by Henning Bender
Bert Carpelan, Lennart Durehed, Arne Eggum
John Erichsen, Bo Grandien, Solveig Greve
Rune Hassner, Gudmundur Ingólfsson
Ismo Kajander, Michael Metcalf, Robert Meyer
Knud Nellemose, Bjørn Ochsner, Jan Olsheden
Allan Porter, Rolf Söderberg, Leif Wigh

Walker Art Center · Minneapolis
Abbeville Press · Publishers · New York

Library of Congress Cataloging
in Publication Data
Main entry under title:

The Frozen image.

 Bibliography: p.
 1. Photography—Scandinavia—
Exhibitions. I. Friedman, Martin L.
II. Bender, Henning. III. Walker Art
Center.
TR88.5.F76 1982 779′.0948′07401471
82-72450
ISBN 0-89659-311-8
ISBN 0-89659-312-6 (pbk.)

Printed in the United States of America.

Dimensions are in inches and centimeters;
height precedes width.

(cover)
Carl Curman
Stockholm park ca. 1890
modern gelatin silver print
from original negative
8½ x 10
21.6 x 25.4
Collection Antikvarisk-Topografiska
arkiven, Riksantikarieämbetet, Stockholm,
Sweden

(overleaf)
Evald Hemmert
Midsummer night dance 1923
gelatin silver print
3½ x 4¾
8.9 x 12.1
Collection Margrét Hemmert, Reykjavík

The Frozen Image: Scandinavian Photography,
a project of "Scandinavia Today," is made
possible by a generous grant from Atlantic
Richfield Company.

Undertaken at the invitation of The
American-Scandinavian Foundation and
the Nordic Council of Ministers, the
exhibition was granted organizational and
publication support from The American-
Scandinavian Foundation and the Nordic
Council of Ministers. Presentation of the
exhibition in Minneapolis was made possible
in part by the Dayton Hudson Foundation,
the General Mills Foundation, The
McKnight Foundation and the Minnesota
State Arts Board.

"Scandinavia Today," an American
celebration of contemporary Scandinavian
culture, is sponsored and administered by
The American-Scandinavian Foundation,
and made possible by support from Volvo,
Atlantic Richfield Company, the National
Endowment for the Humanities and the
National Endowment for the Arts.
"Scandinavia Today" is organized with the
cooperation of the governments of
Denmark, Finland, Iceland, Norway and
Sweden through the Secretariat for Nordic
Cultural Cooperation and with the aid of a
grant from the Nordic Council of Ministers.
SAS, Finnair and Icelandair are the official
carriers for "Scandinavia Today."
"Scandinavia Today-Minnesota" is
sponsored by First Banks through First
Bank System Foundation and by Lutheran
Brotherhood.

This publication was made possible by a
grant from Atlantic Richfield Company with
support from the Nordic Council of
Ministers in association with the exhibition,
The Frozen Image: Scandinavian Photography,
a project of "Scandinavia Today," at Walker
Art Center. The catalogue was edited by
Anne Hoene Hoy.

The views and opinions expressed in this
publication are those of the authors and do
not necessarily reflect the views or opinions
of the authors' governments or those of The
American-Scandinavian Foundation.

The opportunity to introduce a book based
upon a major exhibition is always exciting;
but this is a very special occasion for Atlantic
Richfield Company because the exhibition
which the Company has sponsored is an
integral part of "Scandinavia Today," an
American celebration of the art and thought
of the five Nordic countries. This exhibition
is based on a virtually unknown area of art
in the United States, Scandinavian
photography. Thus, the readers of this
book, and those who view the exhibition
from which these works are taken, become
explorers of a new terrain.

Looking at this collection, the viewers
discover that photographers are artists who
can capture the land, the people, the essence
of a region of the world. These evocative
photographs show us sights we may never
have seen; but these sights are part of the
myriad of cultures which make up the
Scandinavian heritage of many Americans.

Robert O. Anderson, Chairman
Atlantic Richfield Company

Contents

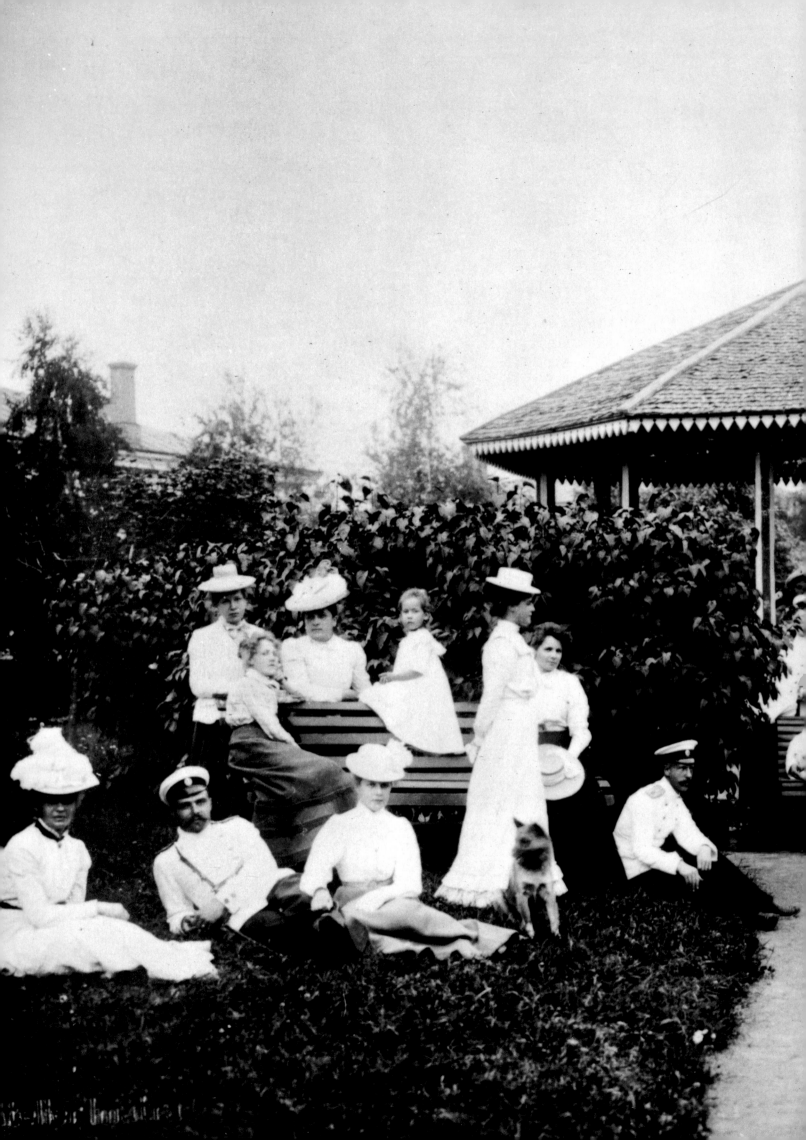

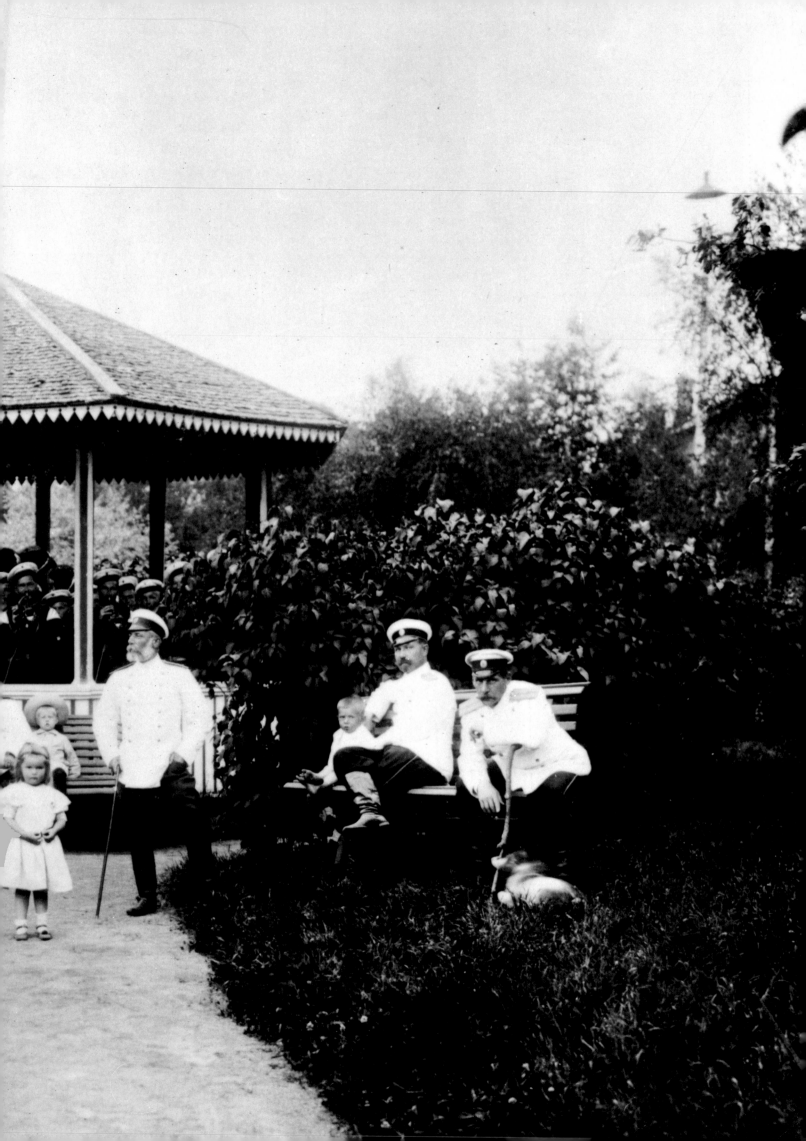

The Frozen Image

Martin Friedman

Two years ago, the Walker Art Center was invited by The American-Scandinavian Foundation to organize an art exhibition as part of "Scandinavia Today," a large-scale cultural manifestation scheduled to occur simultaneously in several American cities in 1982–83. The purpose: to introduce a new audience to the wide spectrum of the arts in the five Nordic countries. For several reasons, photography seemed an ideal subject for our exhibition. It is a Scandinavian phenomenon about which little is known in the United States; indeed, knowledge about it is even limited in the Nordic countries themselves—a situation that reflects photography's status until recently as a stepchild of the arts. Now, however, photography is emerging as a major art expression in Scandinavia, a process witnessed by the new collections being formed and the increase in exhibition activity. Given this promising situation, the Walker Art Center, with the assistance of the International Center of Photography, decided to explore this new area.

Early on, we made contact with a considerable number of curators, photographers, photo-historians and art critics in each of the Nordic countries, and they provided us with important information about photographers, collections and publications we should seek out. On the basis of the preliminary survey, we determined our Scandinavian itinerary, which took the form of two extensive research visits in 1980 and 1981. Representing the Walker Art Center on this project were Mildred Friedman, Curator of Design, Gwen Bitz, Associate Registrar, and myself; and William Ewing, Director of Exhibitions at the International Center of Photography, represented that institution.

After initial visits to various collections in Copenhagen, Helsinki, Oslo, Reykjavík and Stockholm, we realized that our two-year limit for the project would preclude making a systematic historical account of photography's evolution in each country. Such an account, we decided, would best be left for future photo-historical study. Instead, we elected to concentrate on images whose aesthetic merit would transcend national boundaries. As a second criterion, we agreed to concentrate on historical and contemporary photographs that would illuminate unique aspects of the Scandinavian ethos. The results of our search would come together, we hoped, to form a coherent impression of Nordic photography. Our selection and presentation of photographs would be subjective—admittedly and necessarily—and would reflect an outsider's sensibility.

On our first research trip, we surveyed the rich holdings of Det Kongelige Bibliotek (The Royal Library) in Copenhagen, which has established an impressive collection of fine photographic prints, many culled from historical and other archival sources; the Library also systematically collects works by living Danish photographers. We found the most comprehensive collection of Swedish historical and contemporary photography in Stockholm's excellent Fotografiska Museet, which is affiliated with the nearby Moderna Museet where exhibitions of Swedish and international modern art are regularly held. In Helsinki, at the

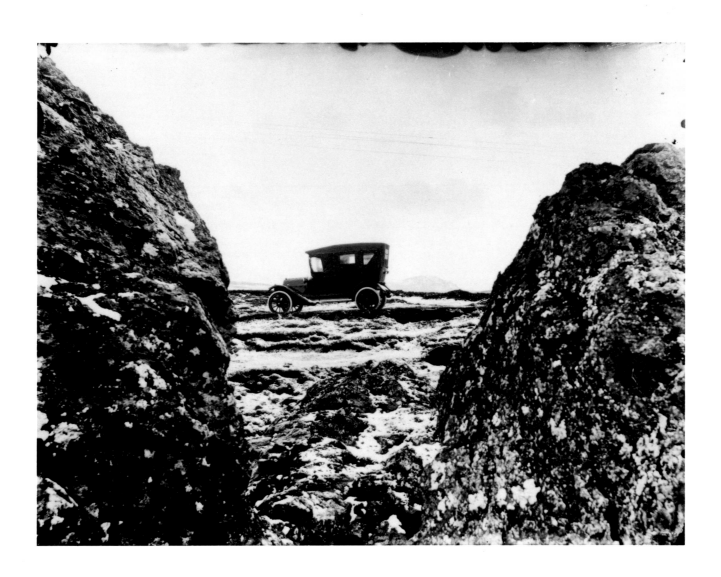

Suomen Valokuvataiteen Museon Säätö (Photographic Museum of Finland), we surveyed a collection that concentrates on vintage prints. Outside Oslo, the Preus Fotomuseum in Horten boasts a superb research library, has fine older works and shows photographs by young Norwegians. In Reykjavík at the Thjódminjasafn Íslands, Iceland's National Museum, is housed a large collection of early glass-plate negatives, which represents the core of that country's photography collection.

After extensive examination of these and other established photography collections, we decided to look farther afield, and considered specific areas of activity that attracted early photographers in Scandinavia. For example, the landscape was an all-pervasive, obvious theme; then there were such general subjects as exploration, ethnography and historical events of national significance. To find material related to such subject areas, it was clear that other sources had to be mined. Our search broadened.

For the earliest records of Arctic exploration we chose works from the archives of Oslo's Norsk Polarinstitutt. Also in Norway, the Sør-Varanger Museum in Svanvik, located beyond the Arctic Circle, provided some of the first impressions of Lapp, or Sami, culture.

At the Arbeiderbevegelsens Arkiv og Bibliotek, Oslo's Labor Movement Archive and Library, we found stirring images of large-scale public demonstrations and strikes. The Bernadottebiblioteket, the library in Sweden's Royal Palace, offered a wealth of never before exhibited photographs of the royal family at such intimate diversions as the presentation of inventively costumed little theatricals. In Helsinki, the Sotamuseo (The War Museum) was a fertile source of photographs of turn-of-the-century army life from the vantage of the officers' club; here we found images of pomp and parades made during the Russian military presence in Finland. One of our most poignant tasks was the selection of photographs taken secretly during World War II, when Denmark was occupied by the Nazis. This eloquent, troubling documentation of Danish Resistance came from the Museet for Danmarks Frihedskamp, Copenhagen's Museum of Denmark's Fight for Freedom. Our travels also took us to a number of Scandinavian cities where we studied extensive collections in libraries and historical societies; there, a particular reward was discovering fine work by relatively unknown or anonymous photographers.

In each Scandinavian country we arranged to see portfolios by contemporary photographers. With the assistance of the Nordic Council of Ministers, notices were sent to photographers and photography organizations, and advertisements were placed in newspapers in each country inviting submissions of photographs for review. While we recognized the importance of a strong representation of photography from each country, we did not approach the selection process with quotas in mind. Quality was the sole determinant.

10

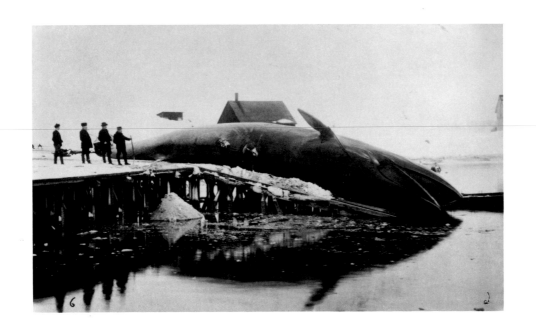

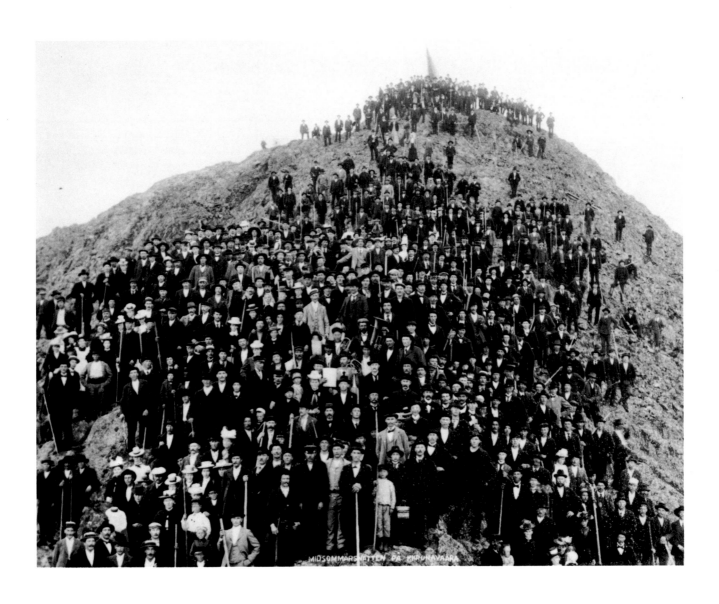

Finally, after we had most of the work in hand, we decided to consider it for the exhibition and accompanying publication according to general categories of subject matter that we believe have been distinctively treated in Scandinavian photography. In this spirit we invited a number of distinguished critics, photo-historians and other experts from the five Nordic countries to contribute essays on a number of photographers whose work relates to these broad topics:

The Endless Vista: This section deals with the ubiquitous landscape theme in Scandinavian photography. The land's special hold on the Nordic consciousness is apparent in images that celebrate the heroic panoramas of mountains, fjords and the limitless sea. In Knud Knudsen's Norway the landscape is rugged, infinitely varied and full of dramatic vistas. In contrast, the vaporous Swedish pastorals of Carl Curman offer a calmer view of nature. Then there is Iceland's hard-edged, treeless topography, the source of angular, quasi-abstract compositions by the contemporary photographer Gudmundur Ingólfsson.

Beyond the Arctic Circle: Beginning in the late 19th century, Danish, Norwegian and Swedish expeditions surveyed the frozen Arctic landscape on such missions as Roald Amundsen's great adventure, the search for the Northwest Passage. The explorers and scientists themselves documented their arduous journeys and have left their impressions of stark lunar landscapes fitfully illuminated by the midnight sun.

Nomads and Settlers: Among Scandinavian pioneers of the camera were dedicated early ethnographers who systematically documented the far-flung nomadic and rural populations. The Sami, who for centuries freely wandered across what is now northern Finland, Norway and Sweden, are to us the most foreign of those outlying cultures. In the late 19th- and early 20th-century photographs by the ethnographer Sophus Tromholt and Ellisif Wessel, the formidable wife of a Norwegian medical officer, we confront some of the first images of the "reindeer people," who inhabited the stark open spaces of the North.

The Early Urbanists: By the early 1900s an important new theme, the city, appeared in Scandinavian photography. Photographers were officially commissioned to portray the burgeoning metropolis with its grand new buildings and boulevards. They memorialized the new bourgeoisie, proudly ensconced in their offices and factories, and cheerfully on holiday. But this was also a time of new social awakening, and in Denmark, for example, some photographers took a less idealized view of the city, choosing beggars and prostitutes as their subject matter.

Portraits: In Scandinavian photography the portrait is a constant theme, ranging from modish *cartes-de-visite* to highly psychological interpretations of the individual. Beginning in the 1880s the Danish photographer Heinrich Tønnies transformed his working-class clients into generic types, representations of occupations that anticipate those so acutely examined by August

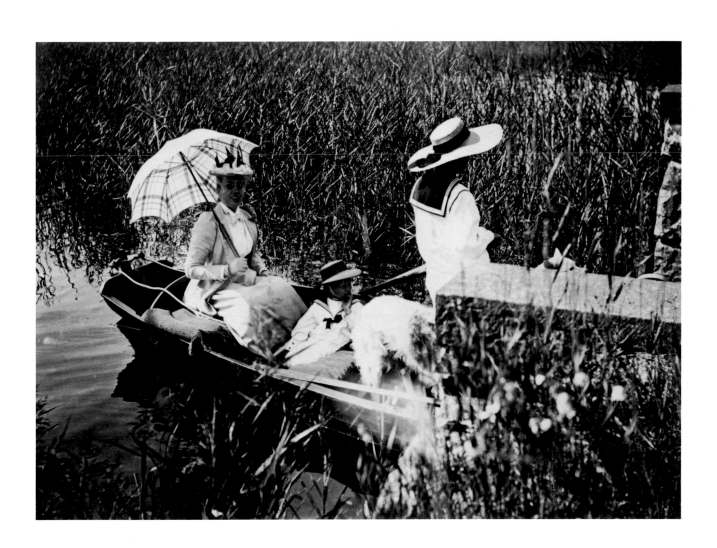

Sander some 30 years later in Germany. The blacksmiths, butchers and chimney sweeps who posed for Tønnies against hand-painted backdrops of antique palaces become characters in what seem to us surrealistic vignettes. In Stockholm, during the 1920s, Henry B. Goodwin won considerable acclaim for his romanticized portrayals of famous actresses and society women, and few photographers before or since have dealt with the female figure in such coolly sensuous fashion.

The Painter's Lens: For Edvard Munch, photography served as a sketchbook and a diary, and many of his snapshots relate to his paintings. Often his photographs were autobiographical. The Swedish writer August Strindberg, Munch's brilliant contemporary, was equally fascinated by the camera—in fact, he built his own—and in a particularly distinctive self-portrait he appears in top-hatted formal attire as a demonic figure.

Color photography in its infancy had a few gifted practitioners and one of the most outstanding was Wladimir Schohin, a Finn whose subtle autochromes of interiors and landscapes are strongly reminiscent of impressionist paintings.

The work of the Norwegian photographer and painter John Riise is outstanding for its formal inventiveness and expressive strength. Beginning in the mid-1920s he produced an astonishing series of portrait heads, strongly modeled in light and shadow. In this laborious technique the features of Riise's sitters grew increasingly abstract, owing not only to his unique lighting and multiple printing, but also to his application of pigment to the print. The unconventional results, with their cubist and surrealist overtones, represent a unique stylistic episode in both Norwegian painting and photography.

The Event: Out of the field of documentary photography have emerged a number of camera artists who go well beyond description into another realm. Hans Malmberg, a subtle, idiosyncratic reporter with an eye for the improbable, invests ordinary events with peculiar overtones. His fellow Swede, Christer Strömholm, on the other hand, focuses on the outlandish, even threatening aspects of everyday life, and in disquieting images of transvestites and snake handlers he explores the eerie limbo at the edge of normalcy. From the photojournalistic tradition comes the Dane Morten Bo, but he gives this idiom a darkly expressionistic inflection. In Bo's urgent impressions, a burning building becomes a sequence of infernal images—a heavy chiaroscuro of searchlights and suffocating smoke from which spectral creatures materialize.

The New Generation: There is quickening of activity today among young photographers in Scandinavia. The documentary technique so prevalent in the 1960s has since given way to more deliberate approaches that reflect new interest in a romantic pictorialism. This contemplative approach characterizes the photographs by the young Norwegian Tom Sandberg. A more subjective attitude toward portraiture and the figure in general

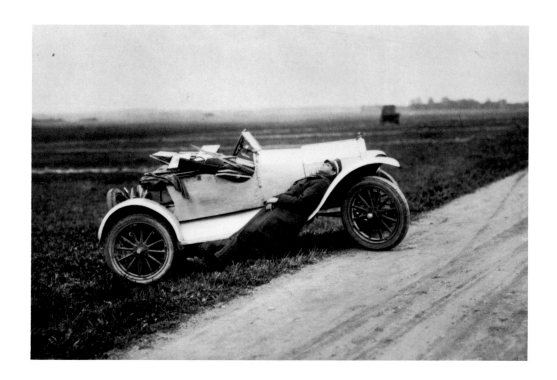

and the use of demanding printing techniques that extend the tonal spectrum of the printing process typify this new attitude. The shift is clearly away from split-second description of fleeting encounters to a deeper concern with artistic issues. For the Icelandic conceptual artist Sigurdur Gudmundsson, who commutes between Reykjavík and Amsterdam, photography is a record of performances in which he is the solitary subject.

What then is Scandinavian about Scandinavian photography? Our answer must be provisional, given the general and subjective approach we took in our study of it. Nevertheless, we might venture that photography in the Nordic countries seemed to us an art of stillness. Naturally, 19th-century visions of frozen landscapes under cloudless skies are quiescent, but, to generalize, even Scandinavian photographs of dramatic events seemed to us psychologically remote from their subjects: events are frozen in time. Here, formal issues—spatial relationships, contours of forms, tonalities—seem to dominate, yet this cool facade should not mislead us. Formal structure and content are not identical. Often beneath that facade we discern disquieting psychic energy—on occasion, even turbulence. To describe Scandinavian photography as good form veneered over a welter of conflicting emotions is perhaps an exaggeration. Nevertheless, in these images, things aren't always what they appear to be. What initially might seem a placid record of a woman's face, a landscape, a group of objects casually strewn on a table, on closer inspection appears filled with portent and symbolism. In the transmutations of Nordic artists, the simplest events assume intense psychological meanings. It is the tension between form and feeling that gives vibrancy to the artistic phenomenon of photography in Scandinavia.

15

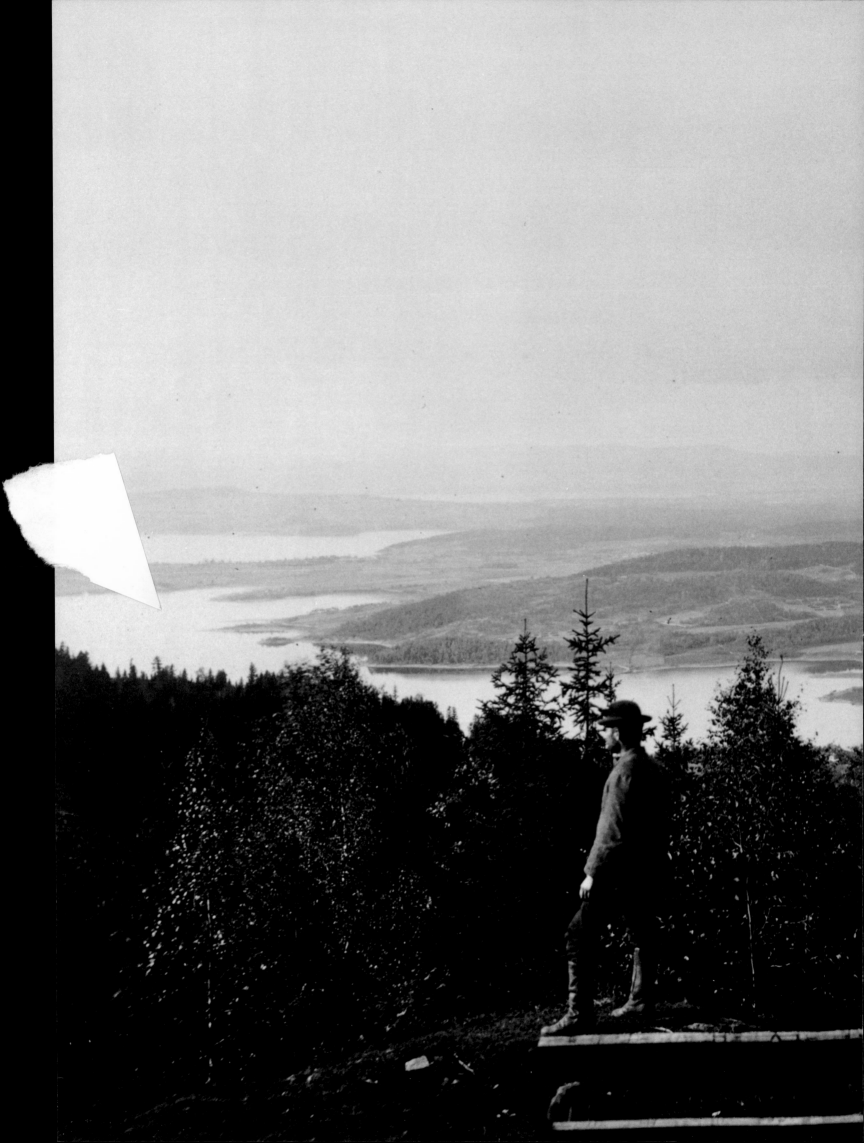

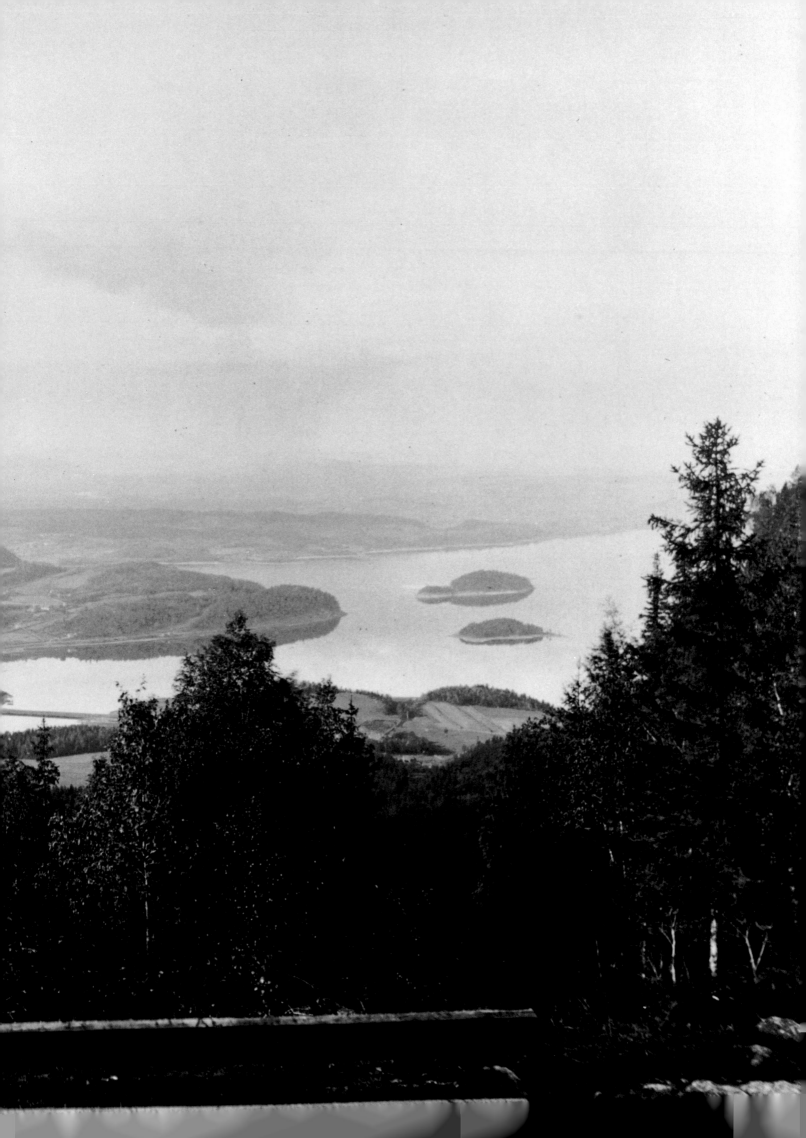

The Endless Vista

MF

The landscape, under the spell of the seasons, is an omnipresent, mystical force in Scandinavia, out of which the ancient sagas grew. It is the Nordic photographer's constant theme. Life in Scandinavia, even in the capital cities, is still lived in close and emotional proximity to nature. Stockholm is celebrated as the northern Venice, for that urbane place exists within great expanses of sky and water, and it can be regarded as a small intervention in nature's vast scheme. In summer its inhabitants cheerfully desert it; many head for the archipelago, a chain of little islands dotted with cottages and gardens that extends into the Baltic. This ardent embrace of nature is understandable in view of what Scandinavians must endure during the rest of the year. Winter's short, bleak days make the region a cheerless place, seemingly forgotten by the gods; thus, the brief spring and the "white" nights of summer become all the more precious. Little wonder that Scandinavians—faced with such extremes— regard nature with awe, a feeling strengthened by Nordic Protestantism, which has infused the landscape with spiritual connotations since the romantic era.

For the landscape photographer, Scandinavia offers more than seasonal changes as subject matter. These northern countries are marked by geological, topographical and climatic extremes— from Iceland, a vast lava rock largely bereft of vegetation, bristling with volcanoes, perforated by steaming geysers, to Denmark's domestication of nature into a patchwork of tidy farms and picturesque villages.

In the mid-1860s Knud Knudsen, armed with bellows camera and tripod, left his Bergen studio to begin what would be a 35-year love affair with the mist-shrouded mountains and fjords of Norway. Though recording well-known landmarks for the tourist trade, he constantly managed to see these with a fresh eye. Through his lens Norway's mountains are revealed as monumental, crystalline configurations, symbols of unimaginable forces. We feel immense dynamism in his photographs of gigantic vertical cliffs and meandering streams that suddenly become wildly rushing waterfalls cascading vast distances to the valley floor. Some of Knudsen's mountain pastorals remark on man's minimal power to shape the grander scheme of things: in one such example, an eccentric arabesque of ribbonlike roads clings to the rugged terrain.

Knudsen's violet-toned prints are reminiscent of the works of such 19th-century German romantic painters as Caspar David Friedrich and Carl Gustav Carus, in whose canvases nature is represented as an awesome force, paradisical or apocalyptic, indifferent to such passing events as mankind. When man makes a rare appearance in these transcendental vistas, it is as a minuscule being in passive contemplation of some overwhelming natural phenomenon—a great cloud-covered mountain or a limitless sea. A similar spirit pervades Knudsen's images of human encounters with primeval forces. His "everyman" stands in silent wonder within an unearthly landscape of enormous blocks of ice or at the edge of a gloomy lake. Sometimes Knudsen

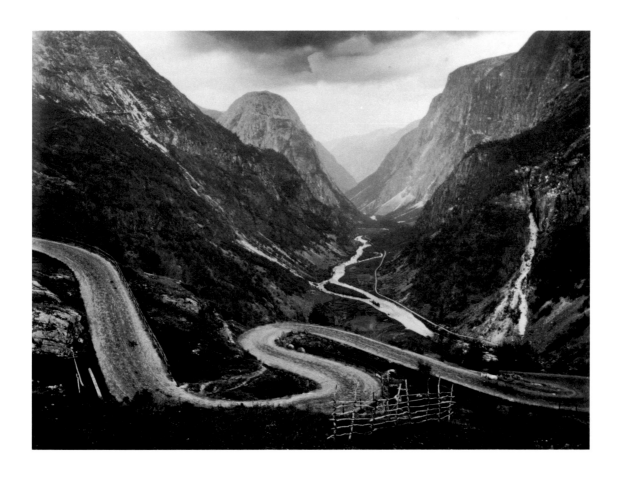

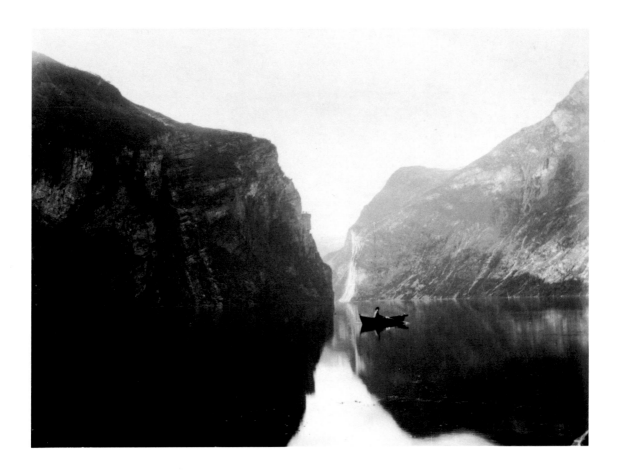

Peer. *When I sailed from Norway,*
I passed this way.
The dregs of memory stay
in the glass.
Up there, where the clefts and
scars are blue,
And the mountain valley is black
and narrow
Like a ditch; and below,
along the open fjords,
The people live.

In this country
They build their houses far apart.

Henrik Ibsen, *Peer Gynt,* 1867

makes quiet comment on conflicting forces within nature, and in some photographs a single tree, battered by the elements, is the sole survivor in a hostile, rocky landscape.

Quite another attitude toward the landscape characterizes Carl Curman's Swedish pastorals. Here the relationship with nature is easy and informal, in the spirit of the French impressionists rather than of the brooding early 19th-century German romantics. The casual creatures who drift through Curman's sylvan idylls—among them, the guests and employees at the spa he owned—are a considerable contrast to the stiffly-posed, awestruck beings who are occasionally posted in a Knudsen landscape. Here are the leisurely pursuits of the new middle class, in summer on the coast, in winter in the openness of the vast parks that were Stockholm's equivalent of the orderly Paris settings that found their way into impressionist paintings.

Impressionist too were some of Curman's pictorial devices, such as a strongly defined foreground, which involves the viewer immediately in a scene—virtually pulling him into it. This occurs in what to us seems a rather bizarre photograph of a few fashionably attired individuals posed in the midst of a rocky, treeless expanse, perhaps on a sea cliff. So strong are the patterns of light and shadow of the eroded terrain in the foreground that we are instantly engaged. A variation of this enticement occurs in a serene, richly toned print of a man and child, seen at a distance, walking in a snow-covered park: we glimpse them through an archway of trees. Form is virtually dematerialized in this irradiated vista. The figures and trees appear weightless, dissolved into subtle tones. Curman's grand winter scene seems less a record of an event than a recollection. In another park photograph he makes use of the fortuitous results of a long exposure time, during which several figures have moved, becoming shadowy washes. A sequence of dark, percussive forms, they dominate this gray nocturne. Carl Curman's fundamental theme was the "garden of the bourgeoisie" in whose calm setting his subjects took their ease.

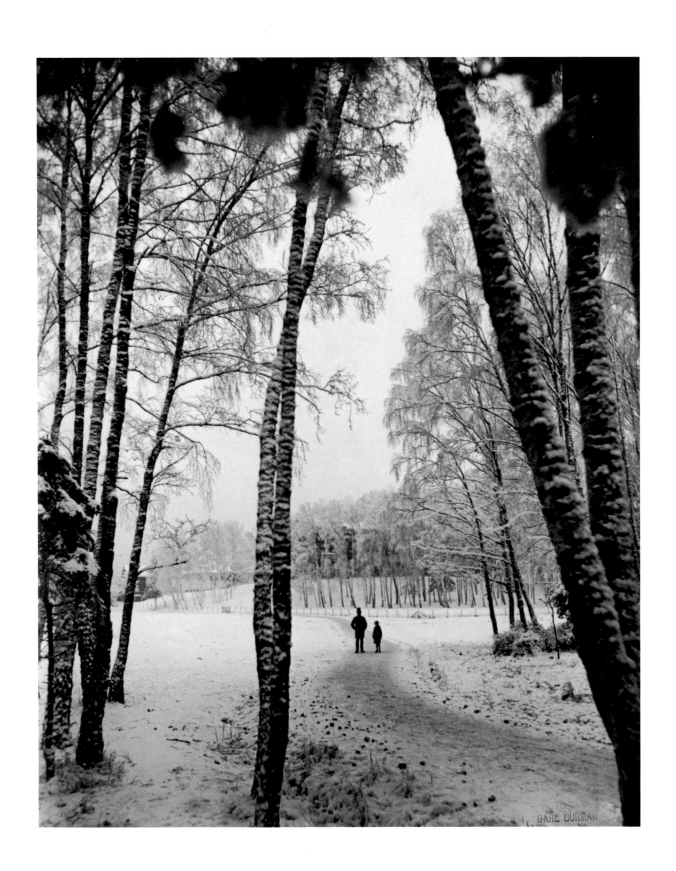

The Primal
Landscapes
of
Knud Knudsen

Robert Meyer

Knud Knudsen
Nystuen at Filefjeld ca. 1885
albumen print
8½ x 11
21.6 x 27.9
Collection Universitetsbiblioteket i Bergen

The landscape occupies a central position in the history of Norwegian art, with roots going back as far as the early 19th century. In 1799 the Dutch painter A. F. Skjoldebrand (1757–1834) trekked through Sweden and Norway to Nordkap and sketched beauty spots for a *Voyage pittoresque* album. These albums of picturesque landscape views were the travelogues of the romantic period and both encouraged and responded to foreign tourism to Scandinavia. Initially illustrated with engravings after watercolors or drawings and then with lithographs, they became the province of the photographer by the latter half of the 19th century.

Also significant for landscape photography in Norway was the grand painting style known as National Romanticism, which originates in German Romanticism and extends that tradition. The work of Norway's Johan Christian Dahl (1788–1857) epitomizes this sublime landscape art. An admirer of the German painter Caspar David Friedrich (1774–1840), Dahl taught in Dresden beginning in 1824, and his European reputation and return trips to Norway between 1834 and 1850 drew young Norwegian painters to the German city. Contacts between Germany and Norway were continued by the Norwegian Hans Fredrik Gude (1825–1903), who taught in Düsseldorf in 1854–62, in Karlsruhe in the 1860s and then in Berlin in the 1880s. Gude, Dahl and their followers created the Norwegian national-romantic school, which flourished almost to the end of the century, and some of their paintings became subjects for *Voyage pittoresque* albums. From this environment comes the outstanding landscape photographer Knud Knudsen (1832–1915).

Knudsen was born in Odda on 3 January 1832, the only son in a family with five girls. His father was a prosperous farmer and his great-uncle sold produce; Knud took up fruit-growing as a hobby. This led to his winning a scholarship in 1861 to travel to Germany to study that branch of agriculture, and he spent almost three years abroad. He may have learned photography before he left, possibly in Bergen under the Danish photographer Marcus Selmer, but in any event, Knud photographed in Würtemberg and when he returned to Norway he had all the equipment necessary for wet-plate photography. In 1864 in Bergen he advertised that his studio was open daily for portrait sittings and that he would accept orders for landscape photographs in stereo-card format and larger sizes. So began one of the largest series of Norwegian landscape photographs, which as early as 1889 contained over 12,000 pictures.

Tourism created the market for Knudsen—and as well for his predecessor, the Dane Marcus Selmer, and such photographers as the Swedes Axel Lindahl and Per Adolf Thorén and the Norwegians Hans Abel and Martin Skøien. Industrialization, burgeoning in the latter half of the 19th century, had created the capital and the leisure time for travel, and the steamships, railroads and hotels to encourage it. English visitors came to the Norwegian coast, and travelers from Germany and elsewhere in Europe sought out its scenery in numbers almost as great.

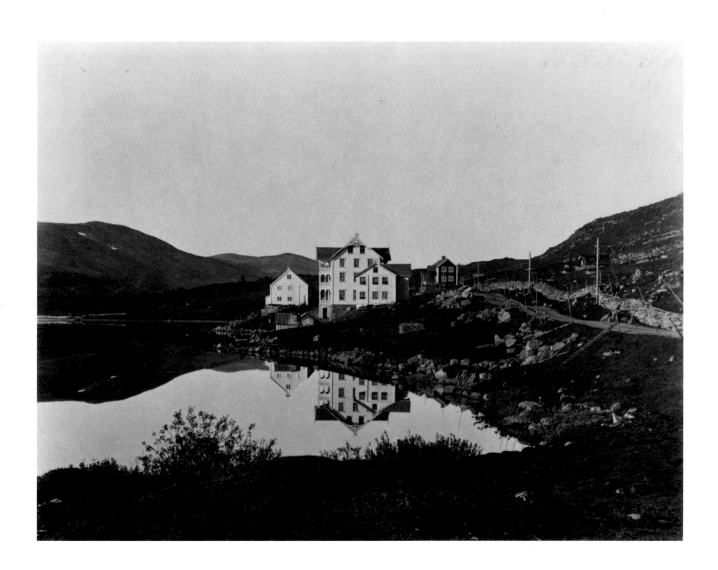

Knud Knudsen
Bondhusbræ en Glacier in Hardanger
ca. 1885
albumen print
8½ x 11
21.6 x 27.9
Collection Universitetsbiblioteket i Bergen

Knud Knudsen
Torghatten, Nordland ca. 1885
albumen print
11 x 8½
27.9 x 21.6
Collection Universitetsbiblioteket i Bergen

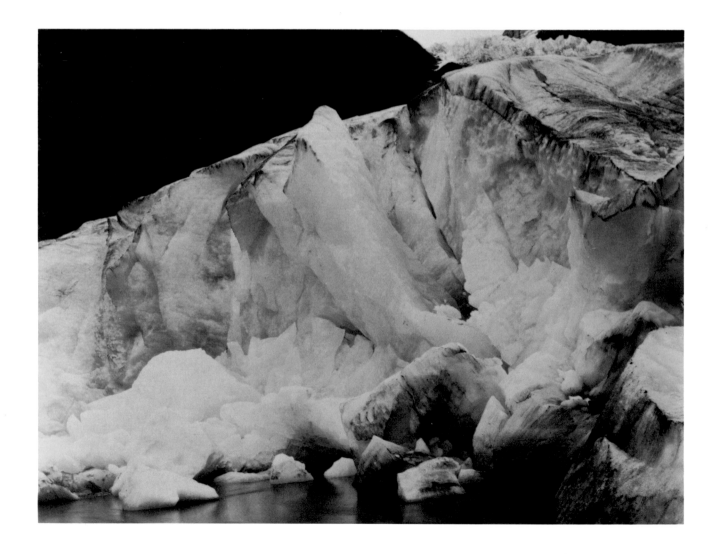

Knud Knudsen
Bondhusbræ en Glacier in Hardanger
ca. 1885
albumen print
8½ x 11
21.6 x 27.9
Collection Universitetsbiblioteket i Bergen

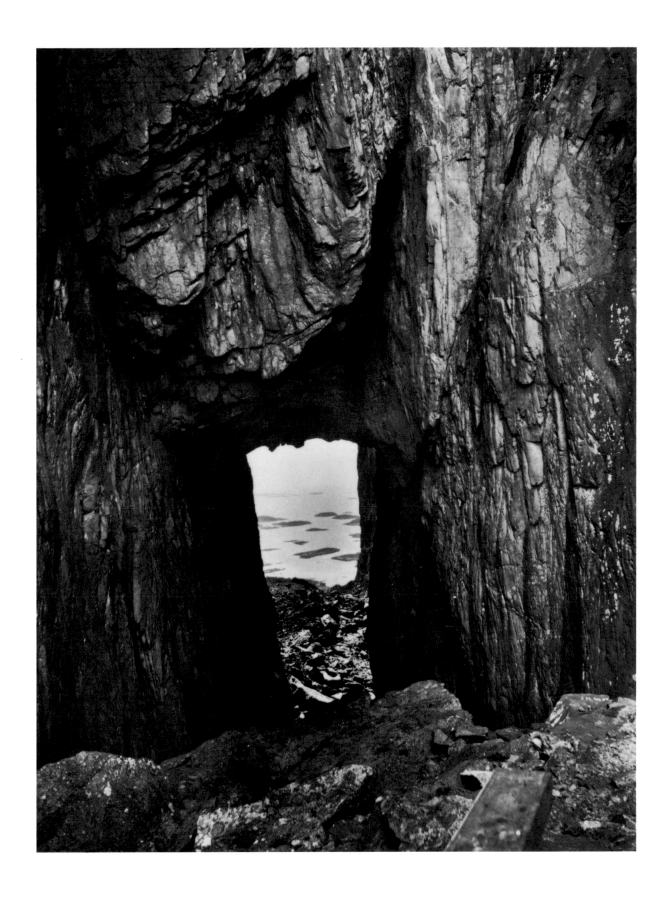

Foreign photographers also visited (including Henry Rosling, from Francis Frith's studio in England), and Scandinavian artists vied with them for representation by travel agencies, which sold pictures abroad to their expectant and nostalgic clients. Publishers also sprang up around the tourist trade, and in Christiania and Bergen travelers could buy series of landscape photographs from booksellers and stationers and assemble these mementos into albums as their personal *Voyages pittoresques*. To satisfy the public's interest in scenic memorabilia, Knudsen crossed Norway a number of times before he retired in 1898, photographing from Lindesnes to the North Cape and recorded landscapes, points of tourist interest (like hotels and stagecoach stations) and scenes of peasant life. To suit his clients' various tastes, he worked in 13½ x 18 cm. and 21 x 27 cm. formats, and in the 16 x 22 cm. format after he adopted the dry-plate process in 1882. The manufactured plates let him capture clouds for the first time, thanks to their greater sensitivity relative to the old wet-plate process, but his pre-1882 landscapes had not suffered: he used the white cloudless sky as a positive element in his pictures.

Knudsen's photography brought him a distinguished acquaintance, as well as wealth. In his native Odda, which had become a resort since the advent of steamship traffic in the 1860s, he knew Kaiser Wilhelm II, who made the lovely town his first stop on his annual yacht visits from 1889 to 1914, a custom that encouraged German tourism to Norway. By the 1870s Knudsen's reputation reached beyond his own country: he exhibited in Copenhagen in 1873 and at Philadelphia's Centennial Exposition in 1876 (he also visited a sister who had emigrated to Iowa); and he won an honorable mention at the Exposition Universelle in Paris in 1878.

How Knudsen's pure landscape photographs relate to other landscape art is an interesting question. In their motifs—waterfalls, glaciers, seasides, upland moors and mountains—they coincide with national-romantic painting. And some photographs

Knud Knudsen & Co.
Spitsbergen, Temple Bay ca. 1920
gelatin silver print
8¼ x 33½
21 x 85.1
Collection Universitetsbiblioteket i Bergen

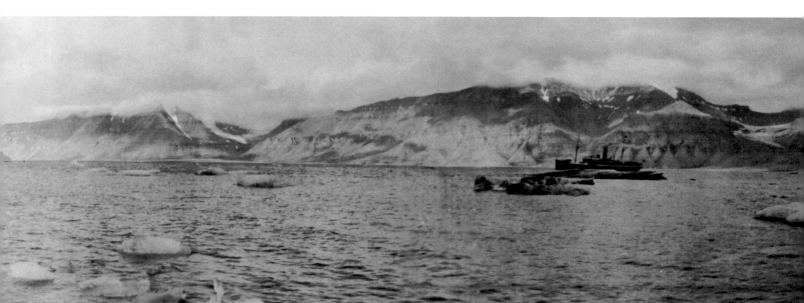

have traditional closed compositions, in which a dominant element is centered and reaches toward the sky and subordinate forms terminate within the frame. But in other photographs, forms and shapes erupt out of the picture, and there is a marked tendency toward a mute, almost menacing sense of the dramatic. These compositions reveal Knudsen's clear and robust sense of form, which in several cases approaches abstraction. Here are plunging lines in contrasting diagonals and verticals, compelling us to concentrate, for example, on one human figure. Delicate light surfaces are a foil to dark areas, and the diminution of atmospheric contrasts into depth serves to define space with delicacy and harmony. There is no evidence that Knudsen tried to encroach on the province of painting, though he collected pictures, was a member of the Bergen Art Association (from 1878) and produced a series of photographs of Hardanger which he sold as "Motifs for Painters." Rather, he used purely photographic qualities in his landscapes, and there revealed his personal response to nature, to its mysteries and forces.

The only photographer of Norwegian scenery who bears comparison with Knudsen is Axel Lindahl (1842 – 1907), whom he may have influenced. While Knudsen often approaches the motif close up, Lindahl keeps his distance. Even when both photograph the same scene, Lindahl's images have a more delicate and poetic expression, conveyed with softer lines. They lack the strength of Knudsen's photographs. Pictorially, Knudsen was supreme in the 1870s and 1880s. One is tempted to quote Novalis in interpreting his pictures: "The world must be romanticized. In this way it will recover its original meaning." This may not have been Knudsen's conscious aim, but it describes the romanticism of which he was a part.

Robert Meyer, a photo-historian and collector of photography, was a founder of Norway's Forbundet Frie Fotografer, which has won government and public support for photography. He published the Norsk Fotohistorisk Journal *in 1976 – 78 and has written books and numerous essays on Scandinavian and American photographers. (Translation by J.R. Christophersen.)*

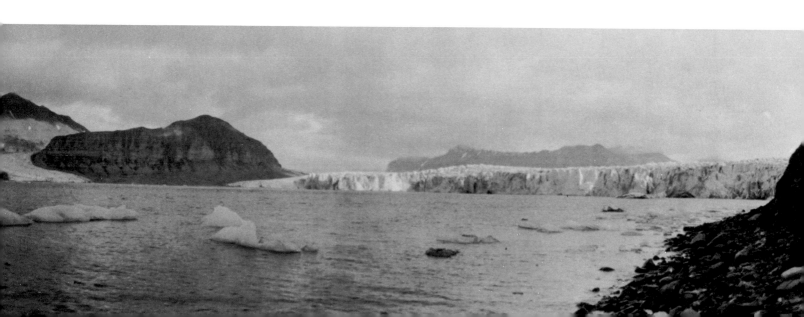

Carl Curman:
Stockholm
and the
West Coast

Bo Grandien

Carl Curman
Rocks on the western coast of Sweden
ca. 1890
modern gelatin silver print
from duplicate negative
8¾ x 6¾
22.2 x 17.1
Collection Antikvarisk-Topografiska
arkiven, Riksantikvarieämbetet, Stockholm

The gifted amateur photographer Carl Curman (1833–1913) found his motifs primarily in two areas, the west coast of Sweden and Stockholm, the capital. Most of his pictures from Stockholm portray the city in winter, its large, snow-burdened parks and its wooded periphery. He photographed on the west coast mainly in the summer. The reason for this division of labor is simple enough: in winter, he was the physician and director of two large thermal baths in Stockholm; in the summer, he ran a large sea bathing center in Lysekil, on the west coast. Photography was not his profession, but one of his favorite leisure-time pursuits.

Curman's interest in the camera stemmed from his interest in art. In his youth he had been undecided whether to devote his life to medicine or to painting, but money determined his choice. At a very early stage of his life, Curman started to take photographs. In the late 1850s and early 1860s, before he had qualified as a doctor, he explored medical photography at the Karolinska Institutet in Stockholm (the national teaching institute and hospital where medical students are still trained). Bills from the year 1862, later found in his effects, indicate his activities in the darkroom he was allowed to set up: albumen, filters and Bristol board were delivered there, as were glossy photographic paper, blotting paper and chemicals. These were the days of wet plates, and Curman was an absolute master of this technique.

Curman was born in 1833, in the Swedish countryside. His parents were unable to finance his medical studies, which meant that he often had to discontinue his training and take work as a tutor. During these enforced breaks, he cultivated his artistic talent. He carved portrait busts and motifs from the old Nordic sagas and made watercolors and drawings of landscapes. In 1854 and 1858 he went on two long hikes in Norway, an activity that was increasingly attractive to tourists.

Early visitors to Norway were fascinated partly by its magnificent scenery, partly by the old settlements that survived along the fjords and in the valley. They saw these settlements and their inhabitants as the direct inheritors of a bygone age, which they identified with the Vikings. And they viewed the natural beauty of Norway in the romantic perspective that had been developed by such artists as Johan Christian Dahl of Norway and Caspar David Friedrich of Germany. To these painters, the mountain landscapes of Norway often seemed to fade and merge with the mystery of infinity itself.

Many of Curman's watercolors and wash drawings from his visit to Norway in 1858 have been preserved. They depict mountain valleys, great waterfalls and rock massifs of superb majesty. The snow-covered peaks, as they tower white and unreal in the distance, often give an impression of being of the same substance as the air itself. Curman portrays with particular care the old wooden buildings of Norway, above all the "stave" churches surviving from the Middle Ages.

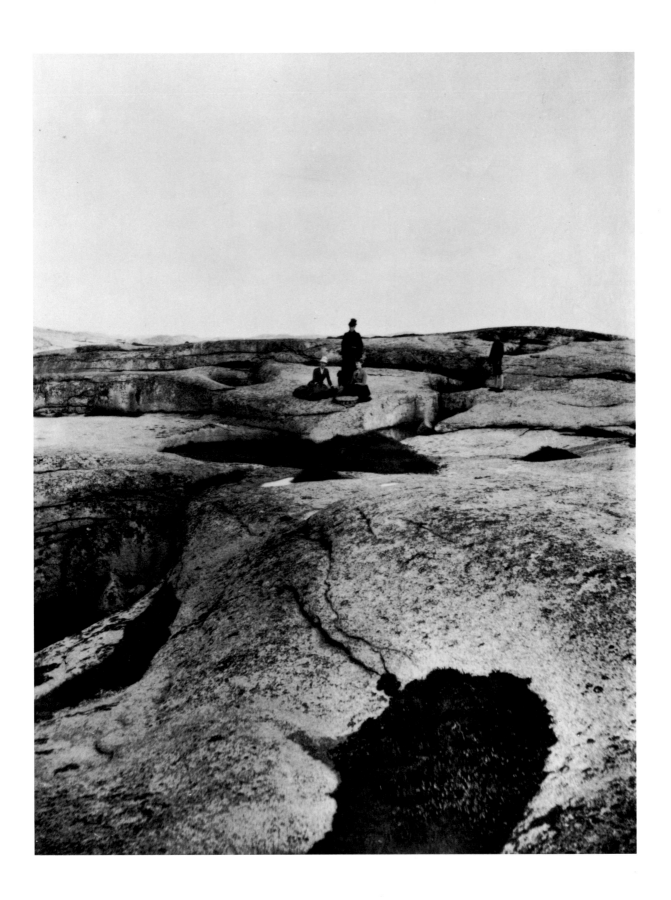

Carl Curman
Park of the baths ca. 1888
modern gelatin silver print
from original negative
8 x 10¼
20.3 x 26
Collection Nordiska museet, Stockholm

As a watercolorist, Curman participated in various exhibitions in Stockholm, and works of his are included in an album of drawings from the province of Värmland, printed in 1855–57. Many professional artists contributed to this topographical work, which contains lithographs of beautiful views, country people in picturesque peasant costume and small factories set beside waterfalls. In 1864 Curman completed his medical training. He then immediately threw himself into an intensive working life, and this, in addition to a wealthy marriage, eventually made him rich. The Curmans' villa in Stockholm, which he designed, became a center of upper middle-class intellectual life.

From the 1860s come the earliest of Curman's landscape photographs. By this decade the art of photography had made great strides in Sweden; the number of professional photographers rose to 65 by 1865. There were few amateurs, however, and landscape photography was a more or less closed field, because the wet plates—the only medium—had to be processed by the photographer himself, using bulky equipment, exposing and developing in the space of a few minutes. The first major technical advances occurred in the 1880s, when durable dry plates became widely available. This made photography an art for the general public, and the great age of the amateur photographer began. In 1888 the Swedish Society of Amateur Photographers was founded. In the following year, professional photographers were also admitted, and the name was changed to the Swedish Photographic Society.

Between 1860 and the 1880s Curman's technical abilities advanced, and he was soon as skilled with dry plates as he had been with the collodion process. His early photographs from the west coast show a certain family likeness with his watercolors: there is an intense light which indicates the closeness of the sea and a predilection for grand, open landscapes with dramatically carved natural rock formations. In the islands around Lysekil, it is above all the granite that presents an astonishing range of forms, and Curman dwells on them. With time, he became a scientific observer, and it is possible to see in his photographs a reflection of his studies of climatology.

In his photographs of fishing villages along the west coast, Curman also displays a considerable documentary interest. People appear not just as indicators of scale, as they do in the island photographs, but as interested observers of the photographer at work. The suite of photographs as a whole gives us a picture of this simple way of life during the last quarter of the 19th century. Apart from their artistic qualities, the pictures are a great resource for the historian and ethnographer.

The combination of artistic and documentary ambition is most evident in the numerous photographs Curman took of his summer bathing center in Lysekil. This functioned as a complete miniature township, with a resplendent community hall as its central feature. Along the jetties below the bathing pools were moored rows of rustic sailboats, with their great sails hung out to

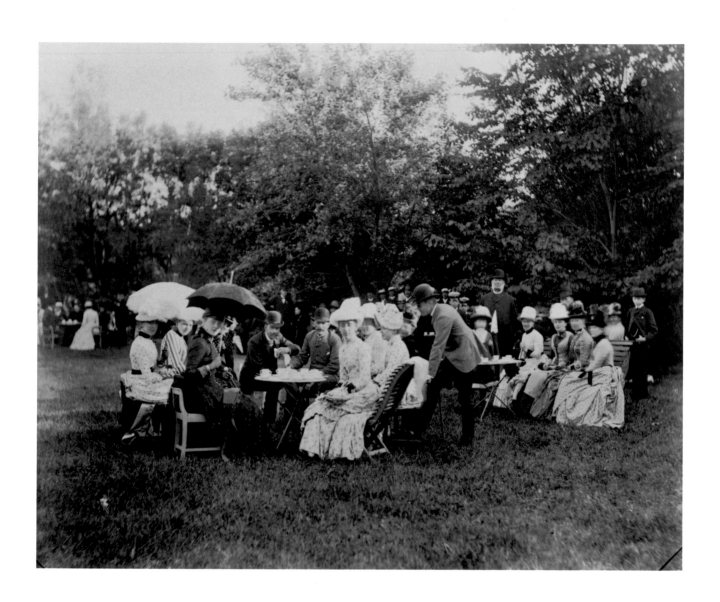

dry. This became Curman's favorite motif. Numerous photographs are dominated by the great, fluttering white sails, often taken against the light. Life in this summer resort emerges very clearly in Curman's pictures.

In Curman's winter photographs of Stockholm, the stillness is striking. The photographer portrays the heavy gray light of the city in February. The landscape plays the primary role, and when human figures are included, it is usually to mark their smallness by comparison with the great trees. In general, these pictures seem experimental—for example, some prints are tinted blue—with an emphasis on aesthetics over documentation. The winter photographs have an atmosphere of poetry, of melancholy, and they differ from the summer pictures much as the heavy and gloomy Stockholm winter itself differs from the sunny west coast summer.

There is also a third area in which Curman photographed, the province of Dalarna, where he summered in 1899. This province is well known for its archaic timber houses and ancient traditions, and Curman felt that he had found in it a revelation of the Swedish "national soul," deriving its origins from the Viking age. He photographed the traditional "church boats"—long slender craft in the Viking style in which villagers crossed Lake Siljan to attend church—the timber buildings and the local population in their folk dress.

The preservation of the old folk culture that was being destroyed in the processes of industrialization and urbanization was the main purpose of the creation in 1873 of the Nordiska Museet in Stockholm, in which Curman played an active part. First called the Scandinavian Ethnographic Collection, the institution was renamed the Nordic Museum in 1880 and given a large building in 1890. To Curman and the other founders, the museum was a means to develop national pride and historical awareness in the Swedish people. A large collection of Curman's glass-plate negatives exists there.

Senior lecturer in art history at Uppsala and Stockholm universities, Bo Grandien organized the first Curman exhibition in 1976. He writes for Dagens Nyheter, *Sweden's largest morning newspaper, and his books include* Drömmen om medeltiden *(The Dream of the Middle Ages), 1974, and* Drömmen om renässansen *(The Dream of the Renaissance), 1979. (Translation by Keith Bradfield.)*

Carl Curman
Women of the Curman family resting at a picnic ca. 1890
modern gelatin silver print
from duplicate negative
8⅝ x 6½
16.8 x 16.5
Collection Antikvarisk-Topografiska
arkiven, Riksantikvarieämbetet, Stockholm

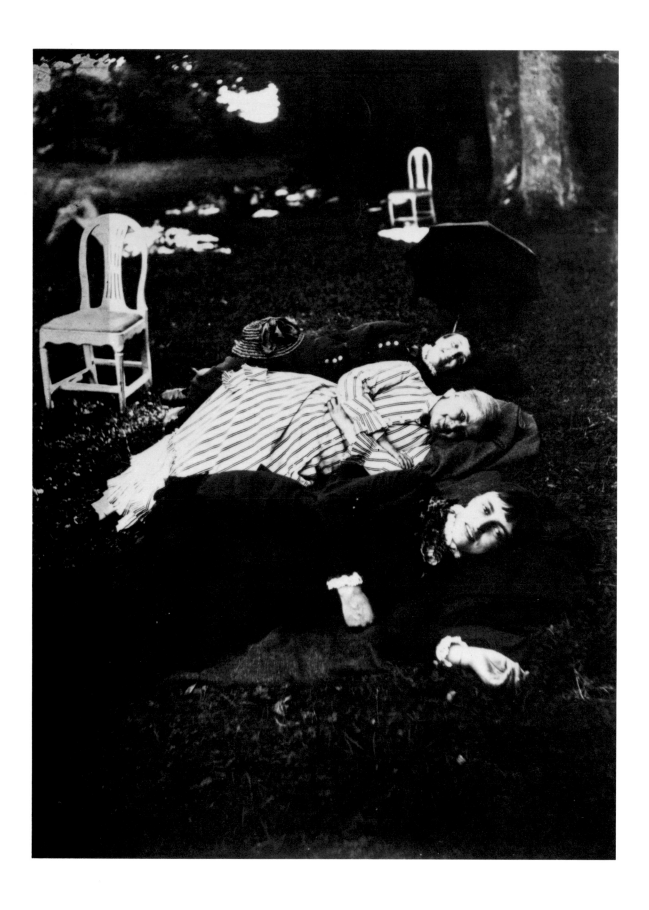

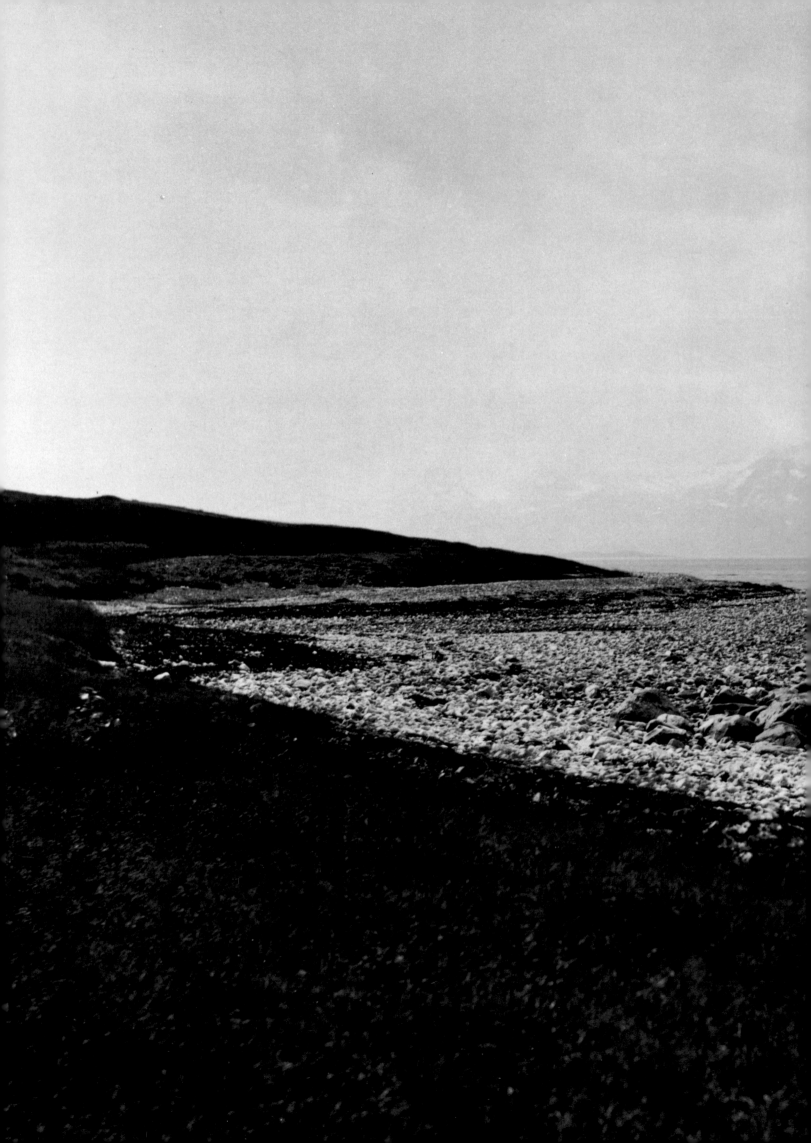

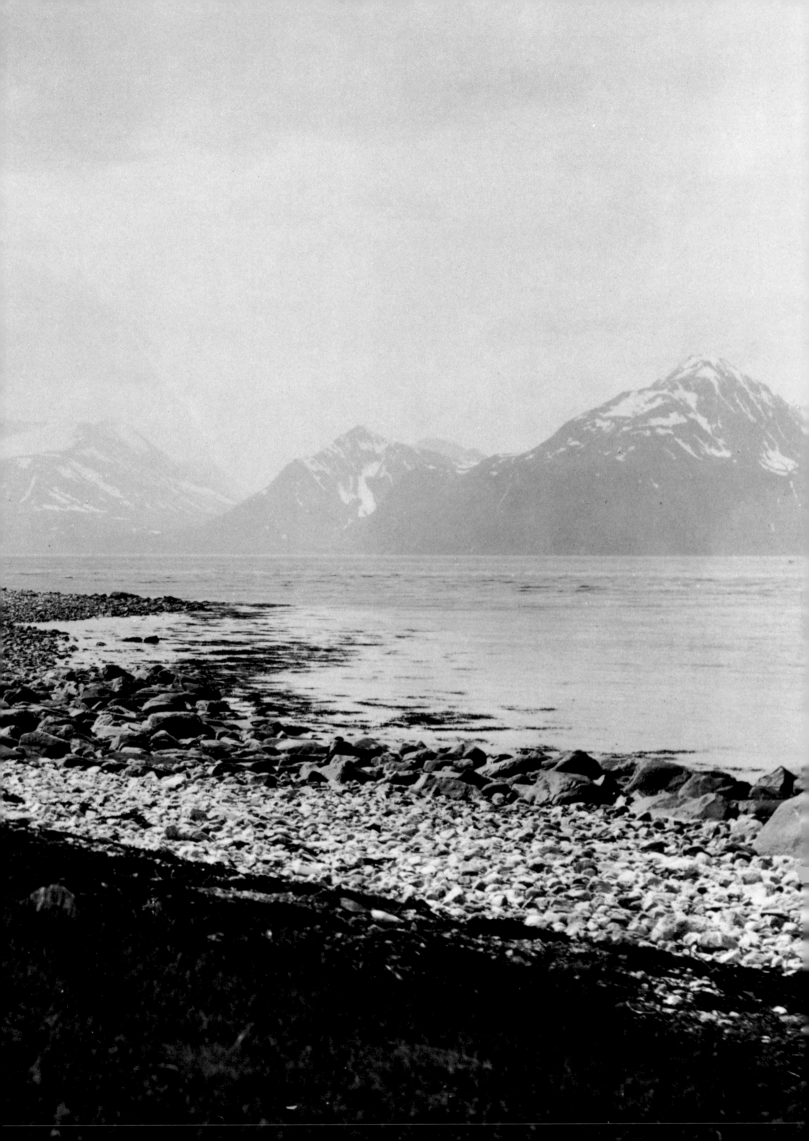

Beyond the
Arctic Circle

MF

(overleaf)
Knud Knudsen
Lyngenfjord, Tromsø Province (detail)
ca. 1885
albumen print
8⅛ x 10⅝
20.6 x 27
Collection Universitetsbiblioteket i Bergen

Thomas Neergaard Krabbe
Ûmánaq Mountain at North Star Bay,
Greenland 1909
platinum print
6⅝ x 9
16.8 x 22.9
Collection Det Kongelige Bibliotek,
Copenhagen

Photography's early days coincided with those of Arctic exploration. An insatiable curiosity about far-flung territories and societies separated from the West by geography and tradition was stimulated by photographs made by explorers and scientists. Though few of these hardy adventurers had camera training, it was they who, in the process of mapping and claiming frozen wilderness for their countries, produced some of the first tantalizing images of landscape well beyond the Arctic Circle.

One of the most celebrated of these explorers was the intrepid Norwegian, Roald Amundsen, whose discovery and successful navigation of the Northwest Passage through the Arctic Ocean climaxed a three-year odyssey that had begun in 1903. In Amundsen's wintry photographs, his little sloop, the *Gjöa*, resembles an icebound Argos. During its arduous progress through northern seas, the *Gjöa* was an object of great curiosity to the nomadic Eskimos with whom the boat's crew established rapport. In one photograph, very probably made off the coast of King William Island, a fur-wrapped young Eskimo woman regards us from the *Gjöa*'s deck.

In a portfolio of platinum prints made in 1909, the Danish physician Thomas Krabbe recorded in exquisite detail the variegated coast of Greenland, in whose secret bays we catch glimpses of dark pyramidal islands and sunstruck ice floes. Light is the great modifier in a Krabbe panorama: it can define the jagged contours of distant land forms with dazzling clarity and, at the same time, dissipate these into mirage-like hazes. The relationship between water and sky is ambiguous and in some photographs they seem interchangeable.

A harsher vision of nature pervades the haunting photographs made by the ill-fated trio of explorers who, under the leadership of Salomon August Andrée, took off in a giant balloon from Spitsbergen on 11 July 1897 to chart the North Pole. After only 65 hours aloft, the battered *Eagle* drifted to the ground. Not until 33 years later was the expedition's last camp found, and among the relics was exposed film, mostly shot by Nils Strindberg, the expedition's photographer. In these desperate images, coaxed into existence through the genius of the modern laboratory, we follow with clarity the trio's fate. Three months after the crash, all were dead. In the ghostly emanations that cloud the first prints, the vicissitudes they endured are all too evident: the prints are foggy, spotted and light-struck in a patination that contributes to their spectral effect. It is almost as if time has become the photographer. The race to the Pole was a matter of intense national pride, but in this gloomy and intimate record we see it as a tragic illusion.

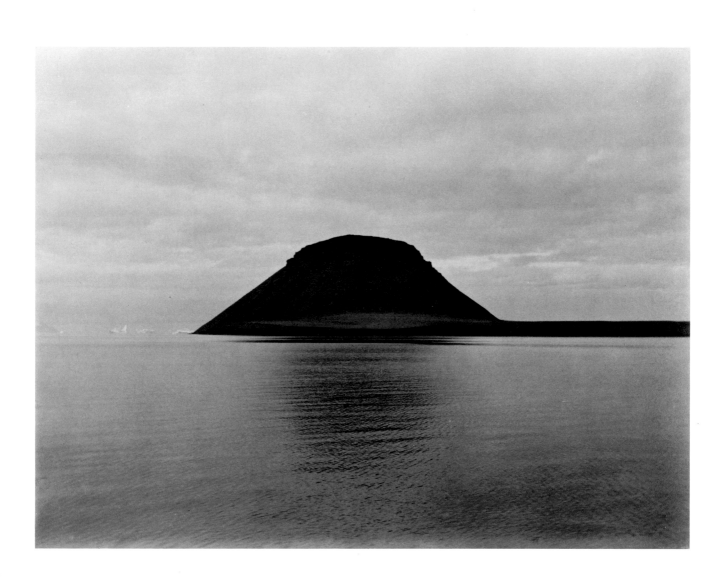

From Expedition to Holiday

Bjørn Ochsner

Nils Strindberg
The *Eagle* shortly after landing on
the ice 14 July 1897
(printed by John Hertzberg 1930)
modern gelatin silver prints
from original negatives
4⅞ x 7 each
12.4 x 17.8
Collection Fotografiska Museet, Stockholm

From the beginning of photographic history, cameras have accompanied explorers to the far reaches of the globe. Between 1840 and 1844, for example, the French optician N.-M.-P. Lerebours published *Excursions daguerriennes*—114 views in aquatint copied from daguerreotypes of Africa, America and Europe, taken as far north as Stockholm. From Egypt, Syria and Palestine came the prints of Maxime Du Camp and Francis Frith in the 1850s. Out of the ruined Mayan cities of Yucatán appeared Désiré Charnay's magnificent photographs of 1857–61, published in 1863. In the Haute-Savoie the Bisson Frères documented the perilous, glamorous Alps which they scaled to a height of 16,000 feet in 1860 and 1861. The Arctic Circle, however, received no comparable publication until 1873, when the Boston photographers Dunmore and Critcherson published their pictures of Greenland and Baffin Island, views made on their expedition of 1869 with the American William Bradford. Soon thereafter, in 1877, the London Stereoscopic and Photographic Company offered a portfolio of 107 photographs of Greenland, Greenlanders and the Canadian coast made by Thomas Mitchell and George White, the paymaster and engineer on two British ships that had sought the North Pole in 1875–76. From this decade on, Arctic photographs multiplied as did expeditions to the North, adventures undertaken most notably by Germans, Danes, Swedes and the Swiss, and by geologists, meteorologists, botanists and explorers, through the 1920s.

To photograph the frozen North was in fact easier than to photograph the desert. While suffering wind-lashed sand, voracious insects and 115° temperatures in his portable darkroom, Du Camp had only about five minutes to develop his wet collodion plates. Arctic photographers, on the other hand, could get proper exposures in as little as two seconds, thanks to intense reflections from snow and ice, and they could delay processing their wet plates up to an hour and a half. The cold made possible a poignant record of one expedition that failed, a balloon flight captained by the Swede, Salomon August Andrée (1854–97), and aimed at the North Pole in 1897. The balloon went down, and after three months wandering on the ice, Andrée and his two assistants met their deaths on Kvitøya, an island 300 miles east of Spitsbergen, Norway. Search parties went out, but it was not until 1930 that the bodies of the explorers were found. With their equipment was some undeveloped Kodak film, which was processed and printed 33 years after it had been used to record the ill-fated expedition.

Before his last foray, Andrée had made nine successful balloon flights, and his first assistant, Nils Strindberg (1872–97; nephew of the Swedish playwright), who took the photographs, had made six ascents. They were both practiced aeronautical engineers, and Andrée had gained support from the Swedish Academy of Science for the 1897 expedition to the Pole. But luck and the weather conspired against them: their balloon lost much of its maneuverability immediately after the start when two-thirds of its trail ropes were accidentally torn off, and as the aircraft traveled north, ice coated the envelope, forcing the

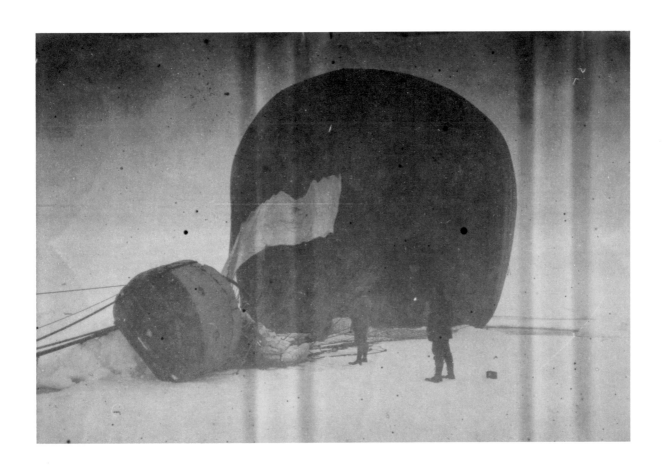

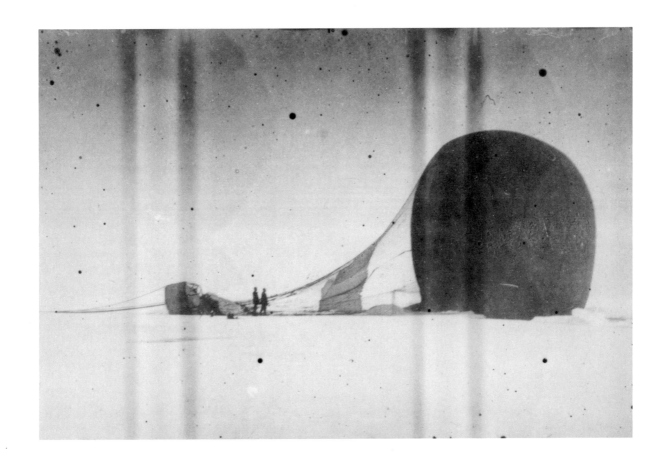

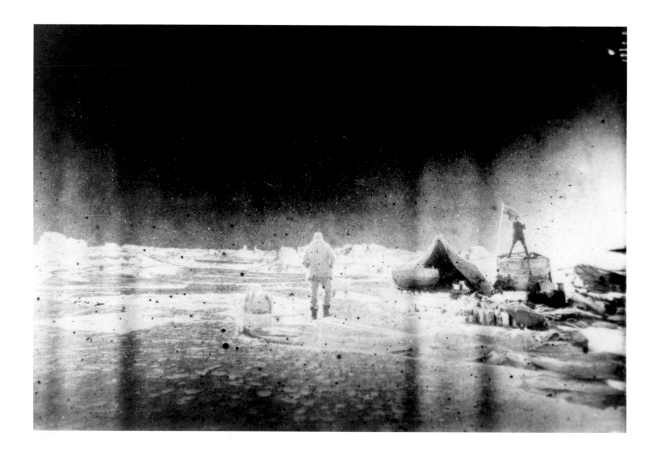

Nils Strindberg
After the landing; Andrée standing on the
gondola, looking for land 20 July 1897
(printed by John Hertzberg 1930)
modern gelatin silver print
from original negative
4⁷/₈ x 7
12.4 x 17.8
Collection Fotografiska Museet, Stockholm

Nils Strindberg
Frænkel (left), Andrée (right) and
Strindberg after 21 July 1897
(printed by John Hertzberg 1930)
modern gelatin silver print
from original negative
4⁷/₈ x 7
12.4 x 17.8
Collection Fotografiska Museet, Stockholm

Nils Strindberg
Strindberg (right) and Frænkel beside a
dead bear after 28 July 1897
(printed by John Hertzberg 1930)
modern gelatin silver print
from original negative
4⁷/₈ x 7
12.4 x 17.8
Collection Fotografiska Museet, Stockholm

*While we were sitting inside the tent and
S. & F. were getting the supper ready and I
was mending my pants I heard a noise
outside the tent and when I looked through
the crack in the opening I saw a bear close
to my nose. I did not leave off sewing but
merely said: see there is another bear for
us, whereupon F. took hold of one of the guns
(which by a chance had been taken into the
tent for cleaning) and crept out. The bear
then stood a few steps from him and . . .
in order to attack . . . but was met by a ball
that made him fall dead after he had gone a
few paces. We continued our work and our
supper before we even looked at the
cadaver.*

S.A. Andrée, *Andrée's Story: The Complete
Record of His Polar Flight,* 1897

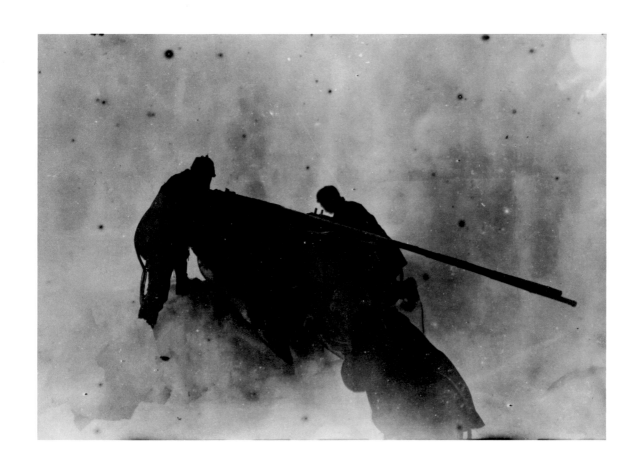

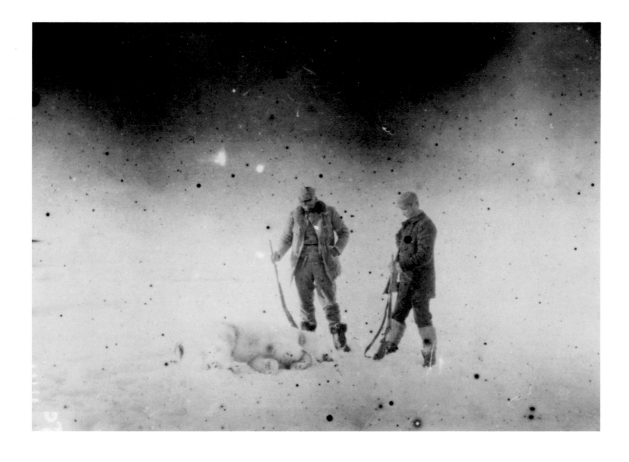

It is not a little strange to be floating here above the Polar Sea. To be the first that have floated here in a balloon. How soon, I wonder, shall we have successors? Shall we be thought mad or will our example be followed? I cannot deny but that all three of us are dominated by a feeling of pride. We think we can well face death, having done what we have done. Is not the whole, perhaps, the expression of an extremely strong sense of individuality which cannot bear the thought of living and dying like a man in the ranks, forgotten by coming generations? Is this ambition?

The rattling of the guide-lines in the snow and the flapping of the sails are the only sounds heard, except the whining in the basket.

S.A. Andrée, *Andrée's Story: The Complete Record of His Polar Flight*, 1897

basket down after 65 hours in the air. Drifting ice made it impossible for the men to reach Franz Josef Land in the Arctic Ocean where emergency supplies were located. Judging from the diaries discovered in their effects, the explorers were initially optimistic about rescue. One photograph shows Andrée standing on top of the basket, scanning the horizon; in another, taken with a self-timer, the three wrestle with their boat and sled; another shows Andrée with the polar bear he had shot, and in a fourth, Strindberg and Knut Frænkel, the other assistant, are posed beside the same animal. But their optimism waned after their ice floe began to break up, forcing them to seek refuge in their damaged tent on Kvitøya. Not many weeks after the photograph with the bear was taken, they were all dead. Strindberg died first, a victim of either the extreme cold or the bear's trichinous meat.

In August 1930 the walrus-hunting crew of a Norwegian ship found their remains, and five rolls of 48-frame, 5 x 7 inch Kodak film. After experimenting with the film that had not been exposed, the Swedish expert John Hertzberg found a developer that strengthened the silver traces without blurring the emulsion; he succeeded in saving about 50 pictures, of which 20 are clear enough for reproduction. These works have a strong graphic effect, partly because of the dark traces left on the film by its sleep in the ice, but also owing to the striking composition of dark figures and objects against the background of white ice and gray skies. Like many expeditionary photographers, Strindberg was a scientist first and a camera operator second, but he was an accomplished one. In 1895, the same year that he was appointed lecturer in physics, he won first prize at a photography exhibition in Stockholm. It is hard not to see his photographs as prescient with doom: how puny are the figures of the three explorers, how empty and alien is their environment.

Quite a different view of nature appears in the later photographs of Thomas Neergaard Krabbe (1861–1936). While the Arctic of Strindberg and Andrée is merciless, the physician and ornithologist Krabbe shows Greenland in his pictures of 1893–1909 as a rigorous but habitable region. His pictures, 7 x 9 inch contact prints, belong to the best of Danish photography and they are invaluable ethnographic and geographic records, documenting the area from the Kap York district in northwestern Greenland down the coast and to Angmagssalik on the east.

As Greenland's resident doctor and medical inspector for the Danish health authorities for 20 years, Krabbe traveled to all the then-inhabited territories, and from 1893 he took photographs of the country and its people. Though his pictures show the fierce climate of Greenland, they identify it as a country in which the strong and hardy can survive. He shows happy young people as well as old, weathered characters, in works conveying his sympathy with his subjects. The photographs are technically superior, with a wealth of tints and a great tonal range. It is probable that Krabbe did not initially photograph with publication in mind, but he was proud of his prints as original documents of the early 1900s and as beautiful images.

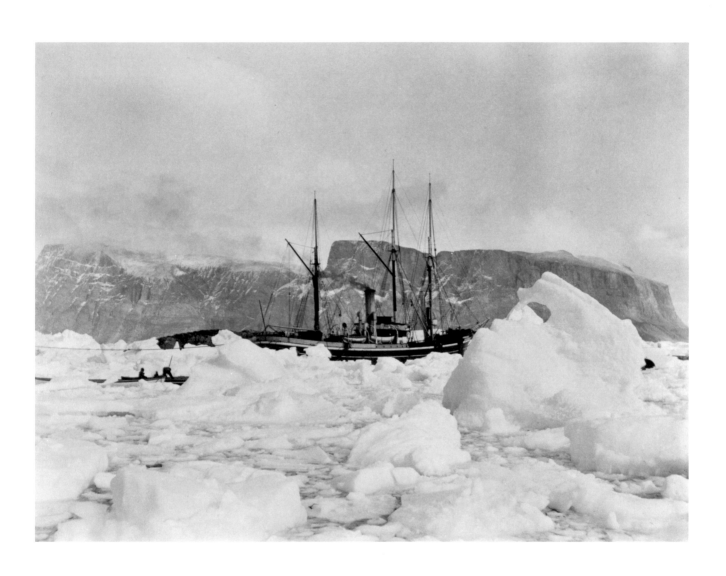

Another photographer of the Arctic regions is Anders Beer Wilse (1865–1949), whose career illustrates yet a third kind of photography of the North. While Strindberg's works were intended as scientific records and Krabbe's are an amateur's mementos of a land he lived in, Wilse's were commercial pictures made by a careerist who advertised himself in 1898 as a "scenic photographer."

Born in Flekkefjord, Norway, Wilse went to sea at age 13, but after attending technical school in Norway he emigrated to the United States in 1884 as a railway engineer. Two years later he was in Minneapolis, where he bought his first camera. In 1898 in Seattle he began his professional career as a photographer, and by 1900 he was so prosperous that he could send his wife and three children to Norway for the summer. Once there, she persuaded him to give up the Seattle business with its three assistants to return to live in his native country. Wilse established himself as a portraitist in Kristiania (now Oslo), but he also photographed ships and made views all over Norway for popular consumption, work that won him government

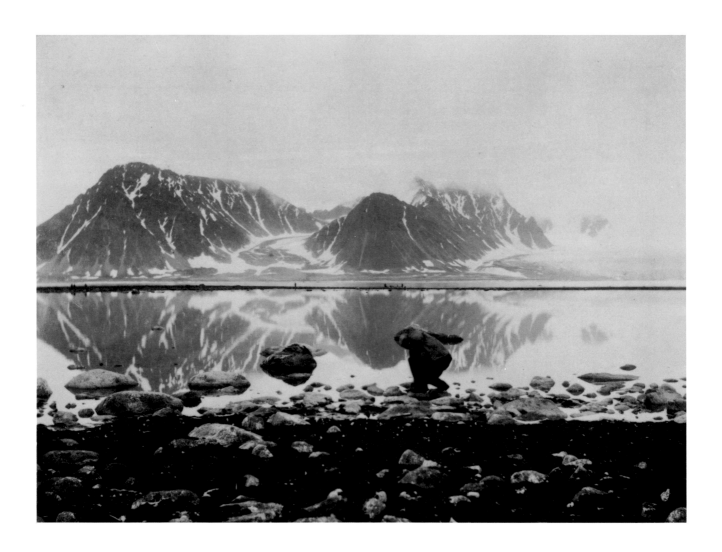

honors, including the King's Order of Merit in gold (a royal distinction instituted in 1908 for contributions to the arts, science, trade and public service). After Wilse's death in 1949, his son Robert Charles, who had been his business partner, took over the firm and operated it through 1958.

Wilse's most engaging photographs date from 1901 through the 1920s. By the 20s the Norwegian island dependency known as Svalbard in the Barents Sea was no longer the starting point for assaults on the Pole. (The American explorer Robert Edwin Peary had succeeded in reaching it in 1909.) The main island, Spitsbergen, and some of the smaller islands were sights for tourists on summer cruises. Wilse went along on them a couple of times, compiling photographic albums that passengers could purchase at the end of their holiday. The islands had come under Norwegian sovereignty in 1925, and were valued for the large coal deposits found on Spitsbergen around 1900. On the northwest side of Spitsbergen, warmed part of the year by the North Atlantic Drift, Wilse took ravishing photographs of mountains and sea. Nature in his sepia images is beautiful, timeless and distant, viewed from the comfort of the tourist's deck chair. Though empty of people, his grandiose vistas are not threatening, but spectacular. This is not a region to be mapped but a landscape to be enjoyed. Ironically, however, not much time had passed since stern photographs of Spitsbergen were made by the navy captain Gunnar Isachsen (in 1906, 1907 and 1909) and by the geologist Adolf Hoel (from 1908 to 1925), and since Strindberg made his tragic images on the Arctic Circle. Wilse's pictures are exquisite travelogues, while Strindberg's stand as symbols of the heroic era of the explorer-photographer.

From 1944 to 1980, Bjørn Ochsner, MA, was head of the department of maps, prints and photographs of the Royal Library, Copenhagen. His books include 100 Years of Photography from a Danish Point of View, *1962;* Photography in Denmark 1840 – 1940, *1974; and* Photographers in and from Denmark to the Year 1900, *1956, rev. ed. 1969 (all in Danish).*

To the explorer . . . adventure is merely an unwelcome interruption of his serious labors. He is looking, not for thrills, but for facts about the unknown. Often his search is a race with time against starvation. To him, an adventure is merely a bit of bad planning, brought to light by the test of trial. . . . Not all would-be explorers realize this truth. The result is many a grave needlessly occupied before its time, and many a blasted hope.

Roald Amundsen, *My Life as an Explorer,* 1928

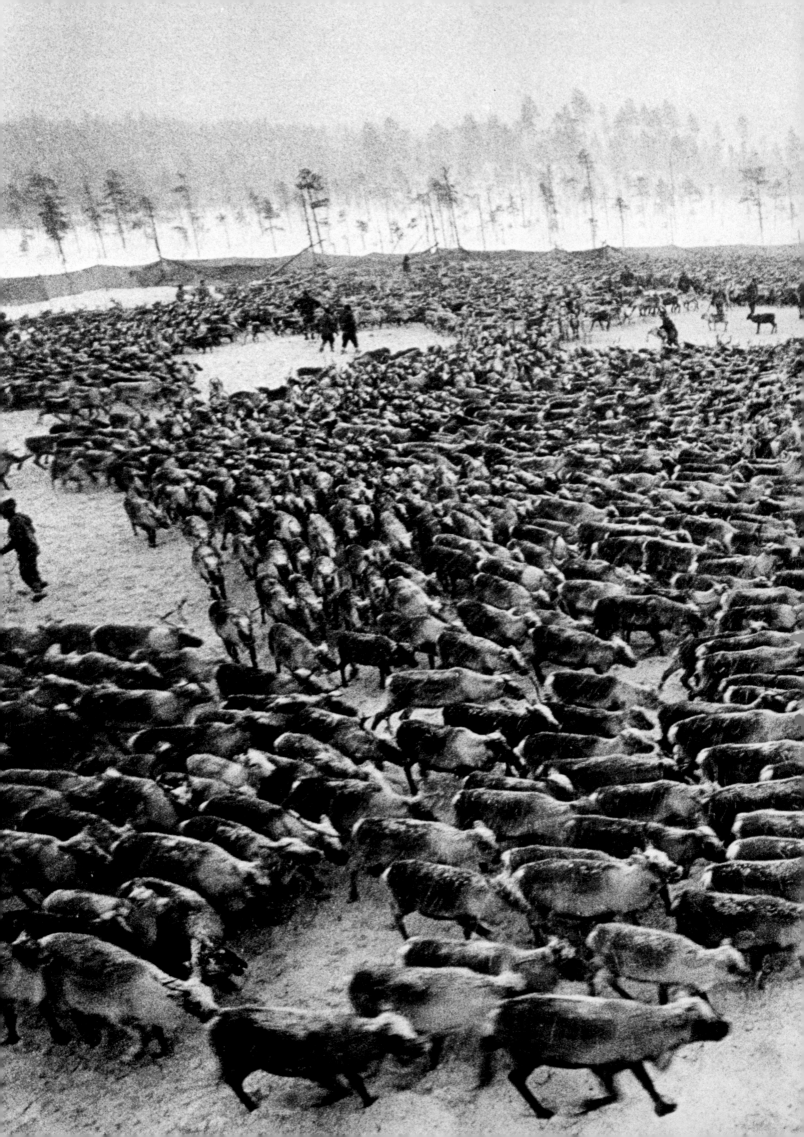

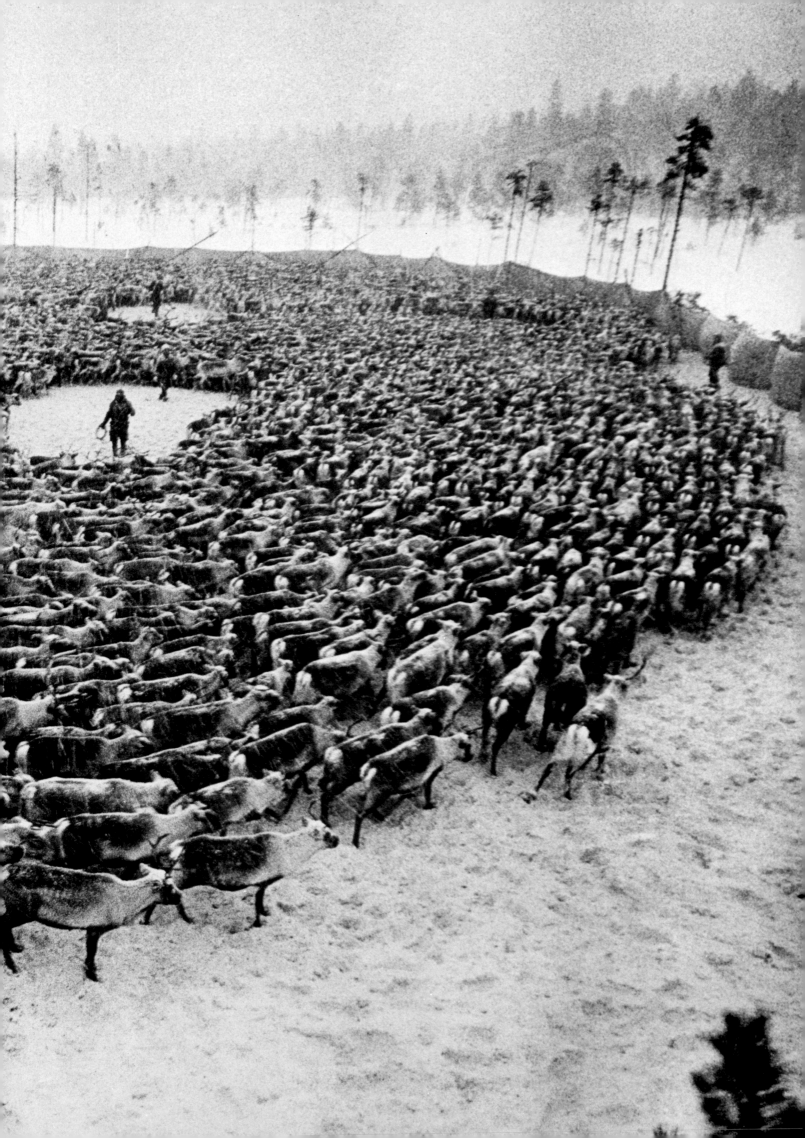

Nomads and Settlers

MF

Among the most interesting side effects of the growth of nationalism in 19th-century Europe was an ardent curiosity about ethnic origins. As nations sought to define themselves, the issue of cultural heritage became paramount, and the long-neglected peasantry with its time-honored customs was suddenly extolled by the middle classes as a stalwart symbol of cultural continuity and stability. Concurrent with the quest for national origins was an emphasis on preservation of the basic virtues—uncomplaining hard work and cheerful coping with adversity—which were romantically attributed to the rural folk.

To 19th-century Scandinavians, the nomadic Lapp, or Sami, was as exotic and remote as the Plains Indian was to white Americans. Apparently, Rousseau's "noble savage" was flourishing among the "reindeer people," an unspoiled folk who roamed the land freely, at peace with themselves and in harmonious relation to nature. With this roseate view of native culture, the photographer Marcus Selmer made his way to Nordland in 1870, where he produced hand-colored photographs of the indigenous Sami peoples of that Arctic region. Formally posed against painted backdrops, these elaborately costumed wanderers regard us with somber detachment. The message implicit in these photographs, not to mention their picturesqueness, made them objects of admiration to contemporary city dwellers.

A more probing, systematic way of looking at the remnants of this venerable culture was provided by the new discipline of ethnography. Among the finest early records of society are the photographs by scientists and government district officers who grew to know and respect these migrant people. In numerous, highly detailed photographs made by the Danish-born Sophus Tromholt and by Ellisif Wessel, the socially concerned wife of a rural Norwegian physician, Sami culture was presented in its primal dignity to the rest of the world.

Of constant concern to these pioneer photographers was the scrupulous documentation of indigenous life, yet we can also sense their response to the individual before the lens. To establish trust with the Samis was no small feat because, like other native societies, they regarded the camera with curiosity and apprehension, possibly as a magic instrument that might steal their essence. Though as a record keeper Tromholt methodically arranged his subjects with the rigid conventions of the 19th-century studio, he made psychological contact with his patient models. Indeed, he seems to have won them over, for he produced extremely sensitive portraits of individuals rather than specimens of ethnography.

Unlike Tromholt, Ellisif Wessel chose her subject matter at will, for she was not committed to systematic documentation. Nevertheless, over the many years she and her husband lived in Finnmark, she produced a rich record of Sami culture, as well as of the hardscrabble existence of Norwegian settlers along the frozen Russian border. So trusting was Wessel's relation with the Samis that her visual accounts show them in action—at

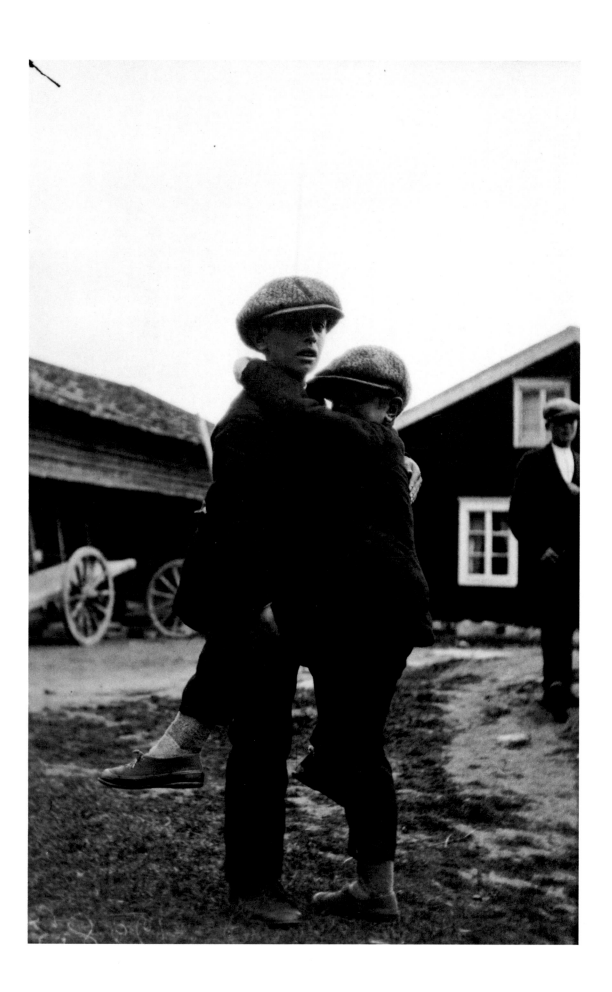

Honest, everyday people, these, content to be what they were. They lived according to the keen good sense of their forefathers, though they lived so close by the town with all its people of rank and quality and the new imported customs. No thank you, the people of the countryside still lived as they had once learned to live and slow they were to adopt such fancy new articles as white collars for the neck of a man and cut tobacco for an honest man's pipe.

Knut Hamsun, *The Road Leads On,* 1934

work and at ease. She had a strong pictorial sense and the Arctic landscape supplied her with an infinite white background, a *tabula rasa* on which she recorded the life of this timeless place. She seems especially to have enjoyed photographing reindeer herds, and she evidently delighted in the calligraphic shapes of antlers traced against the snow. In a particularly fine photograph, a tethered reindeer grazes under a tree whose branches form a great ball of ice crystals. In her numerous portrayals of the Samis and their close dependence on nature, Wessel's central theme emerges as human survival.

Powerful relationships between people, spiritual as well as physical, are apparent in the dramatic photographs of rural Finland by Into Konrad Inha. An ardent nationalist, Inha aspired to reveal the indomitable spirit of his country, which he believed emanated from the land. Though his themes are herdsmen, peasants and villagers, these photographs go well beyond folkloric documentation. There is nothing static or clinical about them; rather, they are filled with tension and drama. Heroic figures pull fishing nets and strong women burn great piles of stubble to clear a field. They remind us of Millet's peasants, but they are more passionately possessed by their toils, which they pursue with fierce energy. Inha's portrayals of elderly villagers and ancient rune singers also have an otherworldly character. In one of his most surreal images, a legendary backwoods guide becomes, through a double exposure, a Janus-headed shamanistic being, seemingly alive in both present and past. In an 1890 photograph, a naked man rushes from the sauna to roll in the midnight snow. These works resonate with atavism, with the mysterious forces that Inha sensed in Finland's ancient people and their customs.

Inha's countryman, Samuli Paulaharju, was also moved by the ageless traditions of Finnish village life and sought to ennoble them in his photographs. But in contrast to Inha's view of the world, Paulaharju's approach was relentlessly factual and fatalistic. His villagers, young and old, have definite roles to play in the grand order of things, even his children, who are pictured so gravely—at their own eye-level—against their bleak surroundings. Paulaharju's photographs movingly depict these impoverished, constricted lives.

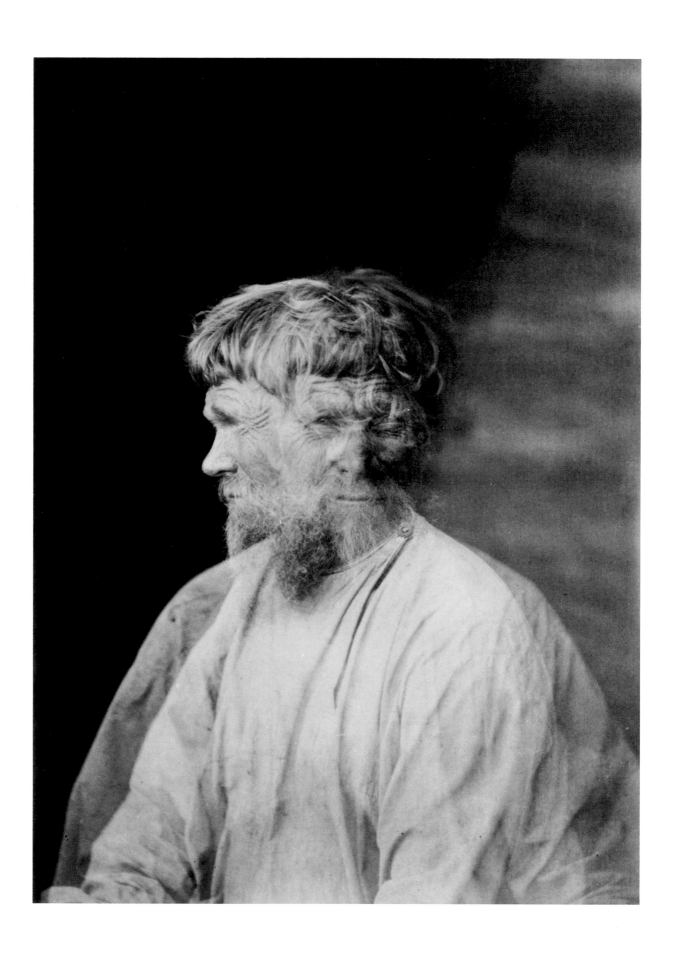

Photographers of the "Reindeer People"

Solveig Greve

Europe in the middle of the last century developed a steadily growing appetite for the strange and exotic. Hardy explorers, scientists and missionaries set about collecting data that would establish ethnography as a science. At the same time, bourgeois city dwellers saw a novel and thrilling world open before them in the travel descriptions of the popular illustrated magazines. This romantic interest was international.

In Norway, this concern with the exotic was directed not only at the outside world but inward: for the urban cultural elite, the Norwegian peasant became a symbol of the country's aspiration to achieve national identity after 400 years of Danish domination, a political domination that had ended in 1814. Out of this patriotic interest in the rustic came five series of prints after drawings and watercolors of various Norwegian folk costumes, issued between 1812 and 1857. A sixth series was in daguerreotype, made in 1855 by the Dane Marcus Selmer, Bergen's first photographer. Photography could compete with etchings only when the wet collodion process, which involved a detailed negative, became widely available in 1851. This, in fact, was the technique Selmer used in turning out his subsequent series of folk studies, some as late as the 1870s. Among these are several pictures of Sami, the "reindeer people." Selmer was first to photograph Sami in 1855.

Today there are about 150,000 domestic reindeer in Norway, and herding them has been modernized by the snowmobile. But in the 19th century the not insignificant industry of the Sami was considered wildly poetic, and the Samis' ancient origins and picturesque clothes—embroidered caps and pointed-toe boots—made them alluring subjects for science and tourism. Sami adorn *cartes-de-visite* made by Claus Knudsen in the Tromsø area before 1865, and appear in the repertory of Knud Knudsen in the 1870s, alongside his sublime landscapes. Knudsen photographed the herdsmen in Tromsø and Finnmark, included them in his series of folk costume pictures and established the typical Sami tourist photograph: a Sami group, frontally posed, motionless and staring, before a sod hut, ideally with a reindeer. In this context, the photographs of Sami by Sophus Tromholt (1851–96) are distinguished art as well as ethnography.

Tromholt and his subjects were far from typical. Starting in the 1870s, the tourist to Norway's North Cape, its northernmost point, dropped in on the summer camp of the Swedish Sami near Tromsø and bought souvenirs made of reindeer horn and hide and paid the Sami to pose. The Sami of central Finnmark, bordering Finland and Russia, lived far from this early mass tourism, however, and were at first hostile to photography. But Tromholt won over those he met. In 1882 the Danish scientist and amateur photographer won a Norwegian government grant to study the aurora borealis, and he spent a year in Kautokeino, living in the sheriff's house and using a prison cell as his darkroom. Aware of his role as a pioneer in this community, he wrote descriptions for *Morgenbladet,* a Norwegian newspaper, and produced about 200 photographs for international publication

and ethnographic museums. He learned the Sami language and used photography as a means of contact with the Sami (or Lapps, as he called them): " . . . Among my instruments there was none which attracted their sympathy so much as my photographic apparatus. Daily some of them came begging to have their *govva*—portrait—taken. My greatest pleasure was to take them up into my dark photographic chamber and let them witness the production of their portrait. Then their surprise knew no bounds, and in awestruck wonder they gazed in the semi-darkness at the birth of their own likenesses. In truth, we, who claim to know so much about the properties of light and the elements, have as much reason to watch this beautiful process in wonder as the simple Lapps; we understand it almost as imperfectly as they."

Tromholt's pictures reveal that he was both a recording scientist and a serious amateur photographer with artistic ambitions. Groups of four or five Sami, positioned as if in a photography studio, show that he had clear ideas of harmonious compositions that were plainly inspired by contemporary portrait photographs. (In fact, he and Marcus Selmer were acquainted, and the Bergen portraitist printed some of his negatives.) Tromholt's figure studies, bust-length portraits with high side-light and dark neutral backgrounds, are most successful, especially a beautiful picture of two female friends who gaze calmly at the camera. (It is striking that Tromholt's female models almost always look directly at the lens; he posed his males with more variety.) He probably wanted to use the women's close-fitting caps as a pictorial element, and this is most impressive when shown full-face. The results are less inhibited female portraits than were usual at that time: Tromholt has suggested the relative independence of Sami women vis-à-vis their "civilized" sisters.

Tromholt's pictures are not just scientific documents of racial characteristics, but sensitive portraits of individuals who happen to be Sami. Their merit in part derives from their occasion: many were taken at the request of the sitters themselves, who were given prints. This voluntary situation, in which subject and photographer fully cooperated and often knew one another, was far beyond the competence of the commercial photographer who happened to be passing through or the scientific photographer who merely considered documentation. In Tromholt's portraits, the Sami are shown largely as they would like to appear, and the works reveal a contact between human beings that transcends cultural differences. Today the pictures have a new cultural significance: in them, the Sami have found the faces of their forebears, and in fact a cross-section of the population of the Kautokeino area in the 1880s.

In 1886, three years after Tromholt visited Finnmark, Andreas and Ellisif Wessel (1866–1949) settled in the Sør-Varanger district near the Russian border. He was the newly appointed medical officer; she descended from a long line of senior civil servants, and had wide interests in contemporary trends in politics, literature and philosophy. The childless Ellisif frequently accompanied her husband on his rounds through the extensive

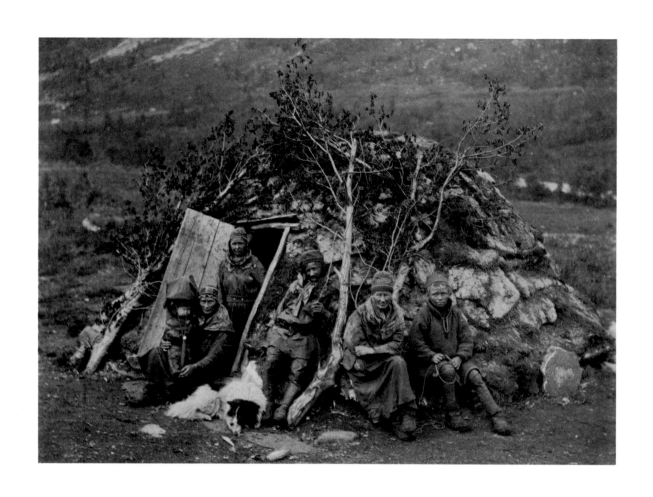

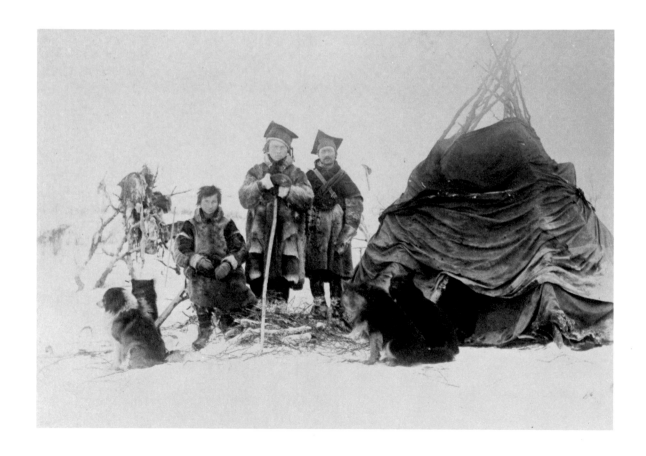

district, and began taking photographs in response to his interest in local history and anthropology. In 1902 they published his travel descriptions and her photographs; many are of Sami, as well as Norwegian settlers and landscapes.

Ellisif came to this harsh area of Norway as a liberal, but the years 1904–05, with their widespread famine and epidemics, turned her into a radical. She was faced every day with the poor and the sick and with the refusal of her own class and the authorities to help them, and she saw the northern farmers pressed by emigration from southern Norway and the local rural class turned into an industrial proletariat almost overnight as a major mining project came to Sør-Varanger in 1906. She helped establish a trade union in the district, and became its first secretary. (She was not alone as a female radical activist—in the 1890s in Norway, several workers' associations for women had started after women workers struck a match factory in 1889—but she was unusual in not belonging to the social class she championed.) In the mid-1900s she turned to socialism and then to Marxism, and she and Andreas sheltered Russian revolutionaries as they escaped over the border. She became the most ardent female champion in Norway of the Revolution. Lenin noted in his diary: "Ellisif Wessel, Norwegian sympathizer, speaks Russian, gave money."

Wessel's photographs of the Sami date primarily from the beginning of her political education, from the 1890s to the turn of the century. They show people at work—milking reindeer, mending nets, riding their reindeer-drawn sleds. Although most of these pictures were probably posed at her request, they have an authentic and spontaneous air that distinguishes them from commercial photographs. Her portraits have a touch of the snapshot, although people often wear their best clothes: they appear in close-up or full length, displaying their straightforward relation to the photographer. Landscapes are characterized by their horizontal lines and the centering of important motifs. This makes them somewhat static, but at the same time stresses the calmness of lakes, of rolling moorland and snowclad country.

Like Tromholt, Wessel shows great intellectual and emotional candor in her pictures and her ability to approach the Sami with respect, despite cultural and social differences. Tromholt may lack Wessel's spontaneity, but his portraits are more artistically assured. In the context of ethnographic photography, it is decisive that they both lived long enough in a community dominated by a Sami population to get to know the Sami as individuals. Although the two were influenced by contemporary pictorial conventions, they did not have to work with an eye to sales. Thus their choices of motif show greater freedom and their figure studies are intimate portraits. They were both enthusiastic amateurs: they and their subjects were the audience for their work, and this is its strength.

Solveig Greve is the Archivist of Photographs at the Library of Bergen University and has previously written about Tromholt's photographs. (Translation by J.R. Christophersen.)

Unknown photographer
A Sami dwelling n.d.
albumen print
8 x 11
20.3 x 27.9
Collection Universitetets Etnografiske Museum, Oslo

Ellisif Wessel
Sami outside their tent ca. 1899
gelatin silver print
4⅜ x 6⅛
11.1 x 15.6
Collection Sør-Varanger Museum, Svanvik, Norway

Finland in the Photographs of Inha and Paulaharju

Ismo Kajander

Into Konrad Inha
Clearing a woodland ca. 1894
gelatin silver print
8⅞ x 6½
22.5 x 16.5
Collection Åbo Akademis Bildsamlinger

There were many explorers and scientists who made trips to Finland, the homeland of the Finno-Ugric peoples, in the late 19th century, but the most memorable records have been left by the photographers Into Konrad Inha (1865–1930) and Samuli Paulaharju (1875–1944).

Inha, né Nyström, the son of a civil servant and his wife, was born on 12 November 1865, in rural Finland. His father, who loved nature and was actively concerned with culture, directed the interests of his many children. His mother came from a prominent family that could boast an architect among its members. Into's family made music, painted, told stories and took photographs. Nearly all of the Nyström children later showed considerable artistic talent. Father Nyström was a great Finnophile, and he put the children into a Finnish-language school at the earliest possible moment. For a short while, the boy Into was in the same class as the future composer Jean Sibelius.

For further education, Into went to Helsinki in 1885 to study geography, literature and aesthetics at the university. But he discontinued his studies when what had started out as a summer job in journalism became a full-time occupation. As a gesture of national pride around this time, he changed his surname to Inha, a name unusual even by Finnish standards.

Inha's enthusiasm for nature took him on long trips around Finland, and one summer he cycled to Germany and Switzerland. These experiences became the basis for some of Inha's newspaper articles. He also decided to take photography seriously, and he studied in Germany and then in Austria in 1889–90.

Even as a boy, Inha had shown a romantic turn of mind. The culture to which he and his siblings were exposed was that of a young, idealistic nation. A love of the landscape and of landscape art was part of this idealism. These components, together with a revealing honesty, were the basis for Inha's multifaceted art.

Inha's first work as a photographer, the glass plates he exposed on a study trip abroad, have been preserved. The enormous differences in altitude found in central Europe enthralled him, for he was used to Finland's level terrain. He depicted castle ruins and waterfalls. After he returned home, he began to photograph the Finnish landscape, and in two years he had produced a wide range of townscapes and rural scenes. These show the influence of the paintings that were popular during his youth and that had created a picture of Finland for its inhabitants. Inha's photographs continued in this vein, and in 1896 he published *Pictorial Finland*.

In 1894 Inha traveled to eastern Karelia. He might have produced an idealized view of the land of the *Kalevala*, the Finnish national epic, but he found that the visions evoked by the archaic verses were becoming hard to summon up, if indeed they had ever had a source in reality. The trip resulted in over 200 pictures, which form Inha's most artistically coherent and

56

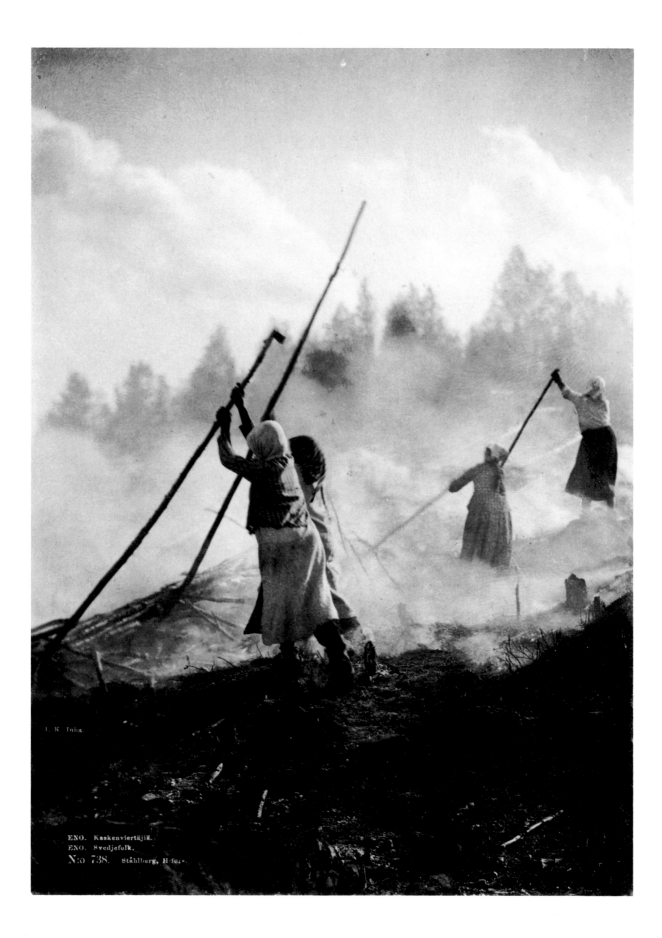

I. K. Inha.

ENO. Kaskenviertäjiä.
ENO. Svedjefolk.
N:o 738. Ståhlberg, H:fors.

impressive work. The camera became the interpreter of its user's experiences. He emphasized the mournful poverty of the villages by pressing chains of houses between expanses of sky and land. As subjects stopped to stare at the photographer, as rustic people do, he followed the rules of good documentation and took the picture on the spot. It would be tempting to use the term estrangement to suggest the spirit of some of these pictures. Their form varies in accordance with the subject's mood. In spite of their realism, a few of the pictures seem subjective and have elements that suggest the supernatural. The most amazing of these involve the ritual of the sauna bath. Also, the photograph of the blind rune singer Arhippainen Miihkali deserves special mention. Inha's romantic worship of Finland's national poetry endows the photograph with an almost mystical atmosphere.

During the summer of 1899 Inha completed a series of large (9 x 12 inch) prints; among them are a few very monumental views of rural landscapes. He was commissioned by government authorities to depict Finnish agriculture for the Finnish Pavilion at the Paris Exposition of 1900. Since Inha admired the traditional way of life, we can understand the difficulty of this job. A new kind of farming and the rapid expansion of forestry as an industry were destroying the idyllic landscape and rural folkways. Inha the artist could not put his soul into the pictures, though the good photographer in him carried out the job commendably. Yet the strain of experiencing these drastic social and economic changes proved too much for Inha, as he saw his beloved landscape and way of life disappearing. In 1905, the year of a general strike that would drastically alter Finnish politics, he became ill, and in 1908 he abandoned newspaper work and became a hermit. To the end of his life, however, he still took pictures, experimenting with different cameras. His late photographs are often small in scale and show details of the landscape: streams, trees and clouds. Through these intimate pictures and his earlier journalistic work, Inha had helped create a national awareness in Finland; he was an independent photographer of its landscape and people, the first of his kind.

Inha was only ten years older than Samuli Paulaharju, but Paulaharju was just beginning his work as a photographer when Inha was nearly forgotten. The younger man made most of his pictures after Finland gained its independence from Russia in 1917, and he specialized in images of rural life. He was born on 14 April 1875, in southern Ostrobothnia, the son of a tenant farmer. Samuli studied conscientiously and in 1901 became a teacher of handicrafts and drawing at a school for deaf mutes. During his studies he became interested in old Finnish architecture and made trips across the eastern border to Karelia, where Inha had photographed. Paulaharju brought back a great number of drawings of that place. This was the beginning of a series of summer trips that he made over the next 44 years in order to collect ethnographic material. In 1906 he published his first book. A total of 23 travelogues appeared, two of them posthumously, and all but the first illustrated with photographs.

Paulaharju proved to be an excellent documentarian, seeking images with the greatest possible informative value. Only one shift can be seen in his work: the move from architectural subjects to people and their activities.

Paulaharju's and Inha's photographs mark the development of ethnographic photography in Finland. Inha helped awaken national consciousness in his wide-ranging pictures and so he made possible Paulaharju's later examination of the details of rural life.

This essay is based on information provided by Ismo Kajander, who is a photographer, Assistant Professor at the University of Industrial Arts in Helsinki and Vice-Chairman of the Society for Photographic Art. He coauthored a book on Inha. (Translation by Martha Gaber Abrahamsen.)

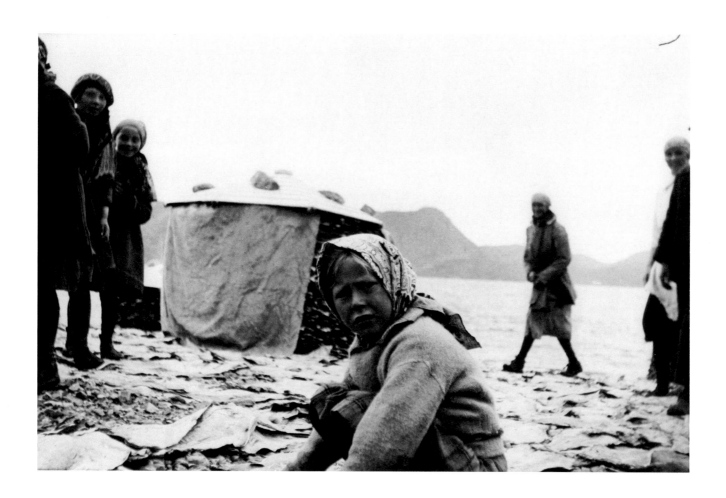

Photography in Iceland: Two Pioneers

Gudmundur Ingólfsson

Sigfús Eymundsson
Funeral procession, Reykjavík 1886
modern gelatin silver print
from original negative
7½ x 8½
19.1 x 21.6
Collection Thjódminjasafn Íslands,
Reykjavík

Sigfús Eymundsson
Travelers, Reykjavík ca. 1886
modern gelatin silver print
from original negative
6½ x 8½
16.5 x 21.6
Collection Thjódminjasafn Íslands,
Reykjavík

When photography was invented, Iceland was still considered an uninhabitable country on a dangerous latitude, at least by the relatively few Europeans who had heard of it. It was known only for its rich fishing grounds and the devilish volcano Hekla. The population, down to 50,000 after two centuries of epidemics and devastating volcanic eruptions, was scattered along the coast, wherever there was a fish to catch or a piece of land to farm. They were weakened by foreign commercial exploitation and merciless nature.

The first association of an Icelander with photography involves Helgi Sigurdsson, who is said to have studied medicine, painting and daguerreotypy in Denmark from 1840 to 1848. But no daguerreotype by him remains. The oldest account of photographs actually taken in Iceland can be found in the travel book *Letters from High Latitudes* by Lord Dufferin, who visited Iceland in 1856 with his photographer and tried to photograph erupting geysers with wet-plate technology. They failed. It was not until 1866, when Sigfús Eymundsson (1837–1911) set up his studio in Reykjavík, that Iceland had a photographer.

Born on a farm in eastern Iceland, Eymundsson learned and practiced both photography and bookbinding in the capital and then in Copenhagen, Oslo and Bergen between 1857 and 1864. After returning to Reykjavík in 1866, he operated as both a photographer and a bookbinder, and eventually started a publishing business. (The Eymundsson bookshop is still one of the largest in Reykjavík.) He made portraits (inventing the "man on his horse" type, popular into the 1930s) and he photographed landscapes and genre scenes, such as boys having their first swimming lesson in a newly built hot-spring swimming pool. To record the rapidly growing town of Reykjavík and travelers leaving or entering by the main street, he had a balcony added to his house and set up his camera there. These pictures are admirably direct and simple: the photographer was recording these subjects for the first time, as though he were in some photographic Garden of Eden. Since there was no local artistic tradition, Eymundsson had to develop his own visual vocabulary, and to adapt the techniques and compositions he had seen in Norway and Denmark to what was unique to Iceland—its vast environment and special quality of light.

In addition to his work as a photographer, Eymundsson was one of the pioneers of the cooperative movement in Iceland and later served as a member of the board of the Bank of Iceland. From 1876 he was an agent for the Allan Line, selling emigrants one-way tickets to America, and he even went to England to photograph the facilities on western-bound ships that might take his clients. To keep up with business he had to hire several assistants for the photographic studio; the most talented was his brother-in-law Daniel Danielsson. After about 1885 it is unclear whether Eymundsson or Danielsson was responsible for the studio's photographs; their styles are indistinguishable. They sold prints both in Iceland and to picture publishers abroad who sought

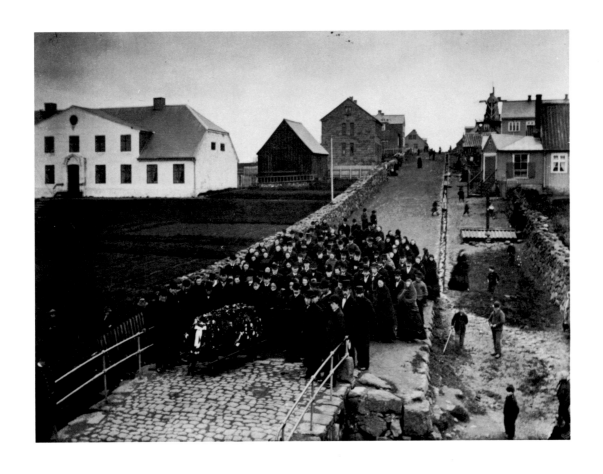

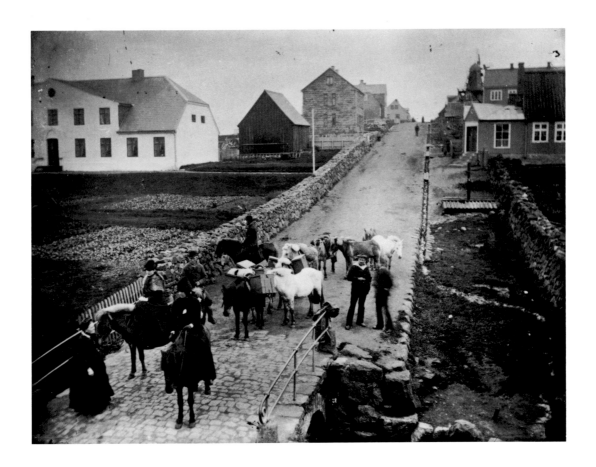

Sigfús Eymundsson
School boys swimming, Reykjavík
ca. 1897
modern gelatin silver print
from original negative
4½ x 6⅞
11.4 x 17.5
Collection Thjódminjasafn Íslands,
Reykjavík

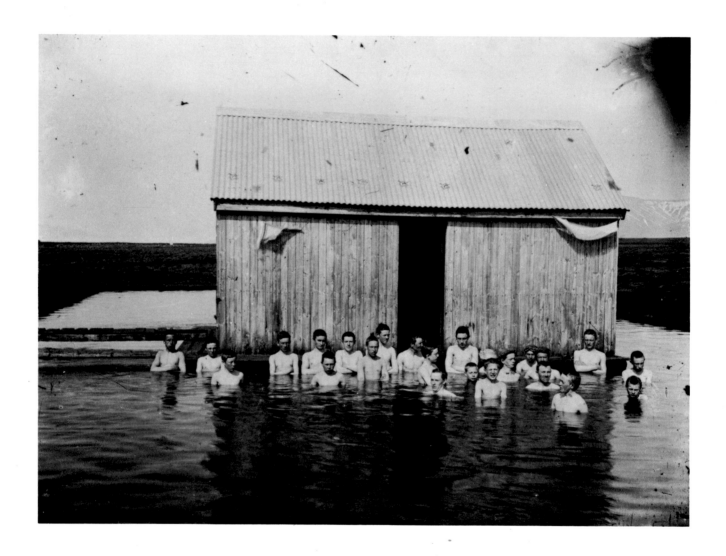

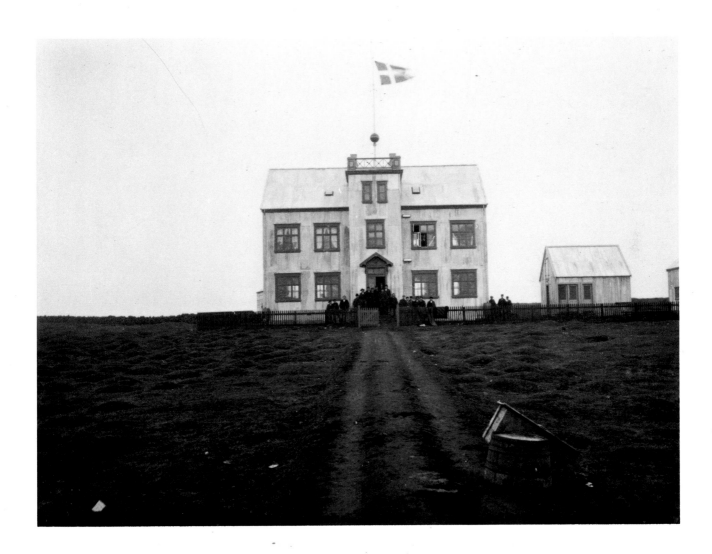

Sigfús Eymundsson
Navigation College, Reykjavík 1898
modern gelatin silver print
from original negative
6½ x 8½
16.5 x 21.6
Collection Thjódminjasafn Íslands,
Reykjavík

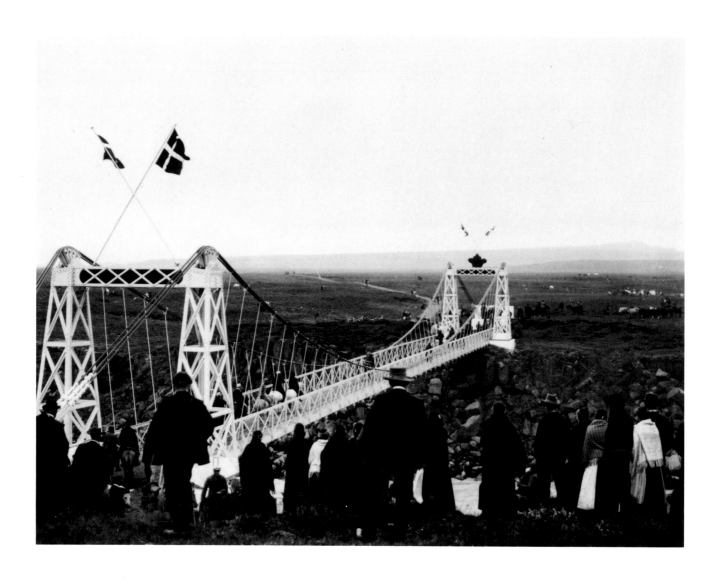

to interest people in the country. Until about 1890 Eymundsson was the only independent photographer in Iceland.

After Eymundsson, Pétur Brynjólfsson (1882–1930) was the country's most important early photographer. Not surprisingly, Brynjólfsson served as an apprentice in Eymundsson's studio in 1900–01. In 1901 the young photographer was on his own, and he traveled in Denmark, Norway and Germany before he settled down in Reykjavík in 1902 and opened his own studio. By 1906 he was successful enough to build a large, modern house with a studio and apartment, and the following year, after he had photographed a summer visit to Iceland by the Danish monarch, he was appointed photographer to the Royal Danish Court.

From 1906 to the beginning of World War I, Brynjólfsson's career blossomed. He employed many foreign photographers (among them the Dane Peter Petersen, who later pioneered in Icelandic cinematography). In 1909 he opened a branch of his business in Akureyri, the largest town in northern Iceland, and in 1912 opened the doors of a movie theater in Reykjavík. But Brynjólfsson had overextended himself. Because of pressure from creditors and his heavy drinking, his little empire

*At this period, [late 19th century] Icelanders
were said to be the poorest people in Europe,
just as their fathers and grandfathers and
great-grandfathers had been, all the way
back to the earliest settlers; but they were
convinced that many long centuries ago
there had been a Golden Age in Iceland,
when Icelanders had not been mere farmers
and fishermen as they were now, but royal-
born heroes and poets who owned weapons,
gold, and ships.*

Halldór Laxness, "The Wonder Pony" in
Paradise Reclaimed, 1960

disintegrated in 1915. The years 1915–18 found him in
Copenhagen operating a photo studio, and after his return to
Reykjavík in 1918 he supported himself mainly by selling hand-
colored prints of his old pictures.

In Brynjólfsson's heyday, 1902–15, when his Reykjavík studio
was in business, his output was enormous and its quality high. He
was the first to use magnesium powder flash to take interior
pictures, and the number and kind of props he used for
his portrait sessions were remarkable. He was first in making
photography a prosperous occupation in Iceland; probably no
one to the present day has achieved the financial success he
did in his best years.

The rest of the history of photography in Iceland can be told
quickly. Pictorialism never influenced photographers there, and
its elaborate printing techniques never reached the country.
Much of Icelandic portrait photography remained in the tradition
of the *carte-de-visite* until Sigridur Zoëga and then Jon Kaldal
imported fresh influences from Europe. During World War II,
Iceland was isolated from Europe, and some photographers
traveled to the United States, later returning with an interest in
American photography. In the early 1960s German avant-garde
photography had some impact on Iceland, and this influence is
still being felt.

The handful of photographers in Iceland who can be considered
serious either support themselves at other occupations, keeping
their camera work as a hobby, or they operate as commercial
photographers. There are no grants for photographic projects
and no galleries exhibiting photography as yet. Some hope is
offered by the recently established corporation, The Icelandic
Photography Museum. It may become an active center for the
collection and exhibition of international photography.

*Gudmundur Ingólfsson, a commercial photographer in Reykjavík, was
co-curator in 1976 of a historical survey of Icelandic photography
held at the Nordic House to celebrate the 50th anniversary of Iceland's
Association of Professional Photographers. He studied at the
Folkwang Art College, Essen, Germany, under Otto Steinert, and was his
assistant in 1970–71.*

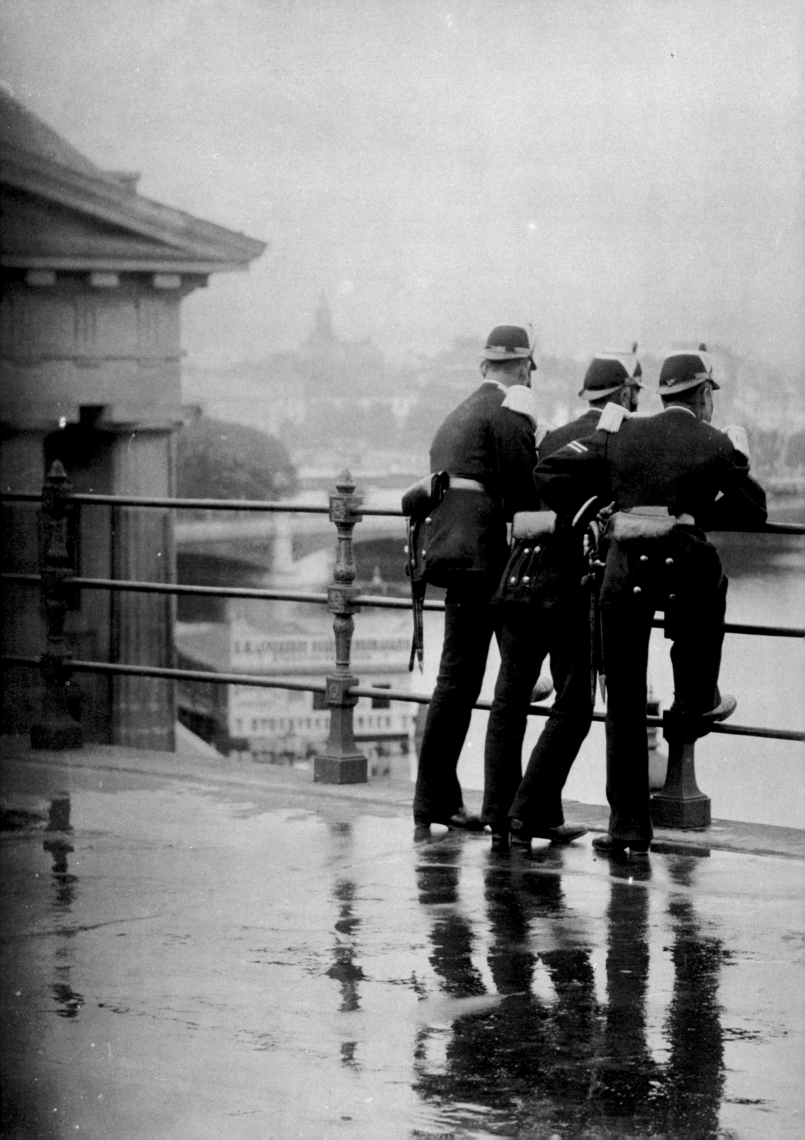

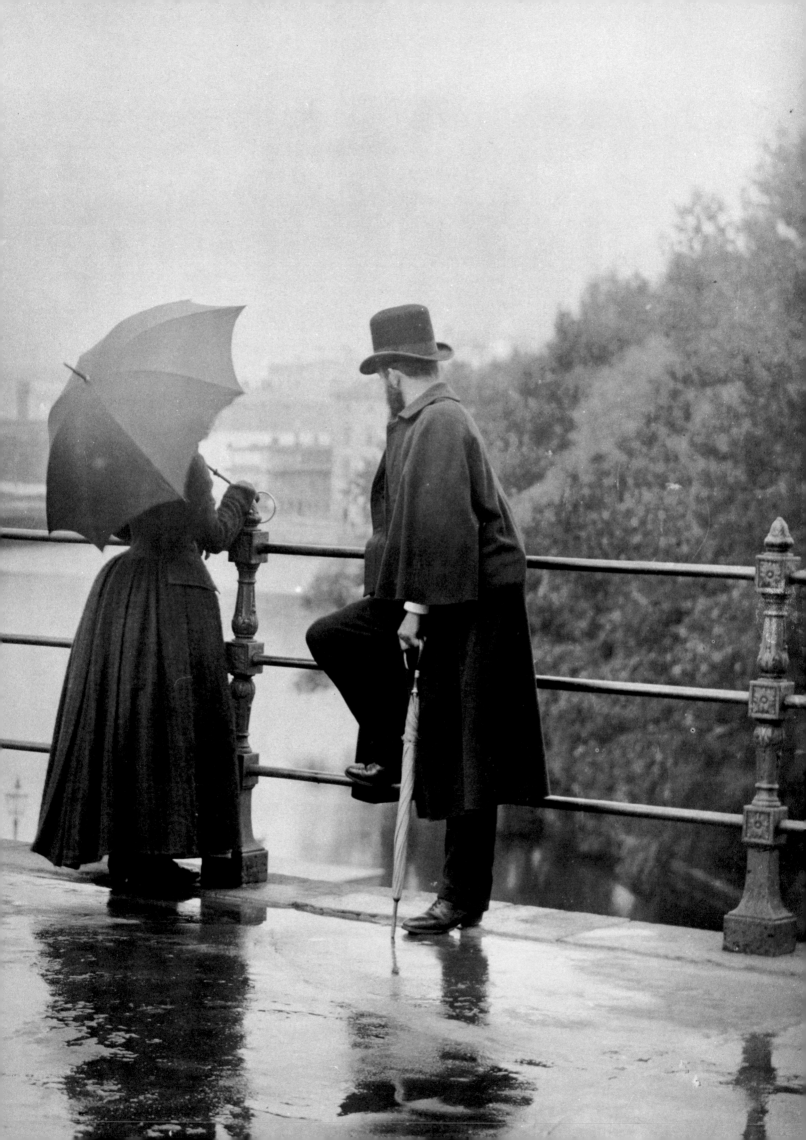

The Early Urbanists

MF

(overleaf)
Frans G. Klemming
Högvaktsterrassen, Stockholm 1888
modern gelatin silver print
from original negative
7 x 9¼
17.8 x 23.5
Collection Stockholms Stadsmuseum

Anton Blomberg
Writing postcards at the Industrial Arts
Exhibition, Friesens' Park 1909
modern gelatin silver print
from original negative
4¾ x 6½
12.1 x 16.5
Collection Stockholms Stadsmuseum

Though landscape is a constant theme in Scandinavian photography, the rapid evolution of city life from the mid-19th century onward, and the commensurate rise of a solid middle class, offered a new and wide range of urban subjects to the camera. In the capitals such photography took diverse forms, from recording the marvels of new and imposing official buildings, wide boulevards and great public fountains and parks, to documenting the picturesque "old towns," the vestiges of the medieval, walled cities being absorbed within the sprawling new centers of urban life.

Such architectural photography had various motivations. It helped satisfy a sense of history: since many old buildings were being torn down in the name of progress, a record of the city's past was needed. For those more committed to the present—and the future—richly detailed photographs of great civic improvements supported local boosterism. They also spurred the tourist trade and were reproduced in books that helped satisfy a growing appetite among the educated classes for images and information about the city's past and present.

Quite another aspect of the city was recorded by the photographers who left its boulevards to wander its back streets. Like those painters who set up their easels in the colorful old quarters of a town, whether Paris or Copenhagen, they were attracted by raffish and picturesque subjects. By the end of the century in Denmark another impulse was felt: social concern, which surfaces, for example, in Fritz Benzen's 1898 pictures of grim slums and in Kristian Hude's bleak vignettes of poor children in sunless alleys in 1907. Not everyone profited by the industrialization of Scandinavia. In New York in the 1880s the celebrated Danish-born reformer Jacob Riis channeled his outrage at the appalling conditions he encountered on the Lower East Side in powerful, indicting photographs of people without hope. Conceivably, the seed for this journalist's adoption of the camera as a tool of exposé was planted in Copenhagen where some street photographers had begun to ask similar questions.

Opposing views of the city are neatly illustrated in two Copenhagen pictures of approximately the same period. Vilhelm Tillge's photograph of 1886 presents a group of highly respectable people in an open-air tram. His concern was to create a harmonious composition, and, in effect, this is actually a studio photograph that happens to have been made outdoors. Within the one-point perspective box formed by the vehicle, the stiff figures are psychologically isolated from each other in their binlike seats. They have the studied aloofness of the Parisians in a Seurat painting; each figure, an abstract element of exquisite contour, is classically positioned. The impression is of precise order and well-being—the bourgeois ideal. For a less polished impression of Copenhagen, however, the visitor could make his way to the Holmensgade neighborhood where prostitutes plied their trade. From the amber surface of an unknown photographer's print, a woman lifting the curtain of her second-story window regards us without expression. Like Tillge's photograph, this is studiously

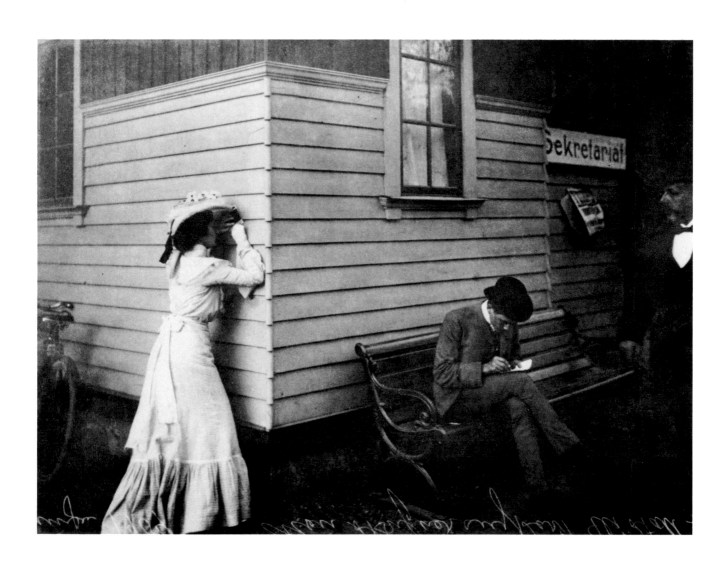

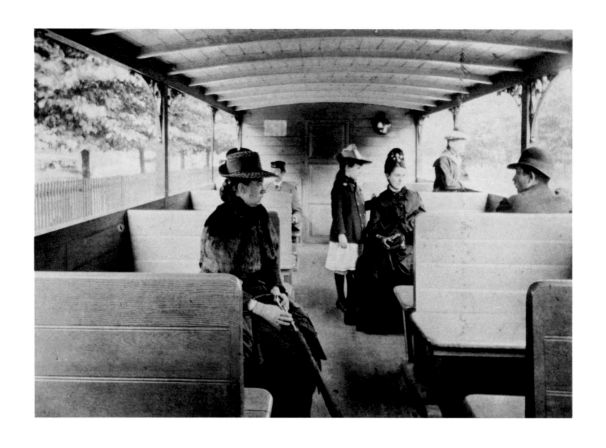

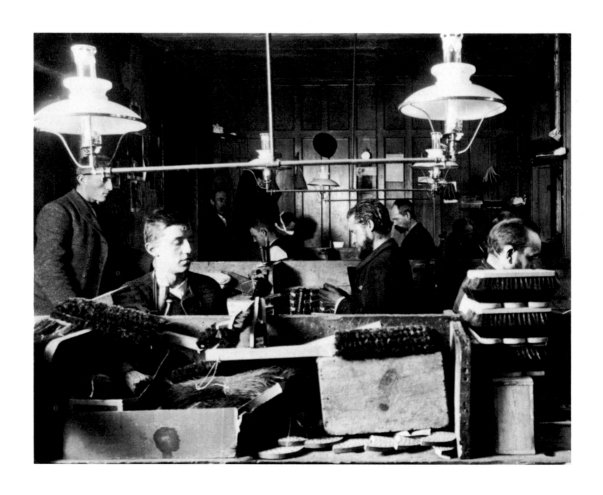

composed; the brothel's windows and doors are rectangles in an orderly, modular arrangement. The work is discreet, even introspective. But the message is clear—the city had its unofficial side.

In the refined, selective reportage of the Swedes Frans Klemming and Anton Blomberg, we receive a more vivid impression of life among the 19th-century bourgeoisie. The work of both men has a decided relationship to painting conventions of the day in Sweden and outside of it. Both dealt admirably with the posed figure and captured, in seemingly offhand fashion, the animation of strollers in the capital. In Klemming's 1888 scene of a bridge on a rainy day, a man and woman and a trio of guards, all with their backs to us, gaze with studied fascination at the water below: the photograph is strongly reminiscent of Gustave Caillebotte's paintings of stone-gray Paris streets. In such vignettes, Klemming reveals himself as a cosmopolitan whose great pleasure was to romanticize ordinary subjects, to transform mundane situations into memorable pictures. His images exude serenity. Nothing gritty or discomfiting was permitted to come before the lens of this chronicler of style.

Blomberg's Stockholm was less static, more offbeat. His photographs contain more information, even a hint of emotion. He seems to have delighted in focusing on situations between people; there is an element of narrative in his work. In his Djurgården photographs of people watching puppet shows and families idly disporting themselves, he is part of the crowd. In some figure groupings he exhibits a taste for eccentric composition. This is especially apparent in a 1909 photograph of three figures at an industrial arts fair. Here are a prim young lady writing a postcard against a clapboard building wall; a young man preoccupied with his own card; and to the right a top-hatted old gentleman whose figure is partially cut off by the picture edge. Blomberg leaves it to us to associate these people. Are they even aware of each other's existence, or will they be? In the unconventional composition of this photograph a connection of sorts is implied.

Though Blomberg could find anecdotal possibilities in everyday situations, he was equally adept at giving a satiric edge to the artificial conventions of the studio. In a series of photographs of great Swedish artistic figures, he was at his most genially acerbic. In such droll apotheoses he presents us with noble depictions of distinguished painters and sculptors, each amid the evidence of heroic creation.

The Early Streets of Copenhagen

John Erichsen

In 1900 the young Holger Damgaard returned to his native Denmark after spending some time in the United States. He had made a living teaching roller-skating in New York City, among other jobs, and he had learned photography. He was aware of the widespread use of photographs in the American press, and so when he returned to Copenhagen he had several of his pictures printed in a weekly newspaper. By 1908 he persuaded the editor of *Politiken*, one of Denmark's leading daily papers, to replace the illustrations of line blocks after drawings with autotypes, images transferred from photographs. That year he started his newspaper career with a charming picture showing some excited children studying the display window of a toy shop. Damgaard would photograph daily events for the paper until World War II.

When *Politiken* first published Damgaard, photography of Danish streets had existed for nearly 70 years. The earliest known Danish photographic record of Copenhagen dates from as early as 1841, a daguerreotype by the engineer Peter Faber and the pharmacist Jørgen Albert Bech showing Gråbrødretorv Square with its beautiful 18th-century houses. During the following decades, photographers with more advanced techniques recorded individual buildings in Copenhagen as well as grandiose architectural views of the city. Their style continued that of neoclassical paintings of town views. Unlike popular genre paintings of the same time, however, these early photographs are, for technical reasons, devoid of people. The town appears lifeless, as if on a Sunday morning.

Early photographers were particularly drawn to buildings of historical interest, and photographs of this kind were published in such books as *Danske Mindesmærker* (Danish Monuments), 1866. In the 1870s and 1880s distinctive and lavish albums complete with colored covers, titles and decorations in gold print appeared. Some of them were of a souvenir-like nature, with French or German texts for the foreign visitor. In addition to castles and other places of historic interest, newly erected public buildings, such as the Royal Theater (1874), began to attract the Danes' proud attention, and Copenhagen's new parks and gracious boulevards were also grandly illustrated.

Initially, people appear only as figures in a landscape in these photographs, but from around 1880 they were increasingly integrated into the pictures and gradually their detailed description became the principal object of some works. At the same time, photographers and their customers were no longer content with pictures only of the fashionable streets of the capital. Some photographers ventured into the city's side streets and alleys where "unofficial" Copenhagen could be found. Why photograph the shady side of town? During the latter part of the 19th century, Copenhagen, like so many other European cities, underwent sweeping changes: its centuries-old defense system of bastions and moats was outmoded by technical advances in the military field, and simultaneously the rapidly increasing urban population, enlarged by emigration from the countryside and Sweden and by improved medical care, sparked an acute demand for housing.

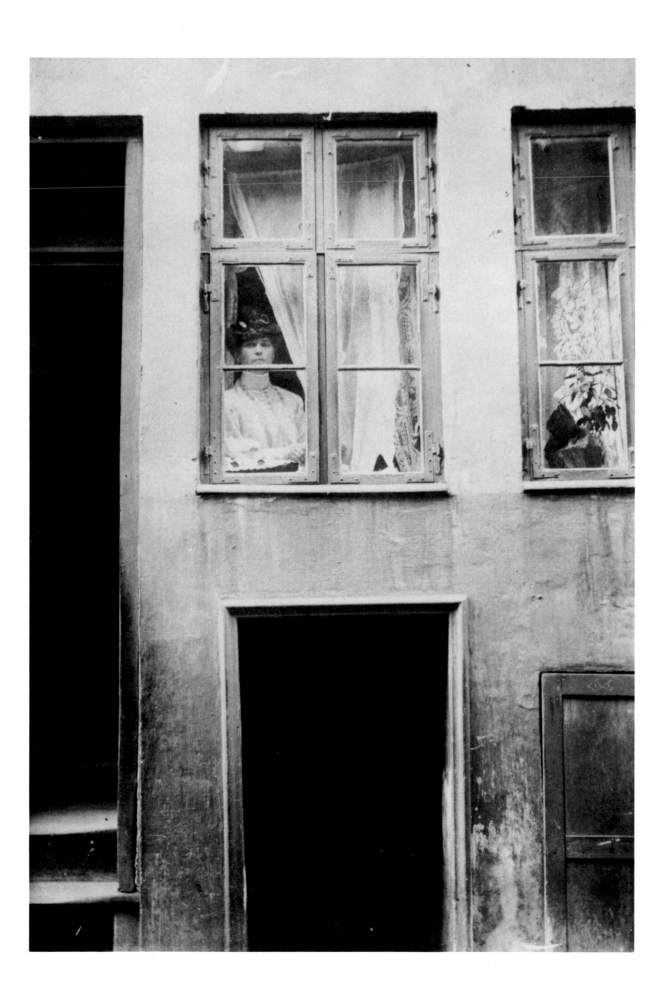

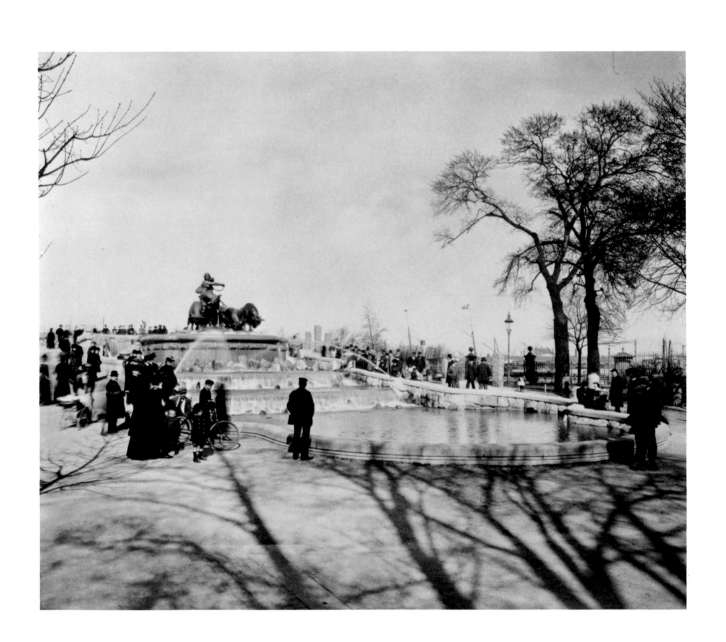

The ramparts were leveled in the 1870s and construction spread
out over the newly opened grounds. The erection of tenement
buildings, started in the 1850s, sped up.

At the same time, a massive cleanup was instigated of the worst
structures in the Old Town. They were replaced by extensive
office buildings. The face of the city was changing, and some
people wanted to document the old before it disappeared forever.
The slum areas of the city were of topical interest, and the civic-
minded bourgeoisie were concerned about the unsanitary quarters
of the Old Town with its health and fire hazards, its rough taverns
and unsafe buildings, its legalized prostitution and rampant
crime. An official in the criminal and police courts described these
districts as ". . . a marsh of dirt, microbes, and darkness stinking
of sewers, where, in the sordid alleyways, groups of crude pimps,
obese hustlers, greedy landladies, and corrupt policemen from
the vice squad, gambling halls, inns, and dark, seamy sex rooms
hid at night. And where organized white slavery operated."

The heated interest in these slum areas meant there was money
to be made from the subject. Fritz Benzen sold postcard views
in his bookshop and just after the turn of the century, he published
booklets of 25 postcards each, titled *Old Picturesque Copenhagen,
Houses and Courtyards*. So fascinated were book buyers with the
quaint quarters of the Old Town, with their half-timbered houses,
outdoor wooden stairways and galleries and backyard water
pumps, that *Greater Copenhagen* was published in 1907 in two
volumes at the finest publishing house in the country.

One anonymous photographer of the time seems to have
specialized in the red-light district, judging by the works in the
City Museum (founded in 1901 to document areas destined for
clearance). The phasing out of legalized prostitution from 1901
to 1906 may have led to his photographs. He posed the prostitutes
in doorways, at windows, sitting in taverns or inside the bordello
itself. His compositions are precise and well lighted, and some
of them appear to have been specially arranged. Presumably, this
Danish counterpart of E. J. Bellocq paid the girls to model for him
and to appear natural.

This photographer and others produced powerful documentary
material with insight and outstanding skill: the people and the
city of Copenhagen at that time are still alive for us in their
images. But apart from the photographs published in postcard
series, such pictures had limited circulation. It was only with the
introduction of photography to the daily press that documentary
pictures became common property. Between the first picture of a
Copenhagen street and Damgaard's first reproduction in a
Danish newspaper, photographic techniques had rapidly
developed, and so between 1841 and 1908 had the world they
were capable of portraying.

*John Erichsen, Keeper of the City Museum of Copenhagen, has published
on the history of the city and on pictures of it from 1587 to the present.
(Translation by Callum Forsyth.)*

75

painters used Klemming's photographs of Stockholm and vignettes of city life as models for their oils and watercolors.

It should not be assumed, however, that Klemming was an escapist or a dreamer. His was a dynamic nature, and he was one of the pioneers of sports photography in Sweden. He also produced series of picture postcards, and from time to time his genre scenes and cityscapes were published in the new picture press. Still, he was at his best as a mainstream photographer of the lyrical school, portraying Stockholm and capturing its turn-of-the-century mood.

Though only three years younger than Klemming, Anton Blomberg (1862–1936) breathed a livelier spirit into his early brand of photojournalism. He was appointed Court Photographer in 1900, but more significantly, he became Sweden's first permanently employed press photographer when he signed a contract in 1899 with the weekly magazine *Idun* (in Icelandic mythology Idun is the goddess of eternal youth). In the Swedish illustrated press of the 1890s, as in the rest of the world, there was an unsteady but irreversible transition from the use of woodcuts to photographs. In the years up to World War I, Blomberg produced a full documentation of that revolutionary era in Sweden. During this period Swedish champions of universal suffrage and feminism were leading the final battle for a more egalitarian society, while the trade unions were struggling into being. In the general strike of 1909, some 290,000 workers protested low wages and discrimination against women, but the union movement was then defeated. Blomberg, an employee of the liberal press, was no muckraker, and indeed Stockholm never had a John Thomson or Jacob Riis, who tried by their pictures of the London and New York slums to exert influence on politicians to correct social conditions. On the other hand, Blomberg's pictures are revealing of social and economic forces in Sweden at the turn of the century.

The Paris-inspired boulevards of Stockholm, with their elegant stone townhouses, were built across the way from worn and picturesque little wooden dwellings. In this world of drastically different styles, Blomberg photographed the human flotsam of social dislocation, the tramps, beggars and street musicians of the capital. He was fascinated by the primitive and colorful popular entertainments that were offered in the Djurgården, with its barrel organs, strolling players and puppet theaters. He contrasted the customers of the brandy-reeking workers' taverns with those of the so-called champagne restaurants. At the same time, as Court Photographer he had a front seat when the Czar of all the Russias and the Maharajah of Bundelkund stepped beneath the Gateway of Honor onto the Stockholm quayside. In the rich world of Blomberg's art, the contrasts are extreme.

Blomberg, like Klemming, was a traditionally trained studio photographer. When setting out into the field, both carried the excellent "traveling camera" of the turn of the century, a bellows apparatus on a stand, with a ground glass that permitted the

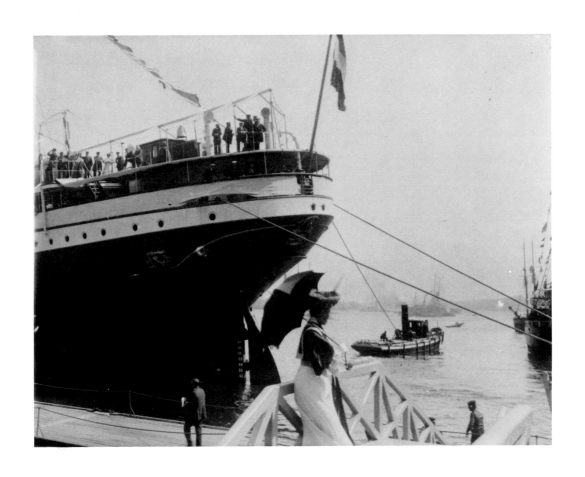

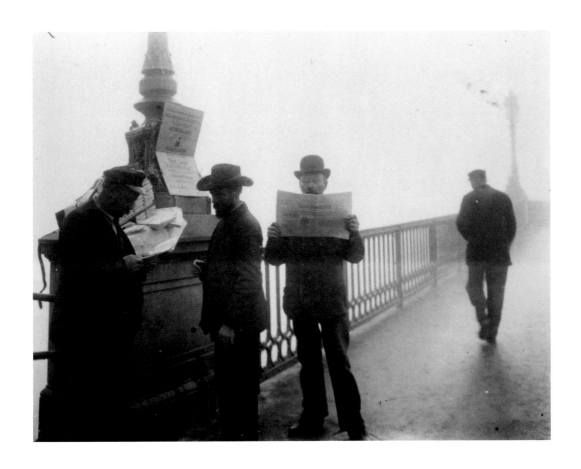

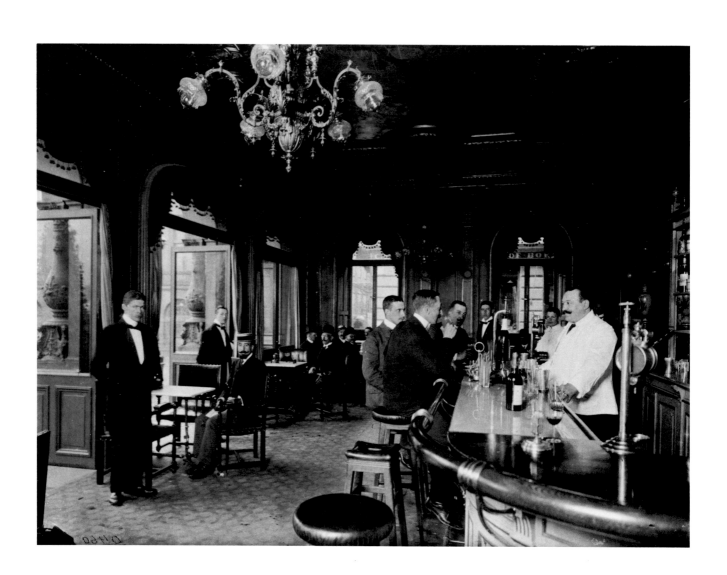

most refined composition. Chance was alien to the procedures of both men, an aesthetic attitude that contrasts with the snapshot methods of modern reporters. Nevertheless, Blomberg was careful to seek the appearance of spontaneity and he used asymmetrical compositions effectively to this end.

One of the genres in which Blomberg can be regarded as a Swedish pioneer is the intimate "at home" photo essay. In Scandinavia as in Europe, the turn-of-the-century reading public was greatly given to the cult of genius. Accompanied by a journalist who wrote the text, Blomberg visited almost all the members of Sweden's cultural establishment in their homes. His pictures were then reproduced in *Idun*, according to contemporary international custom, in large, framed, often brutally cropped montages. On several occasions Blomberg visited Strindberg, who directed the entire proceeding very firmly and decided what was acceptable and what could not be shown.
In general, Blomberg had a good touch with highly sensitive artists and poets, and he could get them to behave in a relaxed manner. His "at home" pictures have a soft, diffused lighting and an attractive air of ease; they suggest a certain degree of improvisation. At the same time, however, Blomberg produced a number of "portraits of genius" in his studio, including pictures of the architect Ragnar Östberg, designer of the Stockholm City Hall. These are staged sparely; the environment is reduced to a minimum to focus attention on the sitter.

Not until the early 1900s did the Swedish daily press begin to employ photo reporters on a full-time basis. When World War I broke out, Blomberg left photography to become an art dealer, and his pioneering contribution to press photography was soon forgotten. Fortunately, however, the bulk of his collection of 60,000 negatives was preserved in the archives of the Stockholm City Museum.

A similar oblivion, and a similar rescue of his negatives, befell Frans G. Klemming. Klemming can be said to have presaged the period of "art photography" led by Henry B. Goodwin around 1910, which with its exclusiveness and aestheticizing dependence on painting stands in the greatest contrast to contemporary press photography. But in the era of Klemming and Blomberg the division between press and art photography was not so distinct. In both their professional and personal work these contemporaries have together preserved a vanished world, the time before World War I of the stroller, the horse cab, the sailing ship—the time of a slower rhythm.

Rolf Söderberg, PhD, is First Antiquarian at the Stockholm City Museum. His publications include French Book Illustration 1880 – 1905, *1977 and* Stockholmsliv i Anton Blombergs bilder 1893 – 1914, *1981. (Translation by Keith Bradfield.)*

Peter P. Lundh: Vacation in Mölle

Jan Olsheden

The area that Peter P. Lundh made famous at the turn of the century is known as "Kullabygden," from the great Kulla Hill. It lies in southern Sweden, on the western coast, close to Denmark and the Continent. The main local township is Höganäs, and some miles along the coast from Höganäs lies Mölle, an old fishing village at the foot of the Kulla Hill. Surrounded on three sides by water, the natural terrain is enchanting, with steep cliffs plunging down into the sea and caves that are the stuff of fairy tales, small coves to bathe in and avenues of beech trees to lure the wanderer. In the late 19th century, the traditional livelihoods of the area were herring fishing, farming and mining. The old village slumbered idyllically. Only in the autumn, when the herring ran, did it really come to life. Job opportunities were few, and here, as in numerous other Swedish communities of the time, many were forced to emigrate to America—to carve a better life for themselves and to ensure the survival of those who remained.

Suddenly, however, sleepy Mölle was overrun by tourists. They came from Denmark, France and Sweden, but above all from Germany. They arrived by steamer from Copenhagen and Malmö. And soon they also arrived by a new railway built directly to Mölle itself. Boardinghouses and hotels shot up, as in any modern resort. By the 1890s Mölle was transformed. What had happened? The answer is that Mölle permitted mixed bathing: men and women—in striped bathing costumes—together, not the customary yards apart. It was a scandal, and thus absolutely first-class entertainment. Behind much of this was the photographer Peter P. Lundh (1865–1943).

It was Lundh who took pictures of the mixed bathing, and disseminated them in postcard form throughout Europe. They brought tourists to Mölle in droves. Photographing them as they arrived was a routine job for Lundh. Even on the boat, they had been given broadsides announcing that ". . . tourists on the Copenhagen steamer will be photographed shortly after arrival at Mölle by Court Photographer Lundh." He met them in the harbor, photographed them next to the train if they had arrived overland, among the rocks when they went hiking, as they swam, and in his studio. There he offered free writing materials and a letter box, and he sold photographic supplies, including Agfa and Kodak film, fresh roses and stout sticks for those intending to walk in the hills. He was diligent and he prospered.

Born on 14 April 1865 near Mölle, the son of a merchant sea captain, Lundh went to sea himself as a boy. On one of his first voyages he was shipwrecked in the North Sea, but he survived unscathed and set off on a voyage to Brazil at age 17. During this trip he became interested in photography, and on his return was apprenticed to the photographer Rudolf Pettersson in Höganäs. Subsequently, Lundh trained in Denmark and Germany, and attended a school of photography in Salzburg, where teaching covered "freehand drawing, painting, photographic enlargement and carbon printing." After a stay in

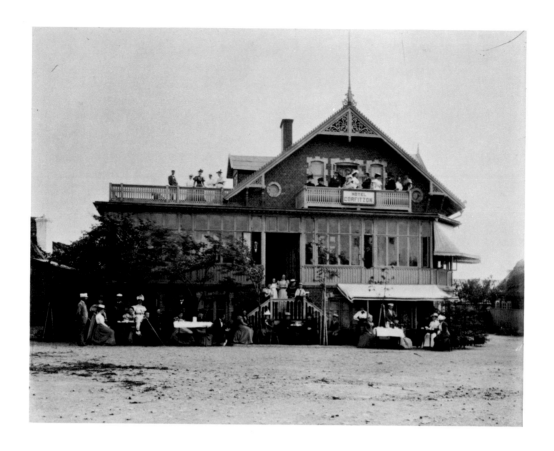

Paris, he returned to Sweden in 1886, dressed, we are told, in handmade boots, cravat and a suit of the latest cut. He immediately began making postcard views of the Kullabygden area. In 1892 he opened a studio in Höganäs, and in 1894 another one in Mölle.

The great bathing rush at Mölle was in the years 1909–14. With the outbreak of World War I, however, the Germans and Danes hastily fled the resort, and its great international period was at an end.

Lundh continued to be active as a photographer, making portraits and recording the important moments of people's lives— weddings, birthdays and christenings, plus holiday excursions. For his own pleasure, he also photographed outdoor scenes, buildings, children playing and the like. He knew his motifs and his customers, and portrayed them with great immediacy. Like many other small-town photographers, he was a kind of reporter or social witness. No historian of popular customs can surpass the keen provincial photographer in the ability to bring bygone times vividly to life. And Lundh, the successful bathing-resort portraitist, was a provincial photographer in the best sense of this term.

Jan Olsheden, a photographer, is the author of several books on the history of photography, and has written on Peter Lundh and Patrik Johnson. He is editor of Aktuell Fotografi, *the photography magazine with the largest circulation in Sweden. (Translation by Keith Bradfield.)*

Peter P. Lundh
Hotel Corfitzon, Mölle ca. 1900
modern gelatin silver print
from original negative
10½ x 13
26.7 x 33
Collection Höganäs Museum

Peter P. Lundh
Vacation in Mölle 1910
modern gelatin silver print
from original negative
10½ x 13
26.7 x 33
Collection Höganäs Museum

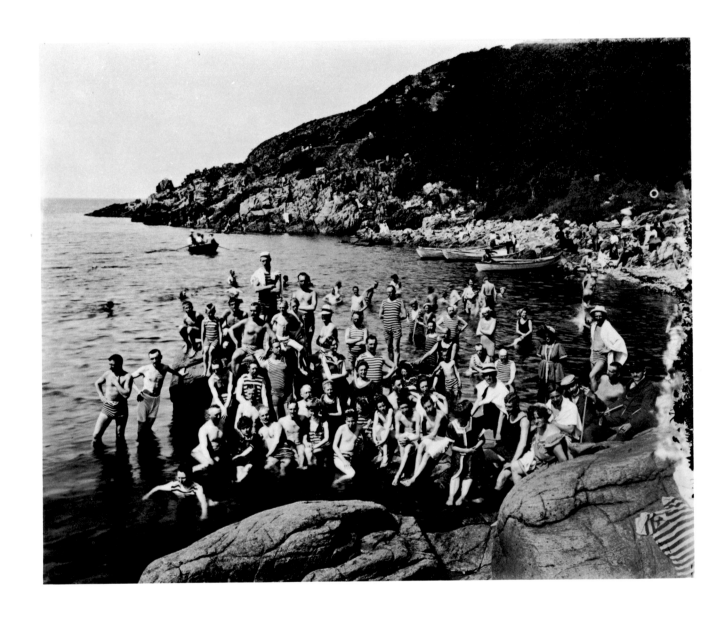

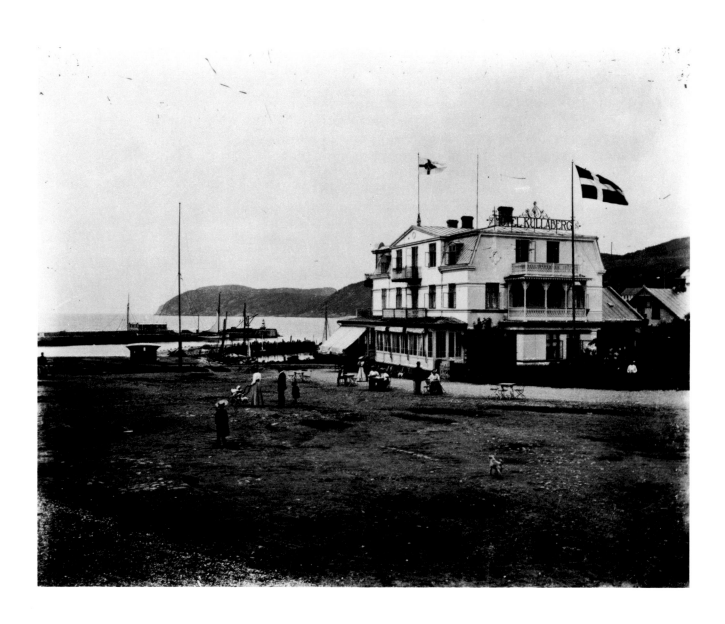

Peter P. Lundh
Hotel Kullaberg, Mölle 1890
modern gelatin silver print
from original negative
9⅛ x 11½
23.2 x 29.2
Collection Höganäs Museum

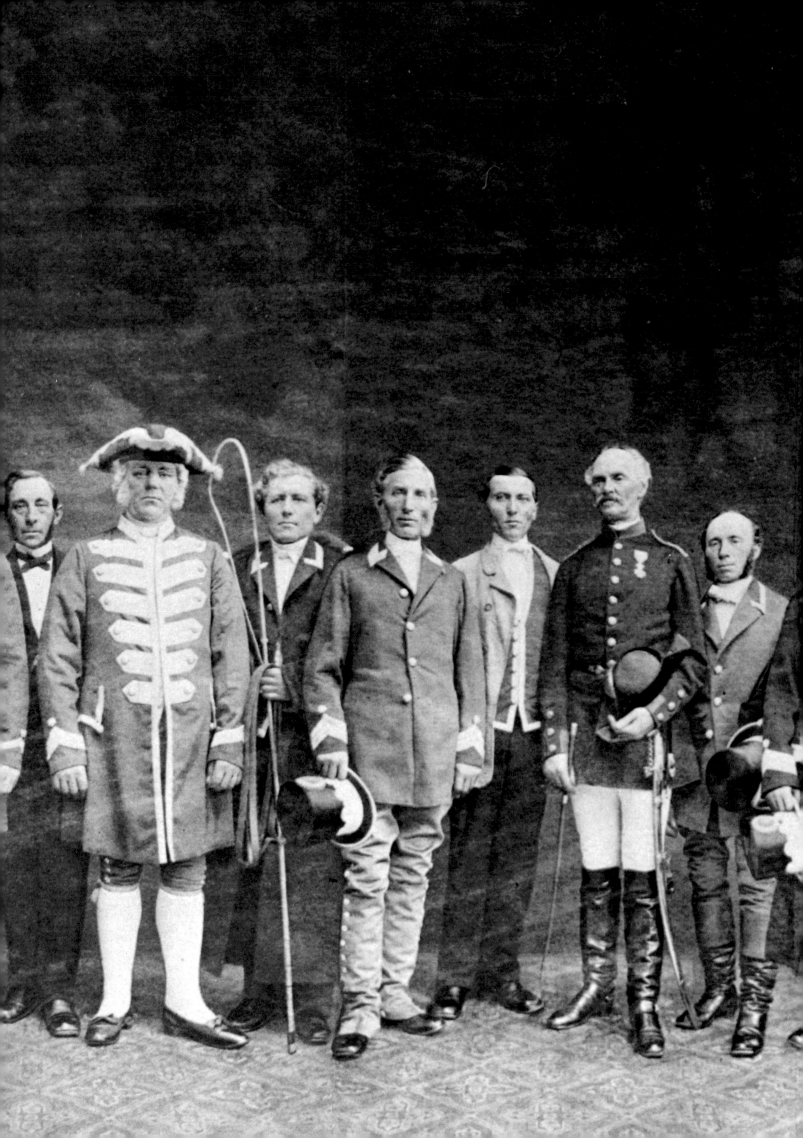

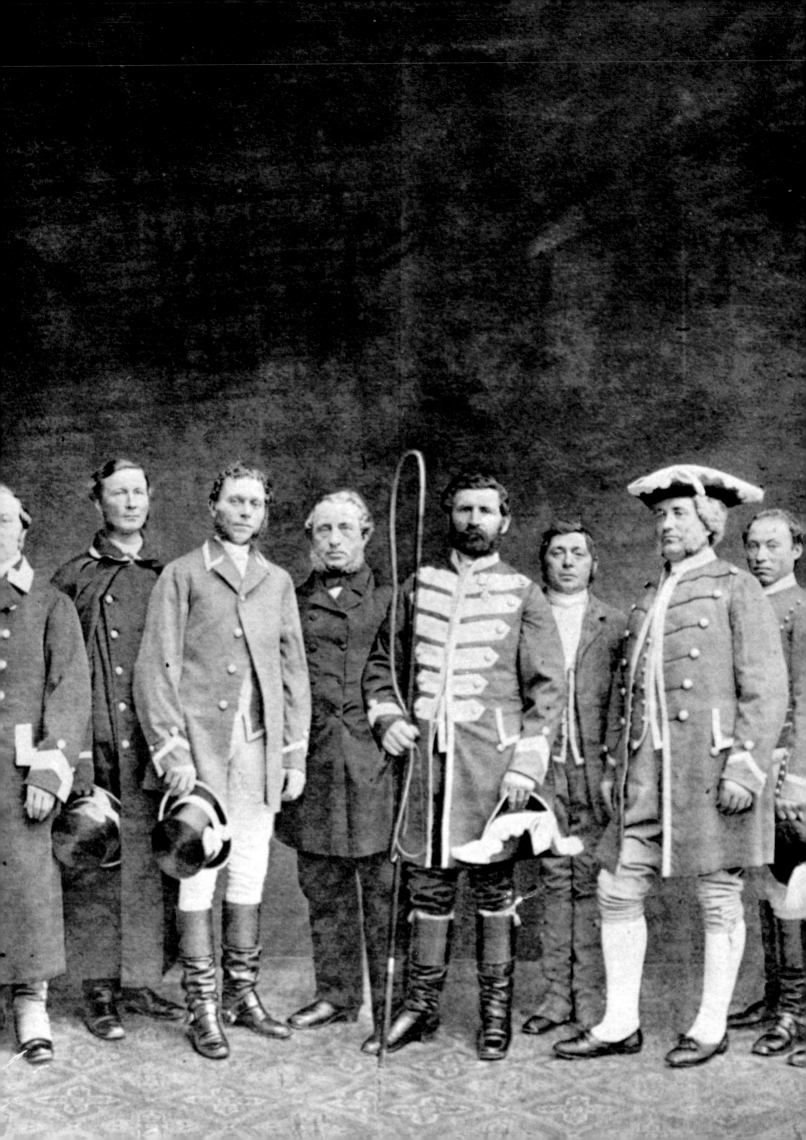

Portraits

MF

With the *carte-de-visite*, the portrait became a staple of European photography, and the Ålborg studio of Heinrich Tønnies was nearly a factory, as Henning Bender makes clear in his essay. The prolific photographers who turned these out had few illusions about making art. Their idea was to please their customers by presenting them with idealized likenesses in the form of small photographs, useful as calling cards and mementos that could be sent to distant relatives. To add a bit of glamour to these rather mundane images, the photographer often introduced a few props, including potted palms and backdrops to suggest a grand-ducal palace, a Persian garden or other exotic surroundings. In such synthetic little dream worlds the subject would assume a pose calculated to project an image of dignity and self-assurance.

Heinrich Tønnies must have been extraordinarily skillful at building a relationship with his working-class patrons, because his photographs transcend the conventions of the *carte-de-visite*. They are an odd mixture of fact and elegance. Tønnies convinced his clients—the stalwart blacksmith, the soot-covered chimney sweep, the swaggering butcher boy—to appear in the full regalia of their professions and with the tools of their trades, which they do with great conviction. If we are to believe his images, their jobs, however menial, were a source of pride to his models. Some 30 years later in Germany, the celebrated August Sander undertook to cover the same territory. In systematic fashion he set out to document virtually every profession and job he could think of, from medicine and museum direction to butchery and sports. Tønnies's portraits, for all their specificity, were paid for by their sitters and thus were meant to flatter; Sander documented for his own interest and his reality is mordant.

The ubiquitous portrait formula of Tønnies had a later echo in Jón J. Dahlmann's Reykjavík studio. There, against a casually painted wintry pastoral, stood any number of Icelanders for instant immortalization. In a mid-1920s photograph, a rumpled young man takes his ease in a setting of appealing incongruity: this engaging version of the *carte-de-visite* makes a fascinating contrast with Tønnies's sophisticated resolutions. Dahlmann's photograph of the young man is doubly interesting because, by chance, it appears on the same print with a portrait bust of a gentleman whose wizened features resemble those of a venerable mandarin. Inevitably, we look at the two prints as a single, horizontal image and make our own interpretations of their meaning.

An anonymous contemporary of Dahlmann, working in Finland, employed a radically different technique in posing his models. In a particularly arresting example of early trick photography, an unsmiling, straw-hatted young man appears five times, seated around a table. The trick, a popular one throughout Northern Europe involving darkroom manipulation of multiple images, produces a startling bit of proto-Surrealism.

Among the most distinctive categories of Scandinavian portraiture is the glamour photograph, whose subjects were actresses and

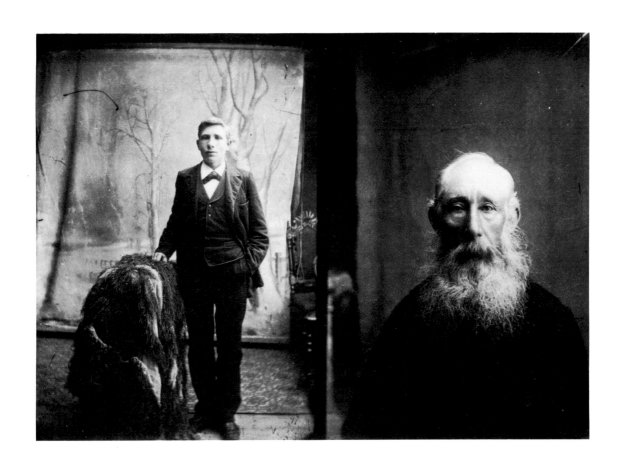

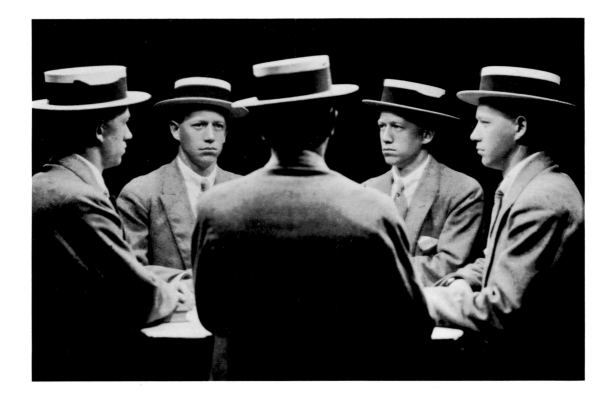

figures of fashion. A *belle époque* sensibility radiates from the little 1912 portrait by Anna Otto of the Danish actress Zanny Petersen. In this highly refined profile study, with its soft illumination, we have a delicately romanticized view of femininity. If Anna Otto's photography is redolent of late 19th-century painting, this is certainly not true of the work of Aage Remfeldt. Remfeldt, only a few years later in Stockholm, produced cloudy reveries in which beautiful women, their eyes closed, are languidly posed against oval mirrors. In such crepuscular visions, Remfeldt's women seem in a state of benign narcosis, utterly self-involved.

Surely the master of the elegant portrait is the German-born Henry B. Goodwin, whose celebrated pictures of the hothouse beauties of Stockholm are among the finest art photographs produced anywhere in the 1920s. Nothing is left to chance in a Goodwin composition. In his soft-focus tableaux, the model's pose, lighting and surroundings are carefully orchestrated. And his subjects were willing collaborators, these great actresses, ballerinas and aristocratic ladies, all serenely aware of their charms. Some, in their hauteur, suggest Strindberg's willful heroines who, for all their apparent fragility, could make men do their bidding. Goodwin's conception of femininity is the real subject of his photographs and a delicate eroticism pervades them.

Portraits were not Goodwin's only genre, however. In a 1920 photograph, the nude figure of a beautiful young model, Carin B., is silhouetted like a Jugendstil ornament. The tendrils of her hair, curling over her bosom, remind us of the tresses of Edvard Munch's beautiful vampire. In another photograph of that year, a magnificent female torso with softly lighted contours materializes from an umber background. In such works Goodwin's model assumes the aspect of primal femininity.

Stockholm, the most urbane of Scandinavian cities, had no shortage of fascinating women to sit before the camera, and the photographer Rolf Winquist is also distinguished for his portraits of them. He extended the glamour photograph into even more dramatic areas with his pictures of great Swedish film stars. In an expressive composition of 1942, the high-cheek-boned face of Gudrun Brost emerges from the shadows. In the work of such photographers as Goodwin and Winquist, a new pantheon of Nordic goddesses was born.

Henry B. Goodwin
Torso ca. 1920
gelatin silver print
16¼ x 8½
41.3 x 21.6
Collection Kungliga Biblioteket, Stockholm

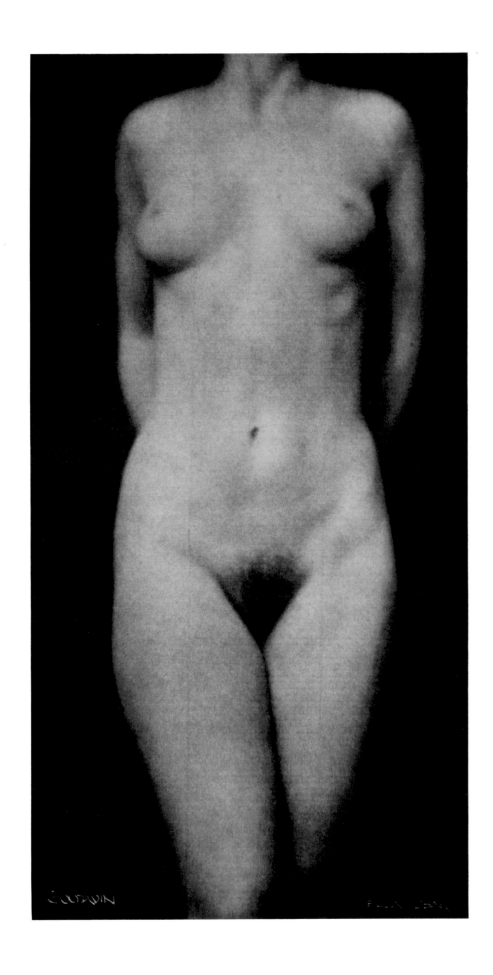

Portraits
by Heinrich
Tønnies

Henning Bender

Heinrich Tønnies
Knud Behrend, butcher's assistant 1891
modern gelatin silver print
from original negative
10 x 8
25.4 x 20.3
Collection Lokalhistorisk arkiv for Aalborg
kommune

The *carte-de-visite*, a portrait photograph in the format of a calling card (6 x 9 cm.) has undoubtedly been the most profitable invention in the history of photography. Constituting 95 percent of the photographs made in the 19th century, these pictures replaced calling cards and were exchanged among friends and relatives and collected in albums. Far cheaper than all earlier portrait forms, they appeared worldwide in the early 1850s, a time of unprecedented population shifts. As families were separated, photographs became mementos of great emotional value. In Ålborg, then Denmark's second largest city, Heinrich Tønnies (1825–1903) introduced the personalized *carte-de-visite* in December 1856. It was "the Christmas gift of the year," his advertisements trumpeted. One of his Christmas gift albums of 1856 has been preserved in the Ålborg Historical Archive: it is said to be one of the oldest extant series of *cartes-de-visite* in the world.

The Archive is rich in the history of photography thanks largely to Tønnies and his descendants who operated his studio continuously through 1969. During his long career he made some 150,000 *cartes-de-visite* and another 100,000 photographs in various formats; most of the negatives have survived. In addition, the Archive contains his order books, detailed records of every photograph he took from 1864 on, citing the date, place, number of copies, price and, for portraits, the name and occupation of the sitter. The completeness of this collection and the superior quality of his work distinguish Tønnies from his numerous colleagues in Northern Europe. Through him can be traced the development of the style and technique of the *carte-de-visite* in the second half of the 19th century. His life illuminates the history of what was then a new career—commercial photography.

Tønnies was born on 10 May 1825, in Grünenplan in the former duchy of Braunschweig in northern Germany. Like his father and everyone else in the small town, he was employed in the glass industry. As a glass cutter and skilled painter of stained glass, he labored at various glassworks in the Ruhr and Braunschweig areas. During these years a glass industry was being set up in Denmark. There was a shortage of skilled native craftsmen, however, so manpower was imported from abroad, in particular from Germany, which was more highly developed in technology. For this reason, Tønnies emigrated to Denmark in 1847. By 1855 he was in Ålborg.

Owing to its central location, Ålborg had excellent communications with the Continent and the rest of Scandinavia. German and Austrian daguerreotypists were attracted to the town. The first of these came from Vienna as early as 1843 and many others followed. Among them was the German-born C. Fritsche. From 1855 onward, he produced daguerreotypes and ambrotypes as well as paper prints made from glass-plate negatives. His work aroused the interest of the glass craftsmen. As a painter of stained glass Tønnies was naturally fascinated by the new, seemingly effortless method of delineation on glass; as a glass

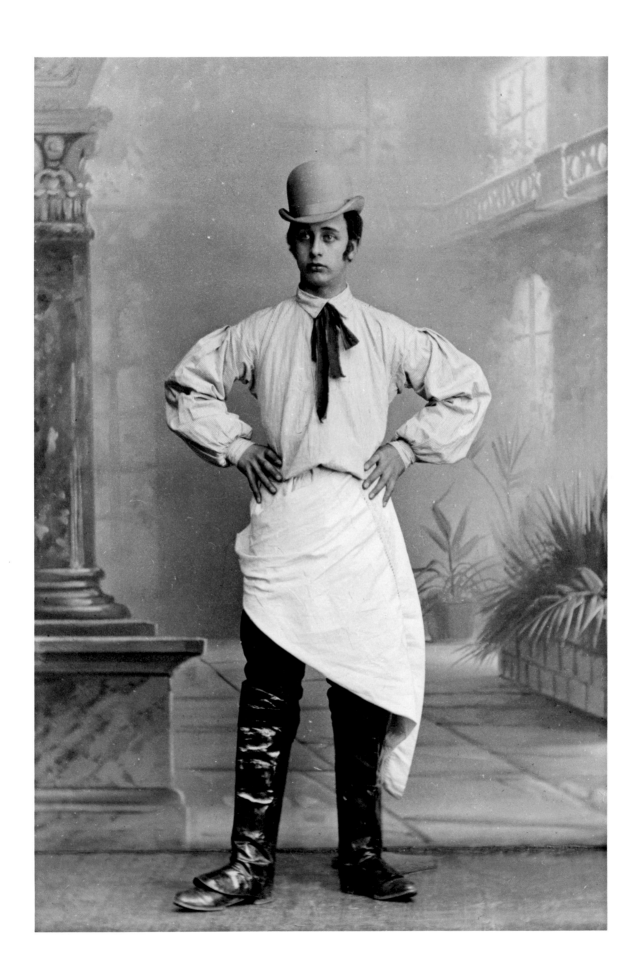

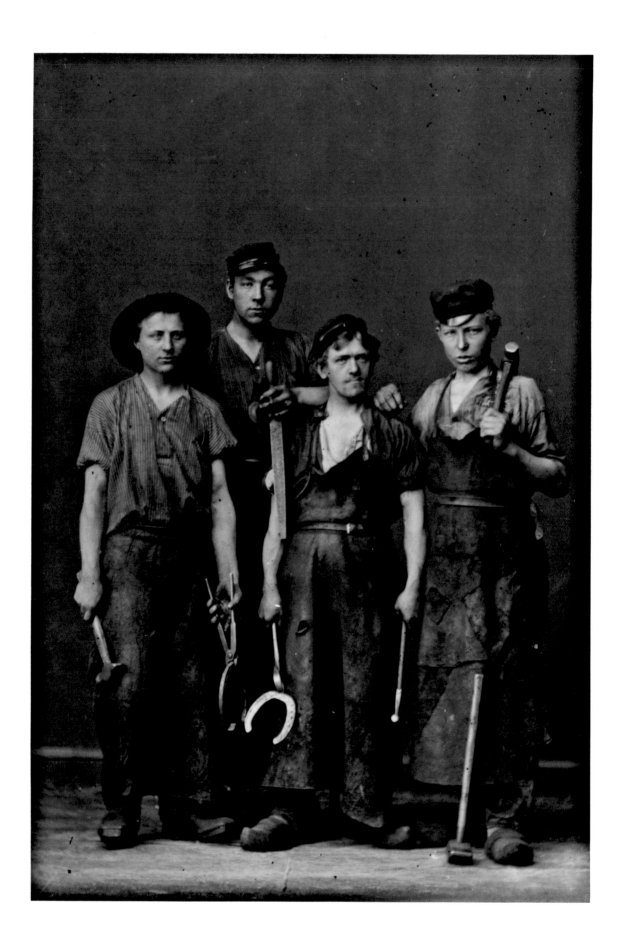

Heinrich Tønnies
Blacksmith Sørensen and assistants 1881
modern gelatin silver print
from original negative
10 x 8
25.4 x 20.3
Collection Lokalhistorisk arkiv for Aalborg
kommune

cutter he was also interested in the camera itself, especially the lens. He acquainted himself with Fritsche's methods and later traveled to Berlin to learn more. When he returned to Ålborg in the fall of 1856, he took over Fritsche's studio and announced that he would make *cartes-de-visite*. It was among the new ideas that he had picked up in Berlin.

Tønnies's *cartes-de-visite* were an immediate success and he quickly became one of the most affluent photographers in Denmark. He invested his money in more advanced cameras and in improving his facilities. In 1880 he built a three-story studio, modeled on the most celebrated establishment in Berlin; it was the largest ever constructed in Scandinavia. He equipped it with the best German cameras available, most notably a giant Voigtländer with a lens 16 cm. in diameter, which had been manufactured in Braunschweig since 1865. Since enlargements were still unknown, the 50 x 60 cm. photographs this could take were remarkable.

Tønnies executed a great number of photographs of Ålborg in the 1860s, making it one of the best documented towns in Denmark at the time. These pictures were sold as a kind of postcard and were used as models for lithographs in illustrated periodicals. This work brought Tønnies an important commission from the Danish National Railways in 1874. He was to photograph in detail all stages of the biggest engineering project in Denmark at that time, the construction of a railroad bridge over the Limfjorden in northern Jutland. Skilled labor had to be recruited from France and Italy for this undertaking, and the laborers wanted to send pictures home showing what they were doing and how prosperous they were. Since Tønnies was the official photographer of the bridge construction, he also took photographs of the laborers in their working clothes, some of them holding handfuls of money.

From this time on, Tønnies made portraits of workers: smiths and housepainters, carpenters with their saws and hammers, chimney sweeps with their brushes, housemaids with their dustpans. Though the number of worker pictures is about half of a percent of Tønnies's 30-year output of *cartes-de-visite*, they form a body of work unique in Scandinavia and fascinating in the light they shed on the professions and the photography of the time.

For all his pictures, Tønnies's prices were considerably above those of other local photographers, but so was the quality. For his worker portraits, his order books show that craftsmen with particularly heavy tools paid extra to be photographed. These pictures had no political motivation; in fact, his granddaughter, the photographer Lili Tønnies (b. 1888), remembers that he was a strict conservative. Apparently, Tønnies had exactly the same attitude toward his portraits of workers as toward his other *cartes-de-visite*. It was all business. For groups he provided discounts on individual portraits; before the Mormons left for Utah, for example, he made at least 2,000 pictures, judging from the negatives that survive.

Jean. *Oh yes, Miss Julie, yes. A dog may lie on the Countess's sofa, a horse may have his nose stroked by a young lady, but a servant . . . well, yes, now and then you meet one with guts enough to rise in the world, but how often? Anyhow, do you know what I did? Jumped in the millstream with my clothes on, was pulled out and got a hiding. But the next Sunday, when Father and all the rest went to Granny's, I managed to get left behind. Then I washed with soap and hot water, put my best clothes on and went to church so as to see you. I did see you and went home determined to die. But I wanted to die beautifully and peacefully, without any pain. . . .*

August Strindberg, *Miss Julie*, 1888

95

Julie. *Listen. My mother wasn't well-
born; she came of quite humble
people, and was brought up with
all those new ideas of sex equality
and women's rights and so on.
She thought marriage was quite
wrong. So when my father
proposed to her, she said she
would never become his wife . . .
but in the end she did. I came into
the world, as far as I can make
out, against my mother's will,
and I was left to run wild, but I
had to do all the things a boy
does—to prove women are as
good as men. I had to wear boys'
clothes; I was taught to handle
horses—and I wasn't allowed in
the dairy. She made me groom
and harness and go out hunting;
I even had to try to plough. All
the men on the estate were given
the women's jobs, and the women
the men's, until the whole place
went to rack and ruin and we
were the laughing-stock of the
neighborhood. At last my father
seems to have come to his senses
and rebelled. He changed
everything and ran the place his
own way. My mother got ill—
I don't know what was the matter
with her, but she used to have
strange attacks and hide herself
in the attic or the garden.
Sometimes she stayed out
all night. . . .*

August Strindberg, *Miss Julie*, 1888

Tønnies's worker pictures, like all his *cartes-de-visite*, evolved like their counterparts in Germany and Scandinavia. Determined entirely by the wishes of the public and extensively retouched, they were flattering rather than true to life. In the 1860s and 1870s they were comparatively simple both as to studio arrangements and accessories, while in the 1880s and 1890s an increasing number of special effects were used to romanticize the pictures or to create the illusion of a more natural environment. Chairs, tables and plants proliferated in the photographs, and so did the variety of painted backdrops used—winter and summer landscapes of fields or woods, limpid lakes dotted with swans and beach scenes with picturesque shipwrecks. Sometimes setting and subject were oddly matched, as in his portrait of a very dirty chimney sweep standing in a palatial interior. Tønnies is not unique among portrait photographers of the time in this superabundance of accessories. Rather, he had more effects and a larger studio than his rivals. And in style he remained several years ahead of his Scandinavian colleagues because of his direct connections with Berlin, through Carl Suck, photographer to the Imperial German Court, with whom he had studied, and his retoucher, August Andrée, who became father-in-law to Tønnies's son Emil.

To modern eyes Tønnies's photographs may seem strange and overcrowded, but their exceptional quality becomes apparent at close view and in modern enlargements of the original negative material. In spite of an extensive production, which on Ålborg holidays could exceed 350 portraits daily, Tønnies and his assistants, who numbered at one time as many as 15, lavished great care on every photograph and always used the most advanced technical aids available. His methods were superior: he was early in moving from the wet collodion process to dry plates, and by the end of the 1870s he began to make dry plates with the Obernetter patent to sell to other photographers. His compositions are varied and assured, and his portraits reveal the unique qualities of his subjects.

Henning Bender began the Historical Archive of the Ålborg Municipality in 1974, and it now contains about 1.5 million pre-1920 photographs of northern Jutland as well as historical documents. An MA in history, he has taught that subject at the University of Copenhagen. (Translation by Callum Forsyth.)

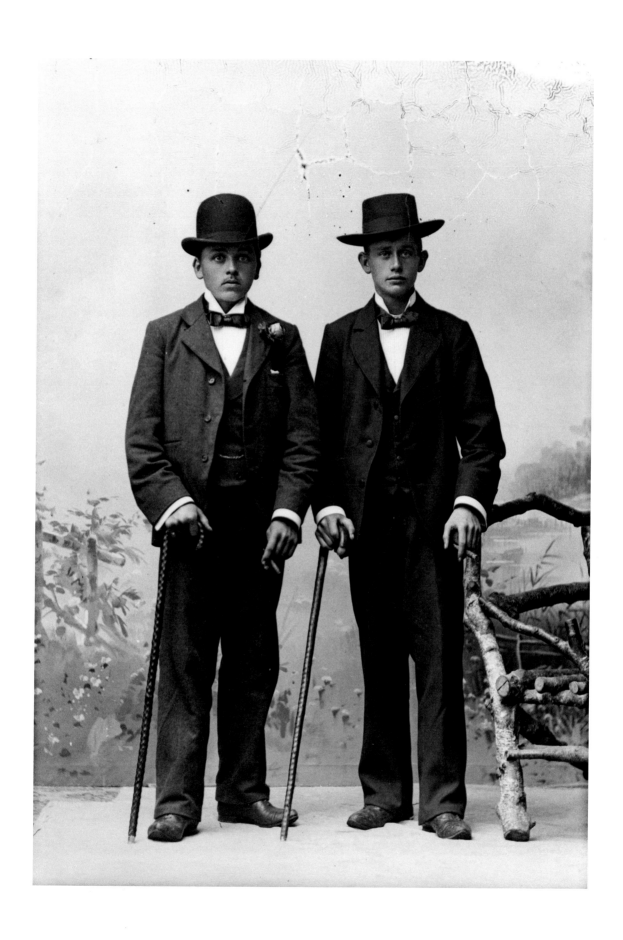

Henry B. Goodwin's Women

Leif Wigh

Henry B. Goodwin
Blanka Liljefors 1920
gelatin silver print
12⅛ x 9¼
30.8 x 23.5
Collection Kungliga Biblioteket, Stockholm

Women in the first quarter of our century: Henry B. Goodwin shows their most alluring traits. In sumptuously printed, large-format photographs, he lingered over the long curves of nude shoulders, confronted the archetypal beauty of a full young torso or held the intelligent gaze of a social lioness. His figure studies, nudes and portraits were internationally renowned among pictorialist photographers of the time.

Goodwin was born Heinrich Karl Hugo Goodwin Bürgel in Munich in 1878. His parents were bourgeois Bavarians: his mother came from a family of scholars and his father was a landscape painter and teacher. The boy was exposed to contemporary schools of painting, and he studied philology, eventually specializing in ancient Nordic languages, especially Icelandic. He was a student at the universities of Munich, Copenhagen and Leipzig, and during this period he married and fathered three children. In 1903 he won his PhD from Leipzig University and in 1905 he was given a lectureship at Sweden's University of Uppsala. By then he had taught himself photography. In Leipzig he got to know the portrait photographer Nicola Perscheid (1864–1930), a strong artist who shaped Goodwin's technical approach to photography and became a father figure to the young philologist.

Soon after Goodwin and his family arrived in Uppsala, the 27-year-old met the recently widowed Ida Helander. This encounter changed his life. He divorced his wife in 1909 to marry Ida, and the couple went to Stockholm. Until 1915 he worked as a lexicographer with the publishers Nordstedt & Söner, but he also hotly pursued photography, probably inspired by his second wife's beauty and artistic ambitions. He wrote for *Fotografisk Tidskrift* and *Svenska Fotografen* and published photographs in these Swedish periodicals where pictorialist ideas were argued. In 1913, through the help of the Swedish Photographers' Association, he brought his old mentor Perscheid to Stockholm to teach a week-long course in the technique of portrait photography. So convincing were Perscheid's lectures and example that his style characterized Swedish portrait photography until World War II. Goodwin himself flourished: he addressed the Swedish Photographers' Association at its summer meeting in 1914 and exhibited with its members in Malmö, and he became the Nordic correspondent of the English bible of Pictorialism, *Photograms of the Year* (a position he held into the early 20s). In 1915 he exhibited at the Varia Art Gallery in Stockholm and inaugurated his own studio, which he grandly called "Kamerabilden" (Camera Picture), on Strandvägen, then as now one of the elegant boulevards of the capital. The Swedish upper classes and intelligentsia, and members of the theater and cinema communities, crowded into his reception room to have their portraits made. Stockholm photographers were enraged by the popularity of the new studio and spread rumors about the foreigner who had suddenly turned professional and stolen their customers. World War I had begun to rage and Heinrich Goodwin Bürgel was now Henry B. Goodwin.

A vital personal style distinguished Goodwin's photography.

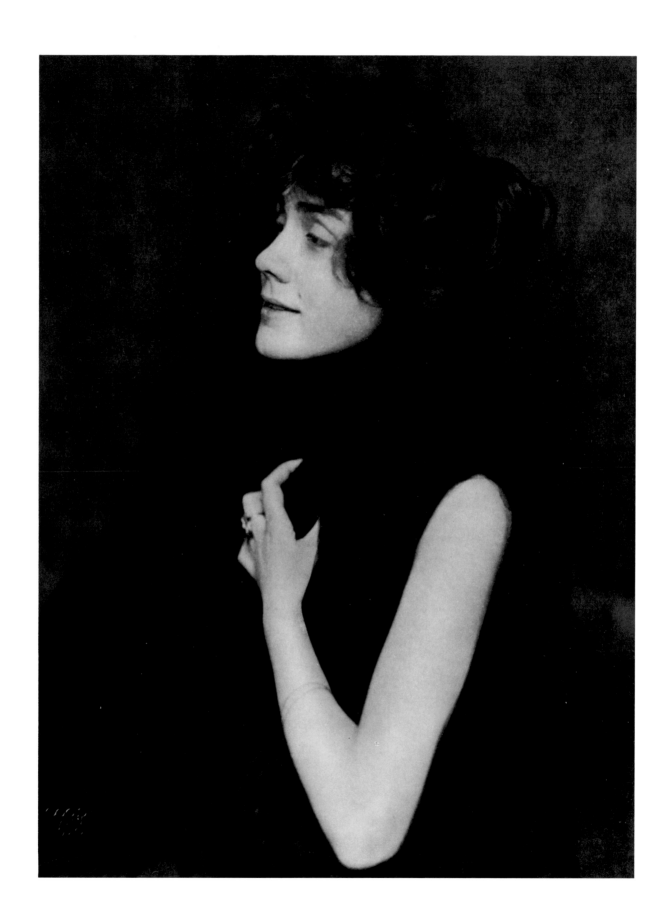

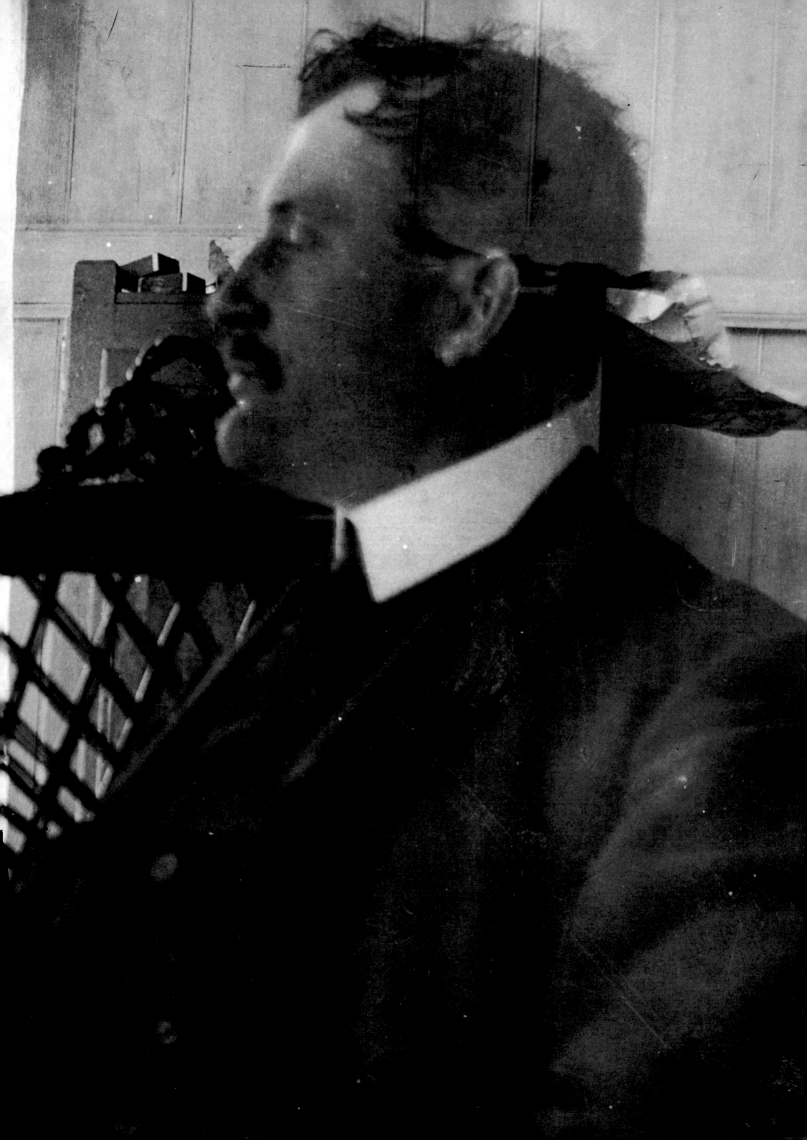

The Painter's Lens

MF

(overleaf)
Edvard Munch
Self-portrait, Am Strom No. 54,
Warnemünde 1907
modern gelatin silver print
from original negative
$3\frac{1}{2}$ x $3\frac{5}{8}$
8.9 x 9.2
Collection Oslo Kommunes Kunstsamlinger
Munch-museet

John Riise
Portrait of a lady ca. 1930
gelatin silver print
$14\frac{1}{4}$ x $10\frac{1}{2}$
36.2 x 26.7
Collection Sonja Henie-Niels Onstad
Foundations, Høvikodden; Deposited by
Statens Håndverks og Kunstindustriskole,
Oslo

The relationship between painting and photography in Scandinavia during the late 19th century generally follows the pattern that prevailed throughout Europe. Numerous Scandinavian photographers and painters who received their training in Germany brought back not only technical knowledge but an awareness of current painting attitudes, and amateur photography clubs in various Scandinavian cities actively collected European periodicals that included reproductions of progressive paintings and photographs. It is no accident that landscape photography, especially in Sweden and Norway, was affected. For all these reasons—and because of the pleasure found in the bucolic side of Scandinavia in the 1880s—an impressionist-related approach was particularly prevalent in Nordic camera and easel work by the late 19th century. In both art forms of the period, the quiet landscape and well-appointed interior are frequent themes. In such Scandinavian equivalents of *plein-airisme*, there is no hint of social stress or psychological pain. Instead, the images are microcosms of middle-class tranquillity.

In their choice of subject and atmospheric quality, the richly detailed autochromes of Wladimir Schohin are evocative of early Monet and Degas. This gifted Finnish amateur was a master of composition, whether working with the figure or with still life, and of subtle, inventive color relationships. Though he understood the use of backlighting to pick out a figure's contour in a landscape, he was less concerned with defining volume through strong light and shadow than with locating the model in a luminous tapestry of delicately modulated color. In Schohin's outdoor views, the figures are carefully defined forms centered against textured backgrounds such as pebble-strewn beaches or light-dappled gardens. We have little sense of them as individuals, however faithfully they are described: rather, they are passive elements in a larger composition scheme. In a ca. 1907 photograph, a woman with a shawl sits against the exterior wall of a house. In Schohin's vision, she is also an abstract plane floating against the rectangles of door and window. Everything is thoughtfully staged in these genteel pictures. Their lone beings appear spellbound. We sense such detachment in a handsome, *intimiste* interior photograph whose sole inhabitant is a pensive woman seated at a table, gazing at a bowl of flowers.

For the gifted Norwegian painter Edvard Munch, photography had a special role, as Arne Eggum points out in his essay. Among other things, his snapshots portray, indeed foreshadow, many themes that appear in his paintings and prints. His ubiquitous female appears in all her guises in his photographs: as a severe menacing presence in a dark, high-necked dress and as a sensuous temptress, a creature of equal parts innocence and desire. Her sole purpose, according to Munch, was to bedevil man. In an extraordinary 1906 multiple-image photograph she is a full-bodied, naked goddess, oblivious of the staring ghostly figure, perhaps her clothed counterpart, that emerges from the wall.

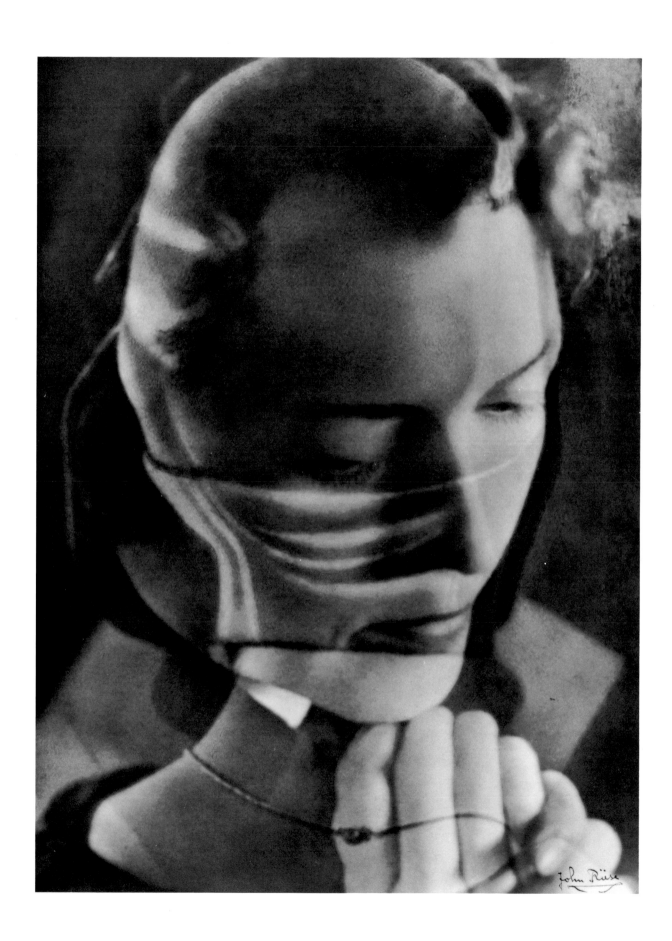

Munch was obsessed with portraying himself in photographs as well as paintings, and in snapshots made over many years we see the remarkable changes that he underwent. First he is an immaculately dressed young man, conscious of his elegant appearance as he confronts the camera. In a 1907 print he appears as an athletic nude standing next to his now celebrated large canvas of male bathers on the beach. Then he is a ravaged creature in a 1908–09 photograph coinciding with a clinic stay in which he tried to deal with his alcoholism and other afflictions. If these private records are not the equals of Munch's other pictures, they are nevertheless extremely compelling images, as much for their inventive techniques as for their insight into his personal life. In their immediacy they bear comparison with the spontaneous pencil and charcoal sketches in which, with a few lines, the artist revealed his turbulent feelings.

Certainly a brilliant personality in the evolution of Norwegian photography is the artist John Riise, whose large-scale portraits produced between 1921 and the mid-1960s are less about the subjects depicted than about his transformations of them. A studio photographer who began his career conventionally, he specialized in close-ups of his sitters, using strong light and shadow to highlight facial features. But soon Riise became so involved with abstract forms that the subject itself was subordinated. For the next 40 years, a succession of stylistic tides—Dada, Surrealism, Cubism, Expressionism—ebbed and flowed through his work with startling effect but in no discernible sequence. In some of his overprinted portraits, which combine elements of one subject's face with features borrowed from another's, heads float ectoplasmically toward the viewer. The juxtapositions of facial aspects borrowed from various models remind us of Dada portraits.

In Riise's spectral images, painting is an integral element of the print surface: he altered his monochromatic prints by manipulating their form almost undetectably with pigment. With meticulous care, he worked to the composition's edge, and his forms fill and animate the rectangle in rhythmic overlays. In these bizarre compositions, the features of a particular person may dominate, but other presences also echo, making the resulting image ambiguous and disturbing.

For all the complexity of these designs, Riise was capable of great clarity as well, and he generated images that are as mesmeric as they are mysterious. The back of a cloche-hatted woman's head is the central form of a superb composition in a multiplicity of warm gray tones. The contours of the head, the neckline of the dress and a string of pearls are translated into a sequence of undulating curves. When in 1955 he began adding color to his photographs it heightens certain areas, but by 1960 the underlying print was all but eradicated by a heavy impasto of florid hues.

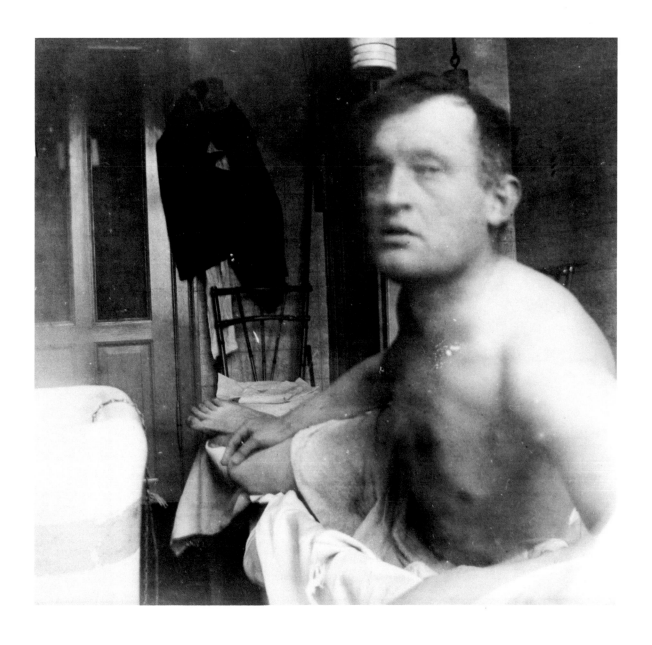

Riise must be regarded as a maverick whose prolific output was marked by half-absorbed stylistic impulses. It seems he attempted to utilize virtually every mode of avant-garde painting that came his way. Whether he ever fully resolved the conflicting demands of photographic versus painterly description remains a question. This dualism contributes to the tension his work projects. At its most successful his photography maintains a delicate balance between these warring impulses.

Munch and Photography

Arne Eggum

Edvard Munch
Self-portrait, Åsgårdstrand,
Norway 1904
gelatin silver print
3½ x 3½
8.9 x 8.9
Collection Oslo Kommunes Kunstsamlinger
Munch-museet
(not in exhibition)

Edvard Munch
Self-portrait in a rented room ca. 1905
gelatin silver print
3½ x 3½
8.9 x 8.9
Collection Oslo Kommunes Kunstsamlinger
Munch-museet
(not in exhibition)

"We want something more than a mere photograph of nature," wrote Edvard Munch in 1890. "Nor do we merely want to paint nice pictures to hang on the wall. We shall see if we cannot succeed in providing the basis for an art . . . that grips you. Art created in the blood of one's heart." In view of his passionately subjective conception of his art, it may seem surprising that Munch was also a photographer. He saw photographs—his own and pictures by others—as means to document his paintings and surroundings, as starting points for portraits, self-portraits and figure compositions and, it would appear, as opportunities for experimentation in their own right. Effects that may have first occurred accidentally in Munch's photographs reappear in his subsequent photography and provide formal variety and enriched symbolism. These pictures illuminate his paintings and graphics, and indeed, in some cases, appear more radical than his easel work in their treatment of space and in the mysterious auras of their figures.

Munch probably first knew of photography as a student in the 1880s in Christiania (the capital was renamed Kristiania in 1897 and Oslo in 1925). Photography had been accepted as an aid to painters in the reproduction of reality, and Munch's teacher Christian Krohg even went so far as to paint directly on photographs. Photography did not apparently begin to influence Munch, however, until after 1892 when he met August Strindberg in Berlin. For extended periods in the 1890s, Strindberg was more concerned with making photographic experiments than with his writing. He also produced intensely "spontaneous" paintings, which he considered in every way equal to Munch's. The latter, for his part, was cherishing literary ambitions. Strindberg's belief that nature can reveal its innermost laws through the medium of the artist must have impressed Munch, and it throws some light on the spontaneous and experimental element in his mature art.

A self-portrait of Strindberg, taken in Gersau in 1886, could be a forerunner of Munch's *Self-portrait with Cigarette* of 1895. The hand holding the cigarette, the pose and expression, the light from below, distorting the features, even the bristling moustache, suggest that Munch was not only familiar with this photograph but that he identified with the Swedish author. At this time, both men were interested in "psychic naturalism," a sort of laying bare of the soul through art. Strindberg believed that photography could reveal personality if the model were encouraged to express various mental states during a long exposure, and it is reasonable to suppose, though it cannot be proved, that this idea is reflected in Munch's different characterizations of each half of the face in his painted and graphic portraits and self-portraits. It is also fascinating to note the similarities between Strindberg's remarkable "celestographs," direct photographs of the stars without the use of a lens, and the shimmering vault of the sky in Munch's art from the 1890s, in particular the versions of the etching called *Attraction*, 1895. Sometimes Munch also drew portraits on the basis of photographs, for example, of Stéphane Mallarmé, Knut Hamsun and Henrik Ibsen. It was probably his

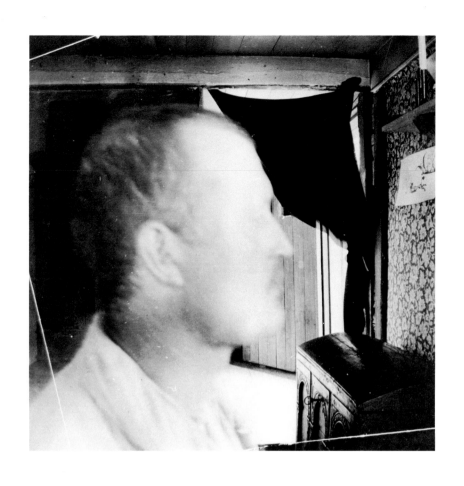

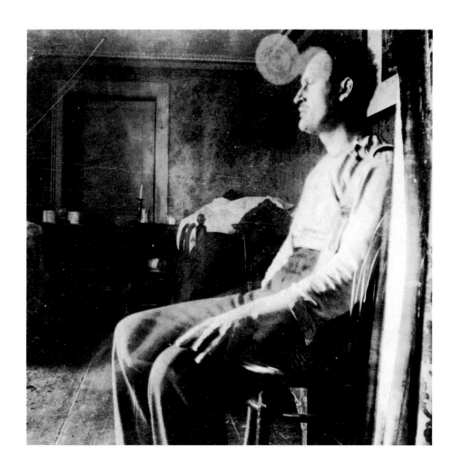

growing preoccupation with portraits and self-portraits that led Munch to buy a small camera in Berlin in 1902. From this point, photography, his own and that of others, proved an incalculable aid to his art.

We do not know what camera Munch used, possibly one of the many small Kodaks available on the German market. In some cases, the film has been preserved, a roll film about 90 mm. in width. By somehow reducing the area of exposure, Munch obtained an area of about 85 x 80 mm. These pictures are all contact-printed. Spanning the years 1902–11, they form a fascinating collection, although they raise a question: are the technical peculiarities in the best of them intentional, or the result of Munch's lack of technical skill? Probably among Munch's first photographs is the picture he made of himself seated on a large trunk in his Berlin studio, surrounded by the paintings that were to make him internationally famous when they were exhibited in 1902 in the Prussian capital. Another five photographs from about this time, depicting the studio, have been preserved. The best known, of a model with long hair and black stockings, appears to have inspired at least two motifs, the figure in the painting *Female Nude* and the lithograph *Sin*, both probably from 1902.

Photographs Munch took at his Kristiania exhibition of November 1902 and pasted into an album suggest that he was trying to achieve an evocative light effect. In the same album is a photograph with a caption added by Munch's sister Inger: "Lavatory window in Pilestredet. Photo: Edvard Munch." On the back of the photograph is written "a swan on the wall." The swan, a symbol of art for Munch, is dimly discernible on the wall to the right and has fingerprints as its "head." The lighting in this unusual photograph is either the result of double exposure or Munch's movement of the camera. But whatever the technical explanation, the work conveys an intense, almost *angst*-filled atmosphere. It was here at No. 30 Pilestredet that Munch's mother sickened and died when he was five years old. The fingerprint, which also appears in some of Munch's other photographs, implies that he developed the film himself.

Munch's photographic self-portrait at his cottage at Åsgårdstrand of 1903 or 1904 also appears experimental in character. It was taken so close up that the features are blurred. The light at the front, shaded by the hanging which has moved slightly during the exposure, and the light from the side seem to have been carefully studied. In another photograph, taken in an unidentified room, Munch is seated on a stool, his left hand on his thigh, showing his shortened middle finger—his "fateful hand"—the result of a pistol accident, an incident that put a dramatic end to an early love affair and haunted Munch for the rest of his life. These pictures belong to a series that Munch later called his "fateful photographs of 1902–08," a series of meditative self-portraits that are notably symbolic and adventurous in form. Frequently the artist appears transparent, because of double exposure or lengthy exposure time during which Munch may have moved into the

Edvard Munch
Self-portrait with Cigarette 1895
oil on canvas
43½ x 33⅔
110.5 x 85.5
Collection Nasjonalgalleriet, Oslo
(not in exhibition)

August Strindberg
Self-portrait in Gersau 1886
modern gelatin silver print
from enlarged duplicate negative
3½ x 4⅝
8.3 x 11.7
Collection Nordiska museet, Stockholm

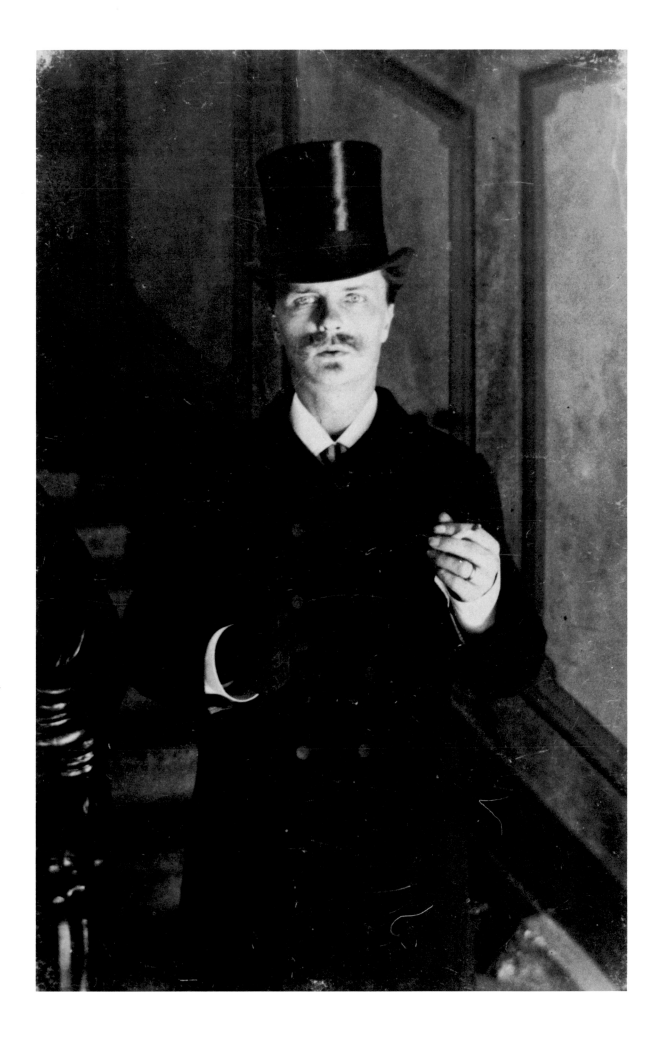

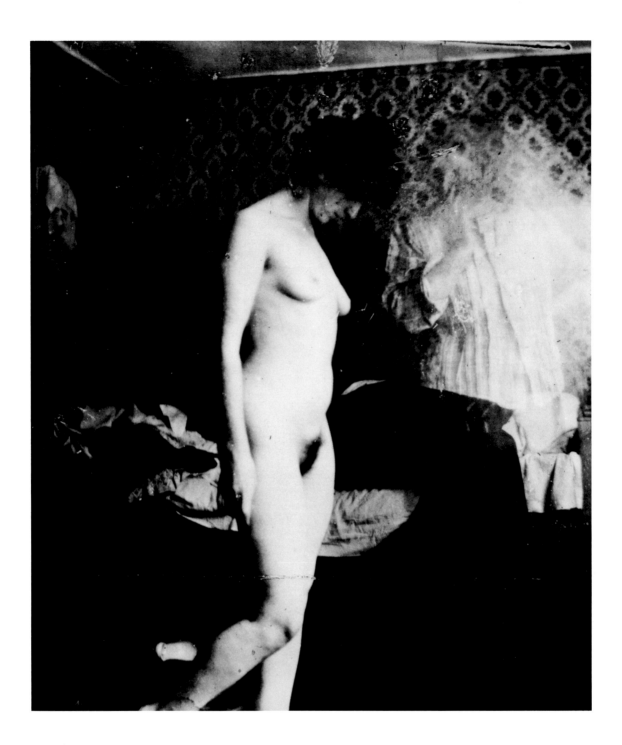

Edvard Munch
Nude (probably taken in Berlin) 1906
modern gelatin silver print
from copy negative
6½ x 4½
16.5 x 11.4
Collection Oslo Kommunes Kunstsamlinger
Munch-museet

Edvard Munch
Weeping Woman 1906
oil on canvas
43 x 38½
110 x 98.5
Collection Oslo Kommunes Kunstsamlinger
Munch-museet
(not in exhibition)

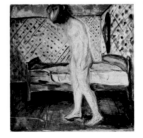

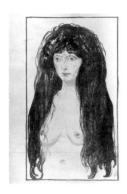

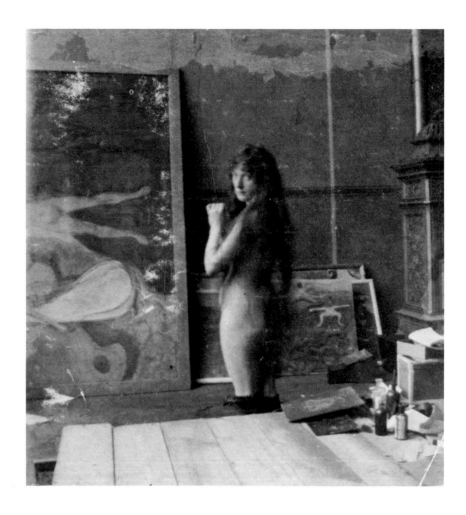

Edvard Munch
The Sin 1902
lithograph on paper
19 x 15½
48.2 x 39.3
Collection Oslo Kommunes Kunstsamlinger
Munch-museet
(not in exhibition)

Edvard Munch
Nude in Munch's studio in Berlin 1902
gelatin silver print
3¾ x 3¾
9.5 x 9.5
Collection Oslo Kommunes Kunstsamlinger
Munch-museet

picture. In most of these works, Munch reveals his distressed mental state and he appears extremely conscious of doing so. In fact, this group of images suggests that in his photography, as in his painting and prints, he found a means of registering his shifting but increasingly desperate psychological condition. (He would suffer a nervous breakdown in 1908.)

One of Munch's most distinctive photographs shows a female nude in front of a bed in a narrow room. A number of versions of the scene painted and printed in 1906 and called *Weeping Woman* can be associated with this photograph. Like the other interior photographs from the same period, it has a fascinating effect because of what probably is a double exposure (planned or accidental). The two images of the woman—one is clad in pale garments and regards the other, who is naked and with bent head by the bed—may well be intentional. The same model also appears in some evocative photographs that Munch took on the Warnemünde beach in the summer of 1907, pictures that again show experiment with double exposure and mirror imagery. Also during that summer he photographed himself at work on the monumental canvas *Men Bathing*. His model is nude and Munch probably was too—his loincloth appears to have been added to the negative (the negative is now lost).

113

Edvard Munch
Self-portrait on the beach in
Warnemünde 1907
gelatin silver print
3⅛ x 3½
7.9 x 8.9
Collection Oslo Kommunes Kunstsamlinger
Munch-museet

*A deep purple darkness descended over all
the earth—I sat beneath a tree—whose
leaves were beginning to yellow and
wither—She had sat down beside me—she
had bent her head over me—her blood-red
hair had entangled me—had twined itself
about me like blood-red serpents—its
finest threads had worked itself into my
heart—then she rose—I do not know why—
and moved slowly away toward the sea—
farther and farther away—then came a
strange feeling—as if there were invisible
threads between us—I felt as if invisible
threads of her hair were still twisted around
me—and so when she had disappeared
completely across the sea—I still felt the pain
where my heart bled—because the threads
would not break.*

Edvard Munch, ca. 1896

After his breakdown, Munch entered a private clinic in
Copenhagen, and he soon transformed his room into a studio.
This provided the setting for the last pictures he probably had in
mind when he referred to the "fateful photographs of 1902–08."
One of these is almost identical with the painting *Self-portrait in
the Clinic*, where Munch again is transparent, as in an X-ray.
In another he is sitting looking at the beginnings of the painting
in question, and here again he prominently displays his mutilated
left hand. Between the artist and his portrait, however, stands a
smiling nurse, holding food on a tray and breaking the tension.
Other photographs of Munch sitting alone convey his recently
acquired inner calm. Munch was aware of his new attitude to
reality, and said of this self-portrait, that he ". . . no longer looks
inward, but outward."

The other photographs from the clinic stay convey humor, even
irony. A picture showing a nurse posing, flirtatious and inviting,
with her hands behind her neck, exudes genial humor, while the
photograph of two nurses—who are the same types of the dark
and fair women in Munch's painting—is psychologically relaxed.
One photograph of a nurse, shown like a statue enveloped in a
vibrant shimmering light, may be the result of trick photography,
and it is in a class of its own. It provides a link with Munch's first
impressionistic female portraits from the early 1890s.

There is no question, of course, that Munch considered his paint-
ing superior to his photography. "The camera cannot compete
with painting," he wrote, "as long as it cannot be used in heaven or
hell." Nevertheless, a study of Munch's photographs from 1902
to 1908 shows that he was experimenting at expressing conditions
beyond the visible, that he in fact endeavored to represent
another dimension in life through the camera—his own hell.

*Arne Eggum is Chief Curator of the Munch-museet, which contains the
artist's bequest to Oslo, some 1,000 paintings, 15,400 prints and
4,500 watercolors and drawings. Eggum has contributed to many books
and catalogues on Munch, including* Edvard Munch: Symbols and
Images, *National Gallery of Art, Washington, D.C., 1978–79.
(Translation by J.R. Christophersen.)*

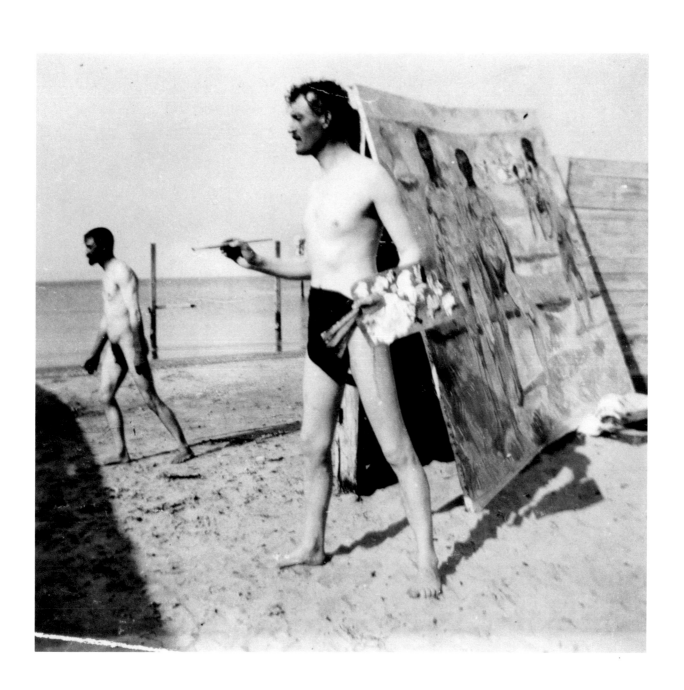

The Painted Photography of John Riise

Robert Meyer

One of the most original and mysterious figures in Scandinavian photography is the Norwegian John Olav Riise (1885–1978). A photographer whose work falls into two periods, 1921–32 and 1953–78, Riise created subtle and ravishingly beautiful "straight" camera work and also pictures of hybrid technique and style alongside his commercial portraiture—large, extensively retouched images and double and triple printings with hand-coloring that allude to Cubism, Surrealism and the suave abstract painting of the years between the wars. The sophistication of his work reveals a remarkable talent and suggests the international culture and contacts that Norway had developed by the 1920s.

Riise was one of 12 children—11 boys and a girl—born to an artistic family in Hareide, not far from the Norwegian coastal town of Ålesund. Riise's father was a schoolteacher who had briefly studied painting and was highly musical. He taught all the children to play instruments; two became musicians, and one brother became a landscape and portrait painter. Riise, who played the organ and composed for it, took up photography, and in 1914 bought his first camera, a large-format apparatus for professional work. As was customary then, he learned his trade by apprenticing himself to established photographers. After work in Ålesund and Oslo, and travel and work in Copenhagen and the resort town of Mölle in Sweden, Riise opened his own studio in Oslo in 1921.

The same year the "Kristiania Kamera Klubb" was founded (it became the Oslo Camera Club in 1925 when the capital was renamed). This was Norway's third association of amateur photographers—the first had been started in the late 1880s—and it sponsored the liveliest exchanges to date with associations in London. Professional photographers were also making their mark abroad, and two won international reputations: the portraitists Waldemar Eide and Aage Remfeldt. Both exhibited from 1919 at the London Salon of Photography, a continuation of the annual shows of the Linked Ring (a group of pictorialists formed in 1893). Like Eide and Remfeldt, Riise felt encouraged to exhibit internationally; he first submitted pictures to the London Salon in 1924. Through 1932 he was represented almost annually in Paris; over 25 of his photographs were shown in the French Salon, by which he set particular store, and he also exhibited in Spain, Italy and the United States. In Norway in this period, the status of photography as an art form had never been higher.

The art Riise admired, however, was apparently not advanced photography so much as avant-garde French painting. It was work he may have seen in the international exhibitions held in Oslo and in reproduction (he seems not to have traveled abroad), that his painter-brother may have introduced him to and that he learned about secondhand through his study of drawing and sketching in 1930 with the Scandinavian painter Leon Aurdal, who had been a pupil of the French cubist André Lhote during the late 1920s. The photographs and paintings of the mid-1920s

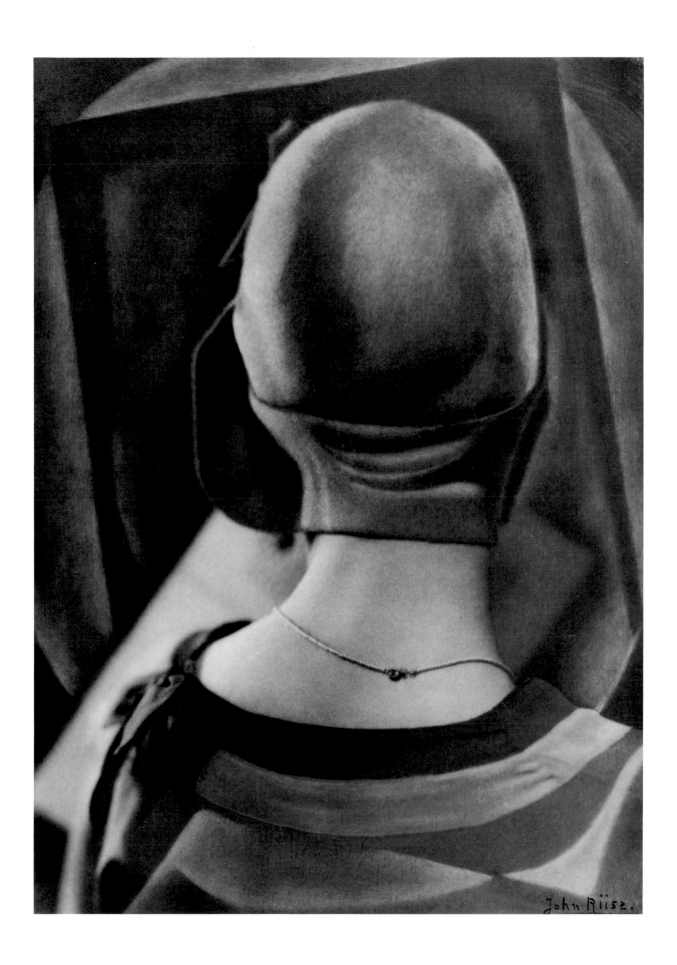

John Riise
Hands 1925
gelatin silver print
10½ x 13¼
26.7 x 33.7
Collection Sonja Henie-Niels Onstad
Foundations, Høvikodden; Deposited by
Statens Håndverks og Kunstindustriskole,
Oslo

by both men show comparable simplifications of form to enhance volume, effects Riise achieved with retouching. Both treated their portrait subjects like sculpture, set against abstract backgrounds. In some studies Riise introduced new shapes into a face to emphasize its three-dimensionality; or his distortions of form make faces expressionistic. In several male portraits, the exaggerations of light and shade produce flat abstract patterns. In his portraits of women Riise often emphasized soft, oval shapes; some surrealistic figures have discreet sexual undertones.

No other Norwegian photographer has approached Riise in his striking combination of cubist and surrealist qualities, and in the international sphere, there are few analogies. The Czechoslovakian photographer Jaroslav Rössler retouched the light and shadow in one portrait to accentuate its sculptural volume, a bromoil photograph reproduced in the catalogue of

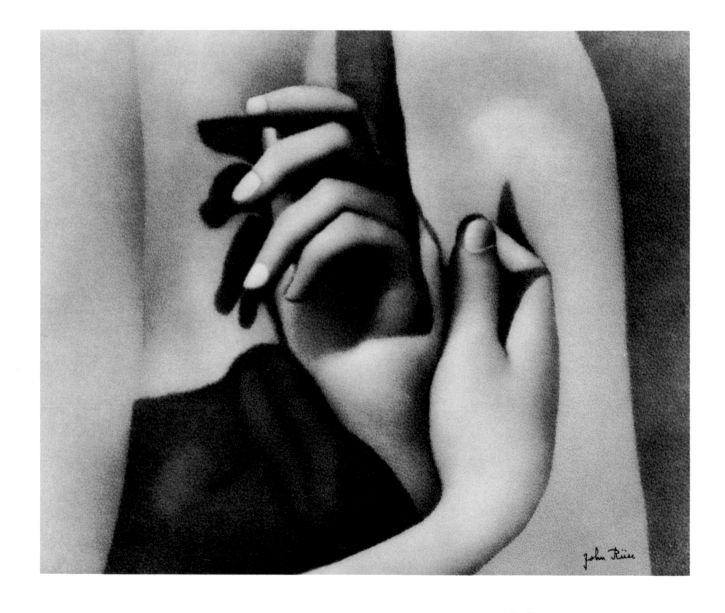

the 1924 Paris Salon. But he did not continue working along these lines. Whether or not Riise's photographs are unique in their mixture of photography and abstract painting—as present research indicates they are—they can be admired now as they were by a French writer in 1927 for their soft, even lighting, their sober tonalities, their simple compositions and their "completely Athenian grace."

In 1932 Riise stopped making art photography and left Oslo. In spite of a supposed steady clientele, including the actors and actresses of the Oslo New Theatre which was in the same building as his studio, his customers were actually few. At last he closed his doors and returned to his birthplace, where he lived quietly for the next 20 years, doing virtually nothing as a photographer.

In 1953 a member of the Oslo Camera Club chanced to see a selection of Riise's photographs and so organized an exhibition. Further large exhibitions followed, and in 1955 they included increasingly abstract, hand-colored photographs from nature. Riise had added paint to a few of his photographs in his 1921–32 period, but this was now an important technique for him. In addition, he began to use his old negatives as the basis for new works in the form of multiple printings, and he also colored over these with chalks or oils, using a wad of cotton-wool or a brush. As many as five different negatives might make a single work, and he often emphasized new forms that arose from the syntheses with color retouching. Of course this makes it difficult to date his pictures: some of the negatives may have originated in the 1920s; others may have been taken in the 1950s and he may have given the picture its final coloring and form as late as the 1960s. The dates Riise provided indicate the completion of his work on a print. He was highly secretive about technical matters, and he disliked discussing art. With dry humor he once declared: "I call my pictures objective art, since I use an 'objective'"—a pun on the Norwegian word for a camera lens.

In 1960, at age 75, Riise took up painting and almost abandoned photography completely; he exhibited his canvases on six occasions in Norway to considerable acclaim. He regarded himself as a somewhat naive abstractionist and a surrealist. He died at age 92, having won international acceptance as both a photographer and a painter.

For biographical notes on Robert Meyer, see the conclusion of his essay on Knud Knudsen. (Translation by J.R. Christophersen.)

Wladimir Schohin: An Early Color Master

Bert Carpelan

Wladimir Schohin
Mrs. Nadesha Schohin ca. 1907
modern Cibachrome print
from original autochrome
9⅞ x 6¾
25.1 x 17.1
Collection Amatörfotografklubben,
Helsinki

At the turn of the century, when Finland was a Russian Grand Duchy, there was a Russian general store in the vicinity of Market Square in Helsinki. After market hours the peasants tied their horses in the courtyard and went to the store to buy tobacco, felt slippers, vodka and other Russian specialties. The store was owned by the Schohin brothers: one brother stood behind the counter, the other, Wladimir, preferred spending his time on the most refined hobby of that epoch—he was a photographer, and went for long, lonely walks in the countryside in search of subjects for his camera. It was a 9 x 12 cm. plate apparatus with a tripod which he carried on his shoulder.

Wladimir Schohin was born in Helsinki on 17 December 1862. It is not known to what extent he had devoted himself to art as a youth, but when in 1899 he became a member of the Amateur Photographers' Club of Helsinki, he was already an excellent amateur photographer. The club had been founded in 1889 by Hugo af Schultén, a well-known personality in the world of culture, secretary of the Finnish Art Society, and editor of the daily newspaper *Nya Pressen*. Attempting to rival a photo club just founded in Stockholm, he announced in the newspaper the formation of a comparable club in Helsinki and became its first chairman. Its purpose and philosophy were to "arouse an interest in the art of photography and to work for its growth and development in Finland." From 26 founding members, the club had grown to 100 by 1895. Despite its name, it made no distinction between professional and amateur photographers. There were commercial camera operators, engineers, teachers and army officers; most members were academically educated. From 1889 to the present the club has existed without interruption, with the same purpose and policies and the same teamwork between amateurs and professionals.

When Schohin joined the club in 1899, the professional photographer and camera dealer Daniel Nyblin was its chairman. This Norwegian-born photographer, who had opened the first photography shop in Finland in 1890, arranged courses and lectures, wrote articles and reviews and thus initiated club members into the mysteries of the photographic art. The program for club meetings consisted then, as today, of lectures, slide presentations and photography competitions. After only a year, Schohin's name appears among the prize winners in the competition records.

Under Nyblin's guidance, Schohin became a master in the making of photographs using the period's so-called interpretive procedures—bromoil, carbon and gum. These were time-consuming processes, requiring a great deal of patience: the production of a single picture could take a whole day. But this appealed to Schohin, to his sense of artistic perfectionism; he enjoyed being able to manipulate his prints to suit his own aesthetics.

The results were exhibited in 1907, in the second photographic exhibition at the Ateneum Art Museum in Helsinki. In Nyblin's

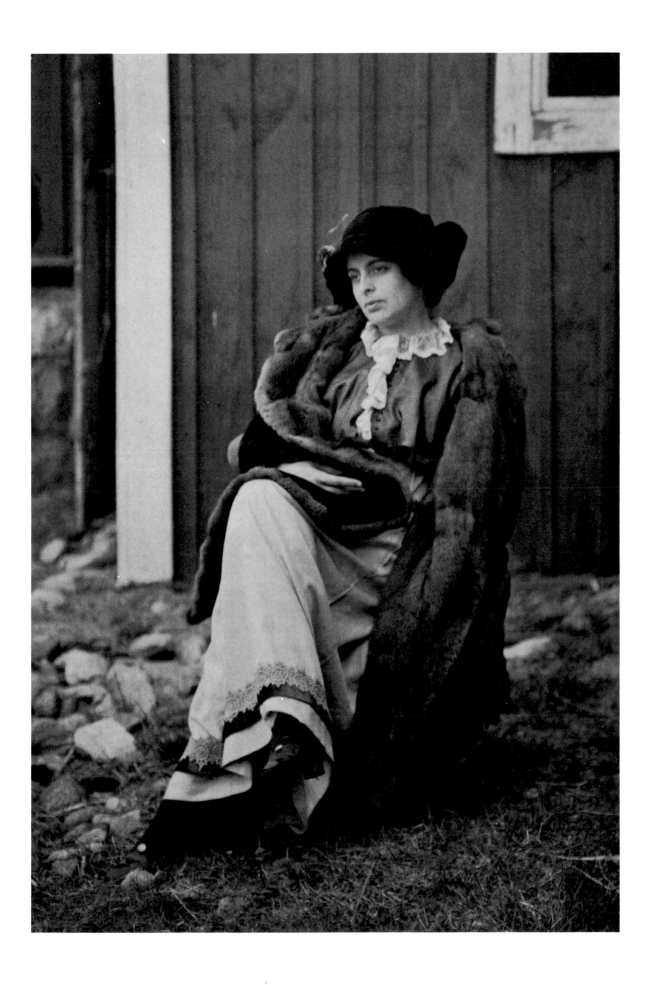

review in his photography journal, *Nyblin's Magazine*, the photographer struggled to find enough superlatives: "Wladimir Schohin presents a collection consisting of the most exquisite small pictures anyone could think of, some in gum print, others in carbon print. What forms, what melodies! Everything is perfect, harmonious, homogeneous. The first prize to Mr. Schohin is really not enough. He deserves still more."

At this exhibition, color slides were projected for the first time, slides made with the new autochrome plates invented by the Lumière brothers in Lyon that same year. Nyblin had ordered the plates from the Lumières and had taken the slides. Subsequently, many of the members of the Amateur Photographers' Club experimented occasionally at making autochromes. But they soon lost interest: the plates were relatively expensive, the development seemed somewhat difficult in this new era of the Kodak and the exposure time through yellow filters was hard to estimate and slow, demanding half a second at f:6 in full sunlight. Portraits in the studio took 20 seconds. This was too long for a professional photographer, and because the slides could not be copied or reprinted, the method was judged to have little commercial utility.

Autochrome plates remained curiosities—for everyone except Schohin. He had the money, time and interest to explore the new technique, and through it he discovered a new means of expressing himself. Color! His sense of form, material, light and harmony of hues was at its best in still-life compositions. Like pictorialist photographs of that time, his color pictures were influenced by contemporary painting, perhaps most by Impressionism. The works of the French painters and their followers, as well as the photographs reproduced in international magazines and books, were studied and analyzed with great care at the meetings of the club. As its librarian and supply supervisor, positions he held for a record time of 30 years, Schohin became knowledgeable about art photography worldwide. During club meetings, Schohin's color pictures were admired and projected with a magic lantern that had been imported from America. In color he had no rivals and few in manipulative printing: a trophy that he donated for a competition in the use of interpretive procedures remained for a long time unawarded until it was decided that the donor could also compete for it.

After Schohin's death in 1934 the club bought his collection of 100 or so 9 x 12 cm. glass plates. This collection of color slides is the most extensive in Finland. (The club archives also include almost 3,000 negatives, slides and original photographs taken by club members from 1889 onward.) In addition to Schohin's color slides, the archives include a number of black and white slides that Schohin made of his family and of club outings to his summer residence in the archipelago outside Helsinki. These black and white pictures are spontaneous and engaging, while his landscapes are carefully composed studies of form and light.

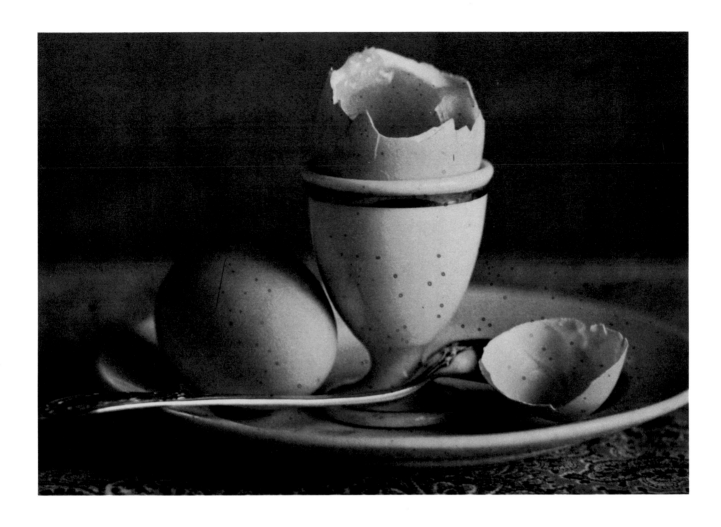

As opposed to his vibrant black and white pictures of people, the formal character of Schohin's color portraits seems to reflect the limited light sensitivity of the photographic material. For his still-life pictures, he arranged compositions and illumination with mastery, and it seems probable that he also succeeded in influencing the autochrome color by using different tinted filters. It is as a color photographer that Schohin occupies his undisputed place in Finnish photographic history, not only because he was the first and only major color photographer of that time in Finland, but also because his work is of extraordinary quality.

Bert Carpelan, editor of the photography magazine Kameralehti *and photography critic for the newspaper* Hufvudstadsbladet, *is also an author (*80 år amatörfotografi, *1969, and* Knäpp bättre bilder *[Take Better Pictures], 1970). In addition, he is a photojournalist and a curator of photography exhibitions. (Translation by Gunilla Carlander-Reuterfelt.)*

Wladimir Schohin
Still life ca. 1907
modern Cibachrome print
from original autochrome
6¾ x 9⅞
17.1 x 25.1
Collection Amatörfotografklubben,
Helsinki

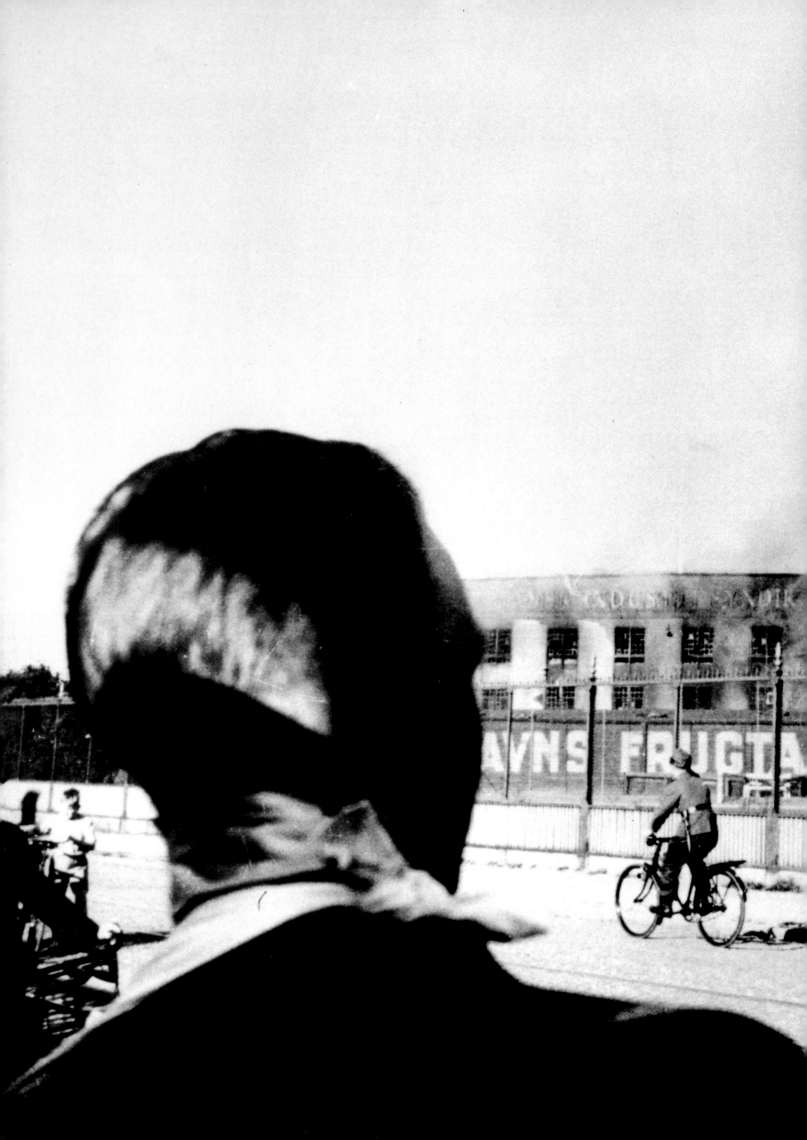

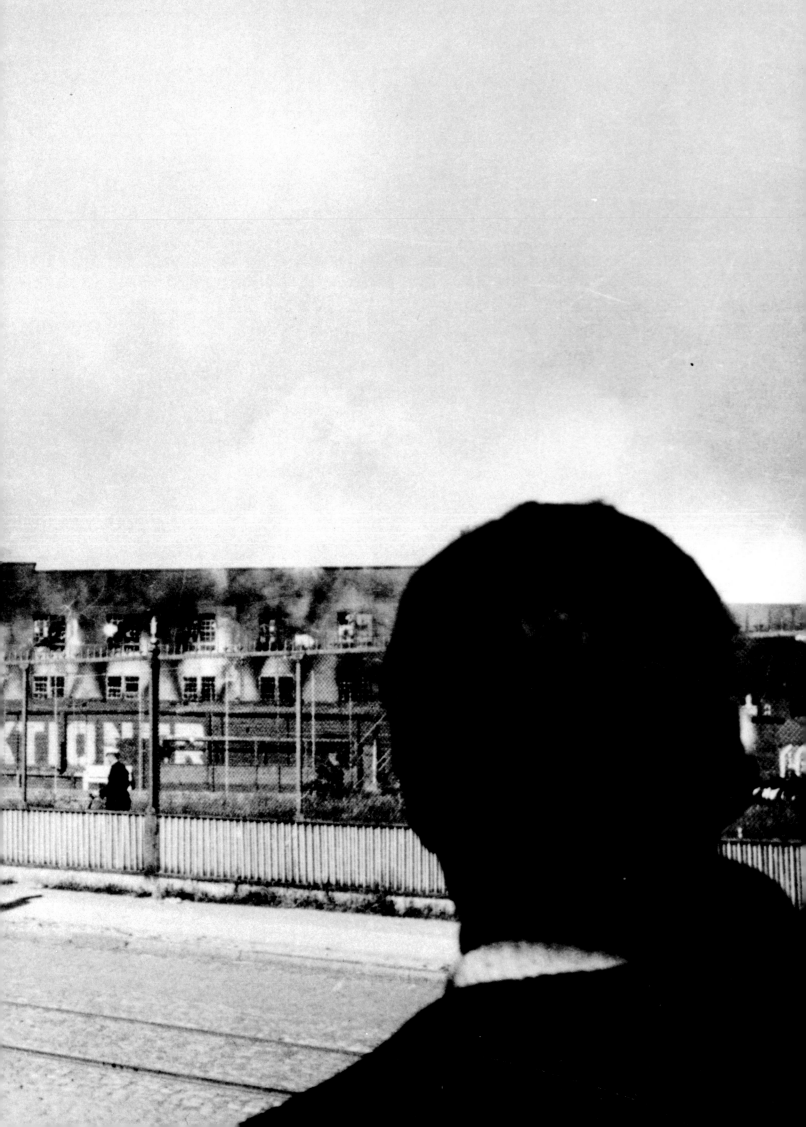

The Event

MF

At what point does an ordinary situation become an event? Presumably, the term event implies some definite action, quiet or sudden. An event has narrative character. These are vague definitions, perhaps, but useful ones to describe a genre of photography that appeared early in the century, brought into existence by such inventions as smaller cameras and faster film, and that reached its apogee in the instantaneous image associated with photojournalism. The "classical" event photograph, an example of richly descriptive reportage, became a staple in Sweden, as Rune Hassner points out, directly after World War II, with newly established general interest magazines as its forum. These publications profusely illustrated worldwide political events, sports, personalities and other newsworthy topics, and a daring new generation of photographers supplied a vast range of material, from stark battlefield coverage that often involved great personal risk to intimate descriptions of the life styles of virtually unknown aborigines in exotic locales. In Scandinavia, as elsewhere, such lavishly illustrated periodicals and news-paper supplements had a heyday, only to be superseded in the early 1960s by the even more instantaneous coverage that live television could offer.

From the evolution of event photography in Scandinavia comes a record of such history-making moments, for example, as a 1920 railway workers' strike, recorded by an anonymous Norwegian photographer with an eye for the heroic crowd scene. Standing at the rear of a gathering of people who are being exhorted by the orator, the photographer captures the tension of the occasion entirely through the dense crowd's reaction. This great sea of people, all but a few of whom face the speaker, completely fills the picture—a motionless form, ready to be activated.

Another early photojournalistic theme with an element of theatrics was the sports event. Today, the 1930s stadium dramas of the Swedish photographer Karl Sandels have a faintly archaic look, owing not only to the quaint, baggy uniforms of the runners and soccer heroes, but also to the strangely static organization of these pictures. Though records of action-filled events, they are also frozen moments in which speeding runners and leaping soccer players are suspended in mid-air. In a 1931 Olympics photograph Sandels caught an all-over pattern of white hurdles: against this pattern the runners resemble notes on a musical staff and the individual athletes are wholly subordinate to the photograph's rhythmic scheme. In all Sandels's pictures we perceive a decidedly personal effort to reconcile the need to record instant high-energy activities on film with a desire to exploit the unique compositional opportunities they afford.

With the advent of World War II, a grim new category of reportage appeared, one that still retains strong emotional associations for most Scandinavians. In the period when Nazi armies occupied Denmark and Norway, many photographs were furtively taken of conditions and events by members of the public, resistance fighters and concentration camp prisoners.

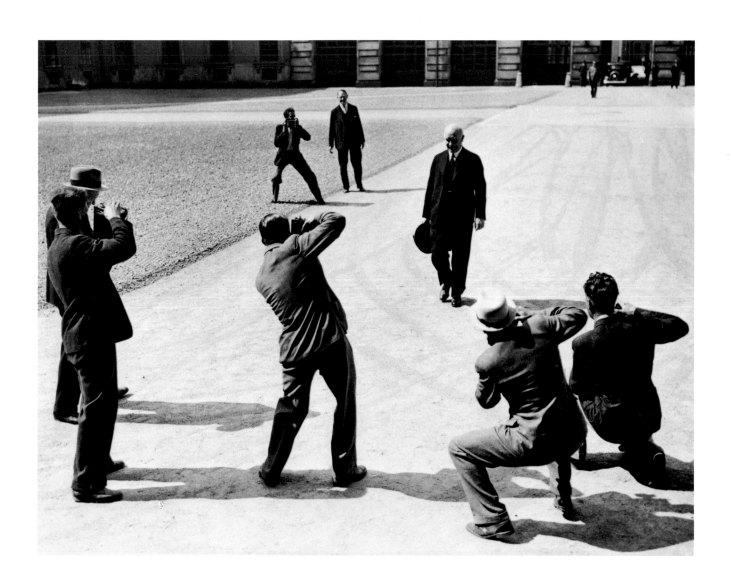

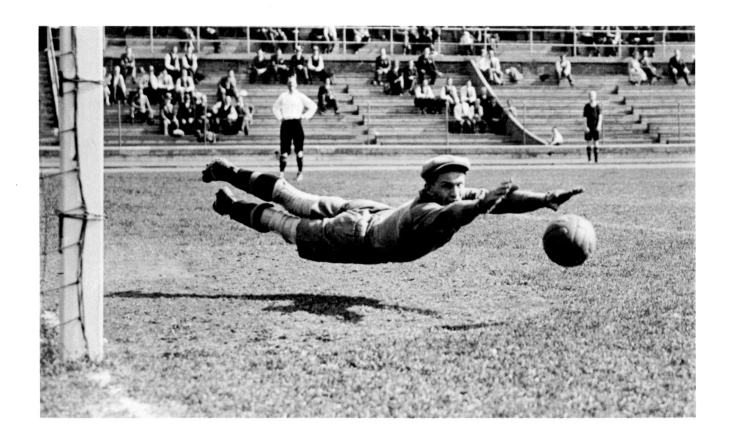

Karl Sandels
Goalie, Olympic Stadium, Stockholm
1934
gelatin silver print
6¾ x 11⅝
17.1 x 29.5
Collection Fotografiska Museet, Stockholm

Today in the Museet for Danmarks Frihedskamp (Copenhagen's Museum for Denmark's Fight for Freedom, 1940–45), harrowing visual documentation of this dark time is to be found. The photographers, practically all of whom are anonymous, were determined to leave records of what they witnessed—and what a legacy it is. Accusing descriptions of misery endured by the citizenry, images of unspeakable atrocities and of acts of heroism by the Resistance are all here. Often poorly focused and grainy— for they were shot under the most difficult conditions—these photographs nevertheless communicate intense feeling as well as information, and some that were later reproduced in newspapers and magazines have entered the public consciousness as icons of that fateful time. In an especially haunting sequence of photographs, printed from a 1944 film secretly made from a cellar window, a Danish Nazi assaults a civilian, beating him to the ground. This lethal, uneven combat of shadowy forms is all too evocative of the demons that inhabit Goya's "Disasters of War."

Working in the photojournalist tradition, the late Hans Malmberg had a successful career that took him well beyond Sweden to cover dramatic events in America, Europe and Vietnam. Less known are his street photographs of ordinary people who appear mysteriously preoccupied. These reveal Malmberg's amazing eye for the unlikely situation and his taste for the incongruities of life, which he offers with such offhandedness that we often have to look twice to appreciate his black humor. Take the picture of an individual of indeterminate sex seated on a park bench. So straightforward is Malmberg's composition that the figure's surreal dress—a fireman's hat with net, sunglasses, coat and gloves—seems nothing out of the ordinary. Then there is the unconventional theme of ladies' mud-wrestling. In his 1953 photograph the serious, topless combatants are graceful participants in a ludicrous, kinky ballet. And in another Malmberg picture—which resembles a still from a Buñuel film sequence—a car has caught fire and while one man attempts to extinguish the blaze, the others are prostrate before the conflagration. So beautifully printed and formally structured is this photograph that it transcends photojournalism and achieves an effect combining menace and wit. Who are these men? Escapees, terrorists or just hapless drivers? Malmberg offers no answer; he presents only an enigma.

For an obsession with the outlandish, however, it would be difficult to equal Christer Strömholm's special vision. One of the most international figures on the Scandinavian photography scene, Strömholm is a one-man counterculture. Temperamentally, his work is allied to that of such photographers as Brassaï, whose taste for the *bas fond* he more than shared. Equally, his fascination with menacing and freakish themes relates to that in the hypnotic images of Diane Arbus. A sour sensationalism underlies much of his subject matter.

In Strömholm's social commentary, carnival snake handlers, transvestites and veiled harridans gaze coolly into his lens, with a hint of some secret knowledge that might contaminate us if we shared it. Children wearing evil-looking masks; actors in the process of applying makeup staring raptly at their macabre reflections; a spotted serpent whose jaws are tightly bound with knotted rope—these are the personae of Strömholm's little nightmares. Perhaps motivated by a disaffection with subject matter traditionally considered acceptable, and the middle-class mentality it represents, he offers us a spectrum of disquieting visions that invite us to ponder the dark side of reality. The simple event, in Strömholm's manipulations, has the portent of a morality play.

Hans Malmberg, Swedish Photojournalist

Rune Hassner

Sweden was neutral during World War II and cut off from the rest of Europe. The generation that grew up during those years had only read about the conflict and heard news on the radio: after the armistice it seemed an urgent task simply to *see* and to understand. To young photographers it also seemed crucial to try to portray the new world that was to be built on the ruins. With these concerns, Hans Malmberg and others showed their work in the first *Young Photographers* exhibition in Stockholm in 1949.

Some of the group specialized in fashion and advertising photography; others were photojournalists. All studied the great picture magazines *Life*, *Look*, the *Picture Post* and *Paris-Match*, born in 1949, plus the work of Richard Avedon, Irving Penn and Erwin Blumenfeld. The language the young photographers evolved was modern and realistic; it consciously countered the painting-inspired aestheticism and romanticism of the amateur photography magazines, the soft-focus nudes and dreamy landscapes that had dominated Swedish art photography from the turn of the century. The *Young Photographers* 1949 show contained only straight photographs, black and white glossy prints, many of them with hard contrasts and graphic patterns.

Malmberg was a member of the group and by the end of the 1950s he was recognized as one of Sweden's leading photojournalists. He had studied in the photography department, founded in the 1940s, of Stockholm's Stads Yrkesskolor (Municipal Vocational School), learned the trade at a photo agency in the capital and started a photo agency of his own with his colleague Sven Gillsäter. Malmberg's picture stories first appeared in *Se*, a sort of Swedish *Picture Post*, and included essays he had made in England and the United States. When the "young photographers" exhibited together in Paris in 1951, Malmberg's coverage of the Korean War attracted great attention. In these years, he published several books of photographs, including *Fädernas kyrka* (Church of Our Fathers, 1950), *Island* (Iceland, 1951) and *Dalälven* (The River Dal, 1957). In 1958 he and nine of his colleagues formed Tio Fotografer (Ten Photographers), a free-lance photographers' cooperative modeled on Magnum. (Today there are eight members.)

During the 1960s Malmberg contributed major photo essays to *Vi*, the Swedish weekly—most notably reports from Vietnam and Laos in 1968. His technique was very simple: he worked with 35 mm. film and made unmanipulated prints. The only exception was a traveling mat system for superimposed images that he developed to take stills for the film, *The Wonderful Journey of Nils Holgersson*, based on the Selma Lagerlöf tale of a young boy who flies through Sweden on the back of a wild goose. The stills became a book.

In 1975 Malmberg assembled his best pictures from his over 25 years of photojournalism for his first solo show. Held at the Fotografiska Museet in Stockholm, the retrospective included numerous works that magazine editors had excluded from his

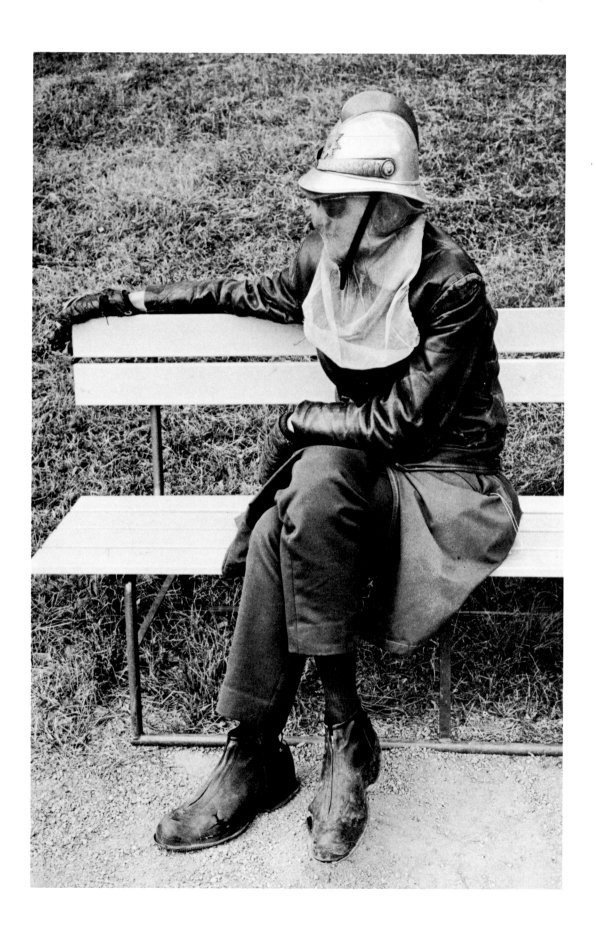

photo essays or relegated to a minor place. Unfettered by the values and priorities of his various clients, Malmberg here appeared for the first time as an artist with a distinct profile. He presented his photographs in small format and identical size and hung them in double rows. It was as if he were testing their impact without the support of dynamic layouts, headlines in bold type or dramatic texts. What had often been lost in magazine reproduction was now exquisitely apparent: the subtle and ambiguous images were meticulously printed, with a subdued and finely graduated scale of gray. It was also apparent that for many years Malmberg had been taking other pictures while he was on assignment, personal commentaries alongside his straightforward factual reports, nuanced observations with something of the spirit of Tony Ray-Jones or Elliott Erwitt. The photographs in the exhibition caught small gestures, coincidental meetings, moments that were insignificant in the theater of world events but that resonated with a sly and sometimes dark humor.

The view of society reflected in Malmberg's 1975 show had evolved during his worldwide travels for the picture press. Reality had often brutally confronted him; the promise of a peaceful postwar era had soon been denied, while the special problems of the Swedish welfare state had become obvious. Although he embraced a socialist view of society, Malmberg was not a crusader with a camera. He portrayed those living in the inhospitable environment of the big city, the rejects of society, the poverty-stricken, but he was careful to avoid any propagandist messages. Instead, his works show the photographer's respect for individuals and his clearly marked sense of solidarity with them. This never lapses into emotionalism and is never intrusive. Here are human relations described quickly, with wit and affection. The sober compositions and technical perfection of Malmberg's pictures initially suggest calm and balance. But there are tensions beneath the surface that give many of his pictures a strange life. This experienced professional photographer kept his own vulnerability and hypersensitivity under strict control while he was at work. He made high demands on himself as a graphic artist and constantly struggled to express the elusive experience of the tensions between an inner and an outer reality. His 1975 exhibition was the last occasion on which he himself was able to sum up his life's work as a photographer. He died two years later.

Rune Hassner, a photographer, filmmaker, writer and teacher, was a founding member of Tio Fotografer. He studied photography with Rolf Winquist in Stockholm and published Bilder for miljoner *(Images for the Millions), a history of the picture press in 1977. In 1973 he was a guest professor at the University of Minnesota. (Translation by Keith Bradfield.)*

Hans Malmberg
On Highway One 1954
gelatin silver print
6¾ x 10¼
17.1 x 26
Collection Fotografiska Museet, Stockholm

Hans Malmberg
Mud Wrestlers, Hamburg 1953
gelatin silver print
6½ x 10¼
16.5 x 26
Collection Fotografiska Museet, Stockholm

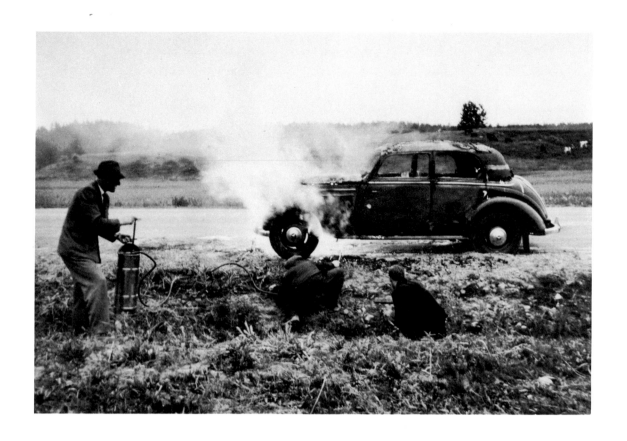

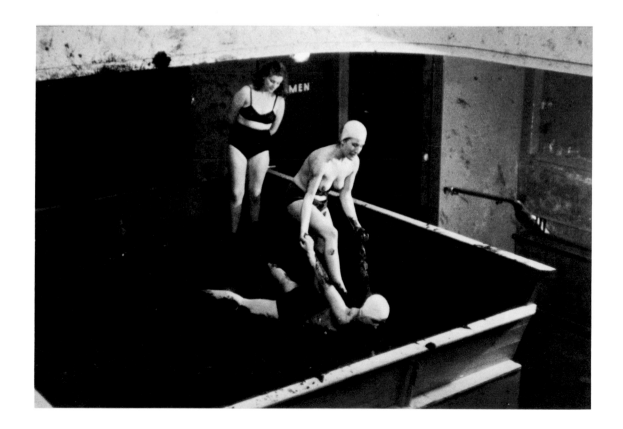

Christer Strömholm: Images of the Dispossessed

Allan Porter

Christer Strömholm
Barcelona 1960
gelatin silver print
11¼ x 9
28.6 x 22.9
Courtesy Camera Obscura, Stockholm

Christer Strömholm grew up between the wars and participated in World War II as a volunteer partisan. Like so many Europeans, he became a member of a second "lost generation," an experience that would indelibly mark his photography, which he began quite late, after he was 30 years of age.

He was born in Sweden in 1918 to a conservative, bourgeois family, whose fortune vanished in the economic crash of the early 1930s. His father, an army officer, committed suicide after an accident in 1934. Soon after, the teenaged Strömholm went to sea, escaping the spiritual claustrophobia and growing Fascism of his school environment. By the end of the decade he had lived and studied languages in Berlin, Dresden, Paris and Rome. The rise of Hitler mobilized him. Before he was 20 he served as a courier for the Loyalists in the Spanish Civil War. During the German occupation of Norway and Denmark, he was part of the Norwegian underground in Stockholm, and after the war he was decorated for his service.

In 1946 Strömholm returned to Paris and a number of aimless years passed—his existentialist years. But at the end of the 1940s in Paris he studied graphic art and began to take photographs. This was a turning point. Otto Steinert made him a member of his Fotoform group, a European association of photographers who were extending the formalist principles of the Bauhaus in their work. Some of Strömholm's photographs were published in Steinert's *Subjective Photography* and in *Art of Today*, a special photo magazine, both published in 1952. His pictures were typical of their time: studies of wall surfaces and abstract compositions in dark and light patterns. Strömholm was influenced by contemporary artists such as Daniel Spoerri, Bernard Dufour and Jean Tinguely, and he soon came in contact with leaders of the Parisian art and literary world, whom he photographed.

Quickly, however, Strömholm's photographs began to diverge from the clinical type promoted by the Fotoform group, and he was not included in the second volume of *Subjective Photography*. He was seeking a new kind of photography, one that would reveal relationships between people. He decided to live for a period of time with his subjects so that they would learn to ignore his camera and to accept him. In this way he believed that he would win their confidence and assure that he was not exploiting their condition. This would later become a cornerstone of his teaching. At the end of the 1950s, Strömholm encountered the transvestites who haunted the Place Blanche. He was struck by their position as the most rejected and isolated of all members of society and he began to photograph them. Over subsequent years he followed their lives and became deeply engaged in their social and medical problems. By the 1970s transvestites had become a rather common cliché in photography, but this was long after Strömholm had exhibited his pictures of them in Stockholm in 1965, in his first one-man show.

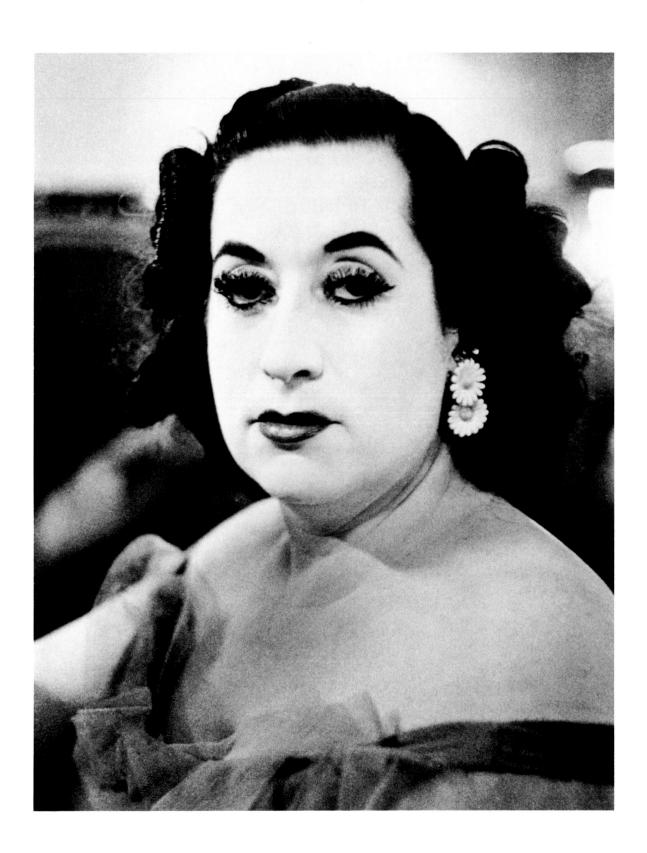

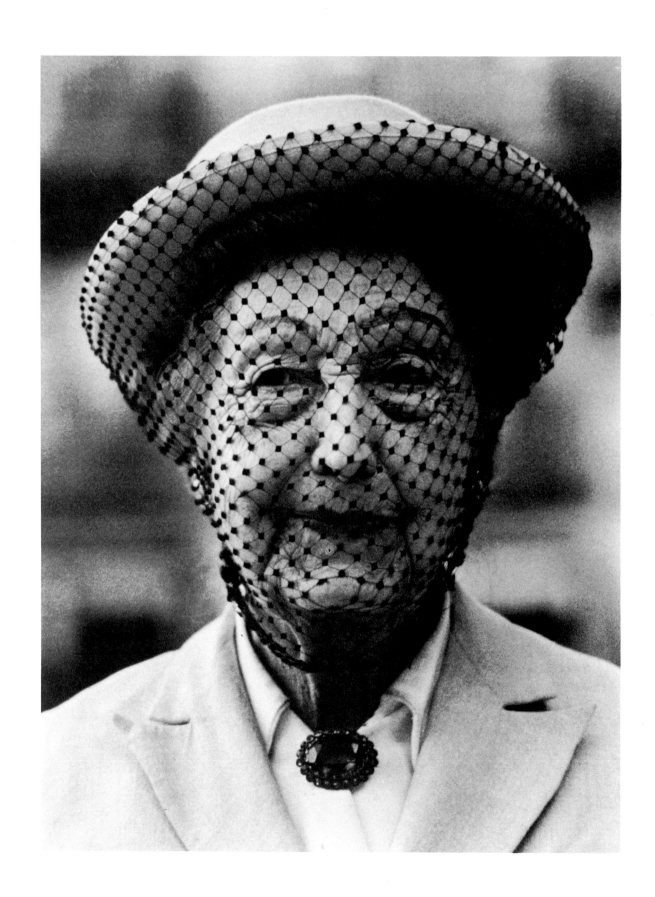

Strömholm's existentialist years ended in 1956 when he returned to Stockholm. He made 16-mm. films with the writer Peter Weiss and began teaching evening courses in photography. Eventually the evening school grew into a three-year institution with Strömholm as director. This was the legendary Fotoskolen, which operated from 1962 to 1972. Here 1,250 students trained; many are now important photographers working across Europe. Some of Strömholm's teaching ideas derived from Steinert, some from his own study: group critiques of a student's photography and projects executed by several students working together were important. The goal of the school was to encourage a personal, expressive photography.

During these years Strömholm made a large part of his own pictures while traveling: to Los Angeles (1960), Japan (1961 and 1963), India (1963), Kenya (1963) and New York (1965). Later he traveled and photographed in Poland, the Soviet Union and East Germany. He exhibited his work in 1965 and 1966 and the latter year published his first book of photographs. After the closing of the Fotoskolen, he returned to Paris, where he lived relatively quietly for a while. This quiet was broken in 1978 by a large retrospective exhibition at the Camera Obscura Gallery in Stockholm, which gained considerable recognition and was widely circulated in Sweden, Norway and Finland. It was followed by his exhibition of 20 unpublished pictures of the child victims of Hiroshima. Strömholm was awarded a national artist grant, a prize from the photography magazine *Foto* and in 1980 a lifetime grant from the Swedish state.

For over ten years Strömholm has been preparing a book on the transvestites of the Place Blanche, a project that he is currently expanding to include images of the surrounding boulevards. Paris cafés seem to be his natural habitat, and he returns nearly every night, taking picture after picture at the tables under the awnings where he meets his friends.

Allan Porter is an editor who lives in Lucerne. He edited the photography magazine Camera, *which until its demise in 1980 was significant in publishing Scandinavian photography for an international audience. His essay is adapted from* Camera, September 1980.

Christer Strömholm
Madrid 1962
gelatin silver print
10⅜ x 8
26.4 x 20.3
Courtesy Camera Obscura, Stockholm

137

Photography of the Danish Resistance

Knud Nellemose

On 9 April 1940 Hitler's troops invaded Denmark and Norway. Denmark's token resistance ended after a few hours of fighting. The government and the king urgently exhorted the Danish people not to resist the Wehrmacht, since it came purportedly to protect Denmark against an attack from England. For the most part, the Danes took a calm, indifferent attitude toward these events. However, a more politically aware circle had propagandized in writing and in speeches against Nazism and Fascism ever since Hitler's rise to power. Many of these people, and of course Denmark's Jewish citizens, believed they were threatened. From this group came one of the most effective Resistance movements of the war and with it a striking body of photographs documenting the activities of the Danish underground.

Denmark had a small Nazi party which, with German support, tried to gain influence and even to unseat the government. In addition, the Germans tried to pressure Danish authorities into giving the occupying power more help, and in 1941 when Hitler made his Anti-Comintern Pact (the Berlin-Rome-Tokyo Axis), Denmark was forced to enter into it. When the Communist Party was outlawed, a large, threatening group gathered before the residence of the German commander-in-chief at Copenhagen's Hotel d'Angleterre, and had to be disbanded by the Danish police, while German soldiers shot over the heads of the crowd. This was the first mass, spontaneous expression of Denmark's will to resist, which in the next few years was to grow into major acts of sabotage against the Wehrmacht.

Also in 1941 illegal newspapers began to circulate in a propaganda campaign that was of great importance for the growing Resistance movement. The weapons and explosives parachuted in by the English made Danish railroad sabotage a powerful weapon against German transports to and from Norway. Resistance grew, even though the number of participants was small. By 29 August 1943, underground activities had become so destructive that the Germans declared a state of martial law throughout the country and disbanded Danish military units. The government resigned when the Germans demanded that Danish saboteurs be tried under German law. In the autumn of 1943, the so-called Freedom Council was created in the government, with all underground organizations represented: now Danes had a government they could trust. General strikes in 1943 and 1944 led to open resistance and to serious fighting in the cities; a week-long strike in 1944 resulted in 100 Danes killed, 600 wounded. Saboteurs from Holger Danske and the BOPA Resistance groups carried out major attacks, most dramatically against the Globus plant and the Riffelsyndikatet rifle factory in the Free Port of Copenhagen, depriving the Germans of important spare parts for their war machine. Railroad sabotage also increased; by 1944 Denmark was unofficially in a state of war. In order to combat attacks on the railroads, the S.S. and its top policymakers ordered trains carrying members of the Wehrmacht also to carry captured Danish saboteurs.

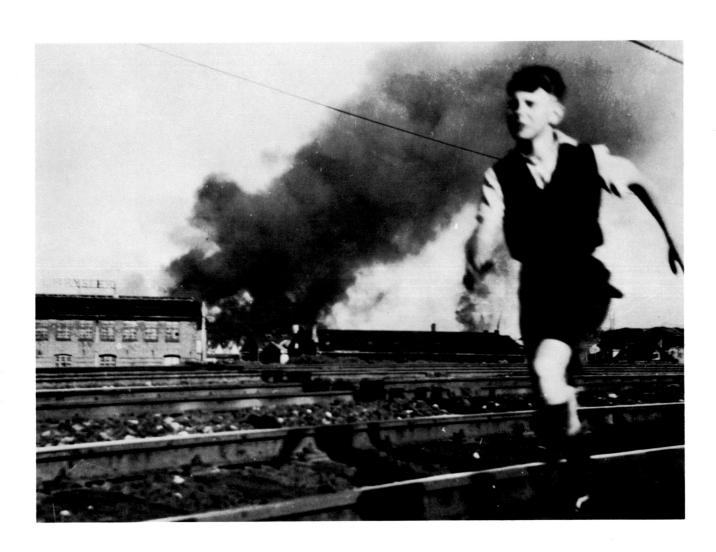

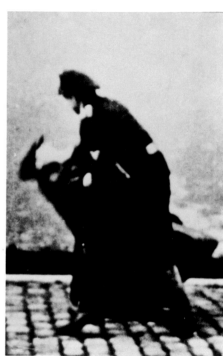

Unknown photographer
Danish collaborationist assaults a loyal
Danish citizen (photographed secretly from
a cellar window) 1944
modern gelatin silver prints
from original movie film
7 x 5 each
17.8 x 12.7
Collection Museet for Danmarks
Frihedskamp, Copenhagen

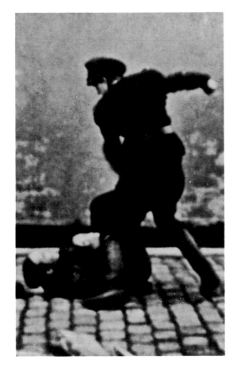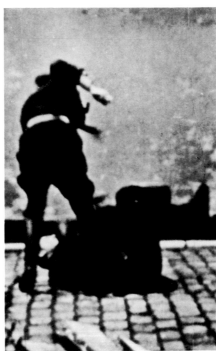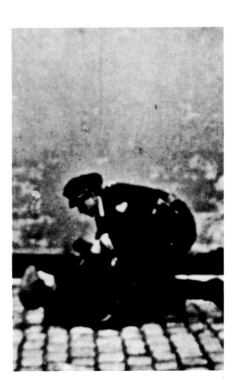

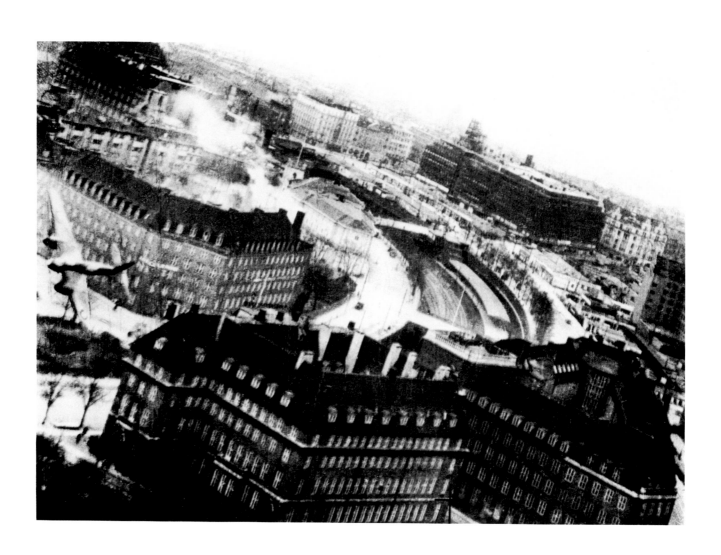

Photographers and often movie cameramen were present after many sabotage attacks. Very fine documentary material of this highly dangerous work was made for circulation abroad, to prove to the allies that Denmark was not Germany's collaborator. Nazi-run terrorist activities, in which Danish traitors participated, were also documented. In the last years of the war, Danes—among them members of the voluntary Frikorps Danmark —served in a special Nordic company that fought on the eastern front against the Russians. Some of this regiment fought the Resistance, both as a military corps (Schalburg-Korpset) and as an auxiliary police force (Hilf Polizei or HIPO). They also worked as informers, handing over many of their countrymen to German executioners. The black-uniformed members of HIPO and German commando groups carried out terrorist acts—blowing up Tivoli, the Langelinje Pavilion (site of the Little Mermaid) and the East Asiatic Company—and they provoked the population wherever they could. On 9 April 1945, the anniversary of Denmark's occupation, a large crowd assembled in Copenhagen to commemorate the dead. During the ceremony, German cars drove through the crowd and opened fire. People were knocked down and kicked by HIPO men, some of whom were captured by underground groups and executed after a hearing.

In December 1943 the Danes founded an underground army, with members brought together from around the country. Weapons and ammunitions were brought in illegally from Sweden. It was planned that this invisible army would emerge when the Allies landed in Denmark or when the Germans capitulated. In 1945 the Germans managed to arrest the leaders and tortured them during interrogations. The makeup of the army and the names of its members were revealed. In order to prevent their capture, the Freedom Council asked the British Royal Air Force to bomb the Gestapo's Copenhagen headquarters, where the lists of those to be arrested were kept. The Nazis used this headquarters as a prison and, to prevent any attack from the air, had put all important Resistance members in cells on the top floor of the building. However, the English fliers were so well instructed that they were able to drop their bombs right into the middle of the structure. Only eight Danish prisoners were killed, while the rest escaped in the commotion. The Germans lost 74 men, 23 of them Danish HIPO members.

In 1945 General Eisenhower telegraphed, "Congratulations to Danish saboteurs" to Denmark's underground, and General Montgomery, during a post-liberation visit to the country, said, "The Danish Resistance movement was second to none." Throughout the occupation, in spite of the strict bans, Danish photographers from the press and the Resistance took documentary pictures.

Knud Nellemose, a sculptor born in Denmark, was a member of the Frit Danmark Resistance group. (Translation by Martha Gaber Abrahamsen.)

Unknown photographer
The Gestapo headquarters in Copenhagen being attacked by the RAF (photo taken from an English airplane) 1945
modern gelatin silver print
from original negative
8½ x 12
21.6 x 30.5
Collection Museet for Danmarks
Frihedskamp, Copenhagen

143

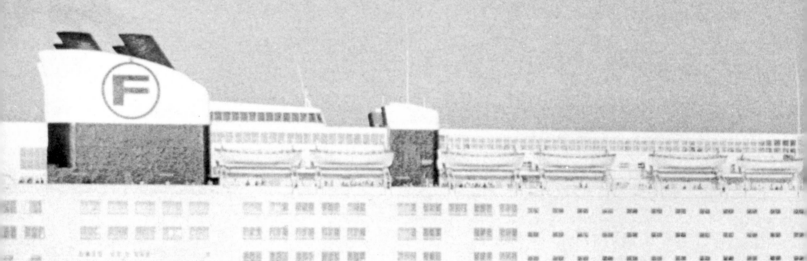

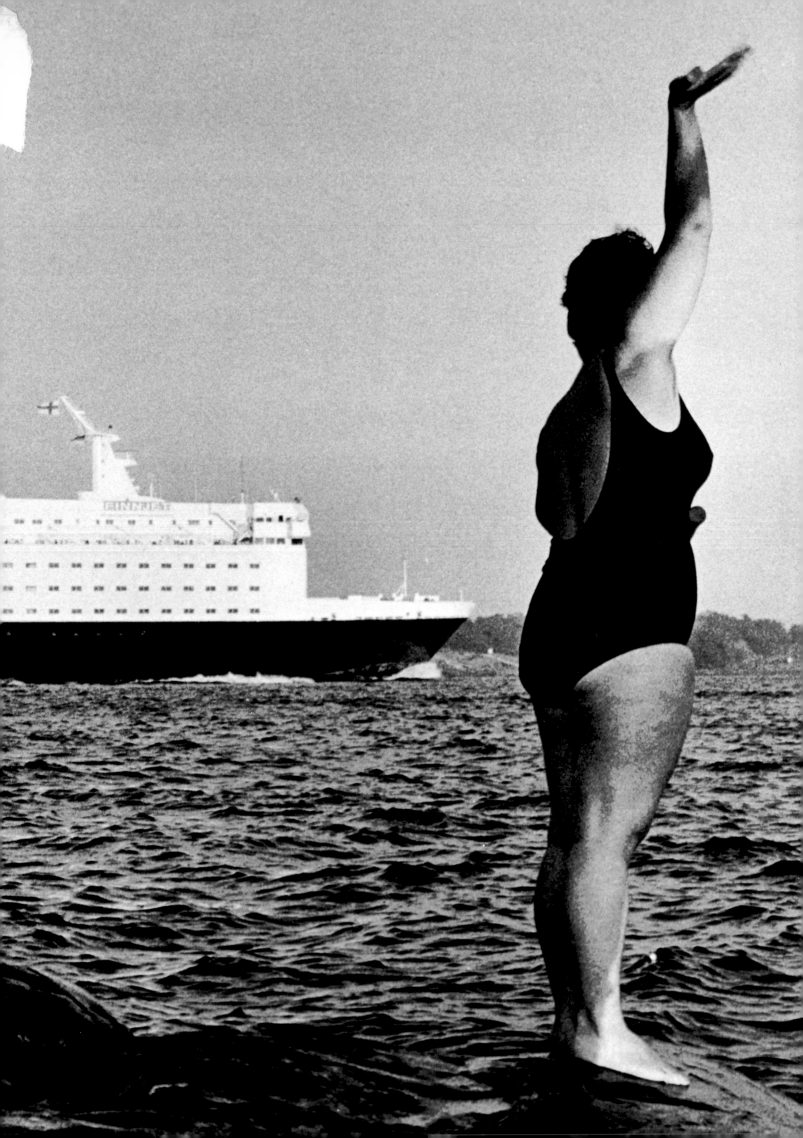

The New Generation

Lennart Durehed

(overleaf)
Timo Viljakainen
Untitled 1979
gelatin silver print
6¼ x 10⅛
15.9 x 25.7
Collection the artist, Helsinki

Bjorn Dawidsson (known as "Dawid")
Stockholm 1972
gelatin silver print
5 x 7½
12.7 x 19.1
Collection Fotografiska Museet, Stockholm

The years following the end of World War II witnessed the emergence of a new Scandinavian photography. To the end of the 1930s romantic pictorialism dominated the art, and landscapes with sun-gilded birch trees seen against puffy clouds were everywhere. But as national boundaries were reopened, new magazines and newspapers illustrated with photographs flowed into Scandinavia. And at the same time, several Scandinavian photographers began to travel and to come into contact with photographers in the major cities of the Continent, Great Britain and the United States. In Sweden a strong reaction against pictorial photography surfaced and stirred the establishment in 1949 with a group exhibition entitled *Young Photographers*. The rebellious youths in that show included Hans Malmberg and Rune Hassner (subject and author of essays in this book) and Hans Hammarskiöld, and their work showed their admiration for European and American photojournalism and their special affinity for the photo essays of Henri Cartier-Bresson and W. Eugene Smith. The exhibition originated in Stockholm and in 1950 traveled to New York.

In the late 1960s Scandinavian photography reflected the progressive political climate of Scandinavia and of the rest of the Western world. Young Scandinavian photographers felt that the camera should be used primarily as a political weapon, to identify injustice and aid in social reform. Simultaneously, a more straightforward, apolitical documentary photography appeared and was widely reproduced in books and magazines and exhibited in libraries and local centers. Without social comment, photographers recorded buildings, villages and their peoples simply to convey information. Sune Jonsson, for example, documented rural life in northern Sweden in a very pure and direct manner.

Many of the young Scandinavian photographers engaged in social documentation and political activism were stimulated by the work of the Swedish photojournalist Christer Strömholm, whose highly personal and revealing photographs demonstrated new possibilities for communicating with the camera. From 1962 to 1972 he ran a photography school that greatly influenced a new generation of photographers. Students were encouraged to feel personally responsible for a photograph and its message as well as for those photographed. Strömholm coupled humanism and photography: technique and commercial goals were of secondary importance. The school quickly earned a good reputation and attracted students from Norway, Finland and Denmark, as well as from many European countries.

Although Strömholm's own photographs are idiosyncratic, several of his students led the development of the brand of socially involved documentation that came to dominate Scandinavian photography during the 1970s. Young Swedish photographers traveled to other parts of the world, several dealing with living conditions in Third World countries. Their photojournalistic reports were featured in magazines and also exhibited. By the beginning of the 1970s these concerned

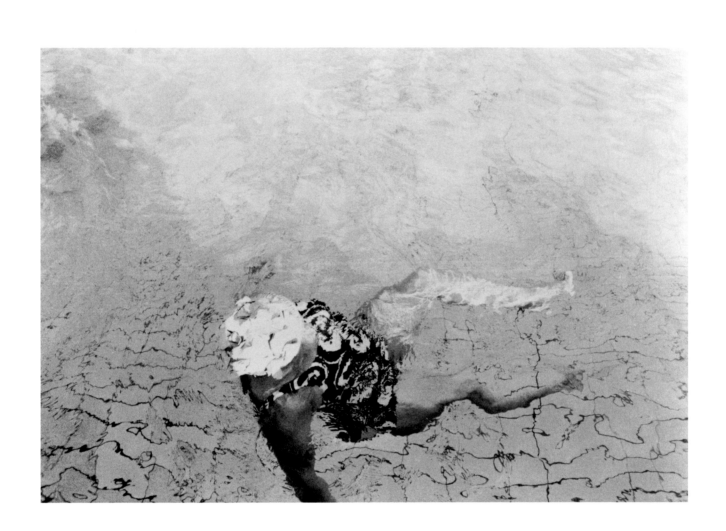

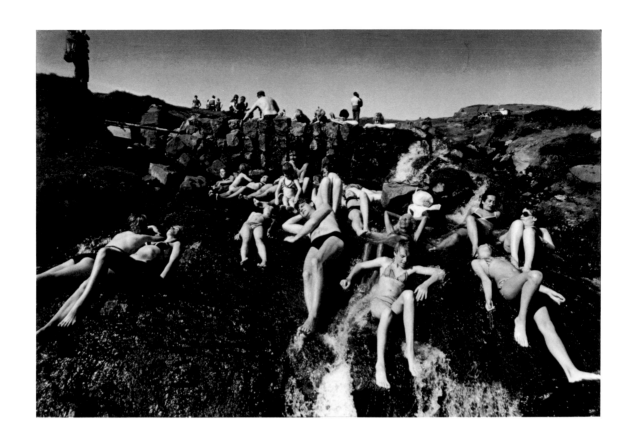

Einar Pétursson
Sunlovers 1980
gelatin silver print
8⅝ x 12¾
21.9 x 32.4
Collection the artist, Reykjavík

Gudmundur Ingólfsson
Erosion 1970
gelatin silver print
11¼ x 11¼
28.6 x 28.6
Collection the artist, Reykjavík

photographers began to focus on social problems at home. The housing crisis of the 1960s produced by the postwar baby boom had led to the construction of a record number of apartment buildings in large suburban areas, but the environment so rapidly built was often cold and impersonal. Several photographers devoted their energies to the documentation of the depressing aspects of these complexes. Another area of interest was the working conditions within large industries in Scandinavia, and investigative photographers increasingly visited mines and automobile factories. This concern was marked in Sweden and to a certain extent also in Finland and Denmark during the 1960s and 70s.

Social documentation never dominated photography in Norway to the extent that it did in Sweden and Finland, even though many ambitious photography students in Norway attended Strömholm's photography school in Stockholm during the late 1960s and early 1970s. Later in the 70s young Norwegian photographers turned to England for inspiration. Many studied photography there with such teacher-photographers as Paul Hill and John Blakemore, and traces of their influence are evident in much of the newer Norwegian photography. Exhibition possibilities are numerous in Norway and public interest is wide.

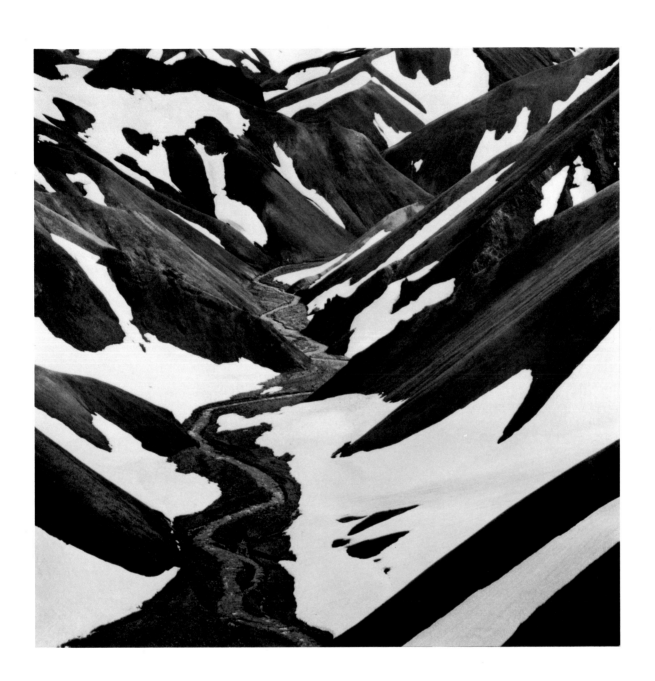

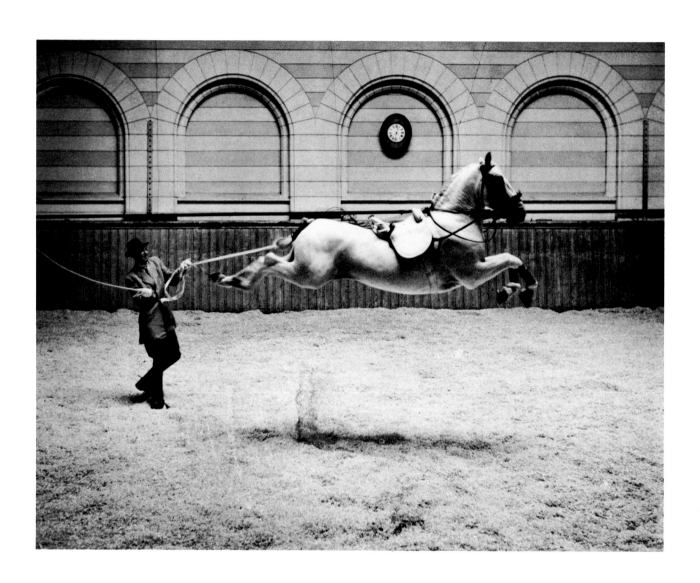

Hans Hammarskiöld
Spanish Riding School 1952
gelatin silver print
14¾ x 18⅞
37.5 x 48
Courtesy Camera Obscura, Stockholm

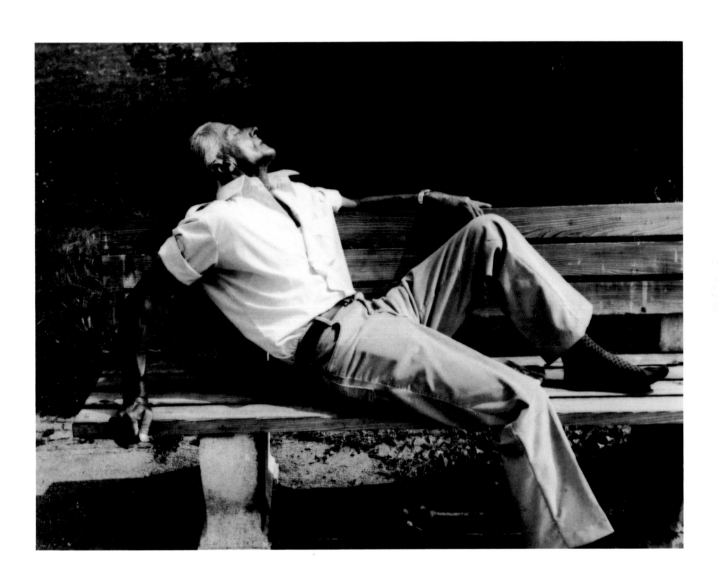

Otmar Thormann
Man on Bench from "Journeys in Austria"
1976
gelatin silver print
7 x 9⅜
17.8 x 23.8
Courtesy Camera Obscura, Stockholm

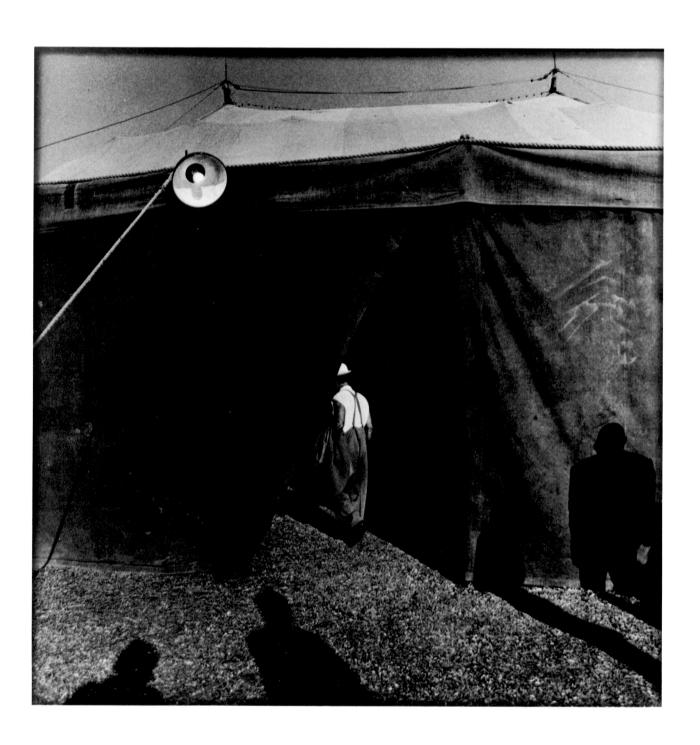

Through the efforts of the group known as FFF, the Forbundet Frie Fotografer (Free Photographers' Association), a noncommercial organization, artistic photography has achieved a high status, complete with government support in the form of scholarships and project assistance. Five photographers receive an annual guaranteed minimum wage, subject to review every five years, and can devote themselves to creative photography.

In Helsingförs, Finland, photographs are exhibited at the Photography Museum and at the Hippolyte Photographic Gallery. Finnish education in photography is the best available in Scandinavia: the Academy of Industrial Arts in Helsinski, for example, offers a five-year course in photography. Several of the teachers at this school were formerly students there and now teach and work on their own photographic projects. These projects are often documentary, yet photographic styles differ dramatically. Pentti Sammallahti, who is one of these teachers, has made a series of poetic photographs of the Irish countryside. Timo Kelaranta frequently returns to the small town in central Finland that was his ancestors' home and takes sensitive photographs that typify the refined documentary style evolving in Finland. Photography based on the qualities of abstract form alone has received little response in Finland. The reason for this may be that a tradition of social documentary photography became firmly rooted in Finland during the 1950s and 60s, and photojournalistic books established the tone that is still dominant. Strömholm's photography school, photographs taken by the Farm Security Administration in the United States, and to some extent publications of the work of Paul Strand are among the few outside influences that have affected Finnish photography. Perhaps indicative of changes to come, however, is the recent emergence of a new style of photography that is more subjective and visually charged than current documentary photography. The result will probably be without exact parallel in Scandinavia, for Finnish photography, like Finnish culture as a whole, blends Eastern and Western influences, and has evolved in a certain isolation.

In Denmark developments have been quite similar to those in Sweden. However, few facilities exist in Denmark for exhibiting photographs, with the result that identifiable directions are not as visible in Danish photography. The numerous photography books and exhibitions by Morten Bo are a living legacy for the Danes. Like his contemporaries in Sweden, he uses his camera to document factories, schools and women's centers, and in *Alarm* he published the photographic results of a long, hectic period he spent with a group of fire fighters. His most recent works show a more private and abstract approach. He now makes intimate studies of fragments of reality.

In Sweden in the late 1970s, a new style of photography emerged in natural reaction to the limited number of ideas that had dominated the field in Scandinavia for so many years. Inspiration was frequently derived from older foreign masters of the art. Photographers such as Josef Sudek and Frederick Sommer were

increasingly appreciated for their creative approaches to photography. A small group of Swedish photographers began to approach the medium from a radically different standpoint, determining that if you want to change society, you must start by changing yourself. Photographs now began to deal with personal experiences and private feelings rather than with social conditions. Photographers presented their experiences and those of their friends with respect and warmth. At the same time, their concern for photographic technique had also grown.

The large-format camera regained popularity after the extended domination of 35 mm. photography. Such old methods as platinum and gum printing are applied with increasing frequency. An exhibition of Lennart Olson's large gum prints in 1979 at the Camera Obscura Gallery in Stockholm demonstrated the artistic possibilities of photography in this old printing process. Staged compositions increasingly serve as subject matter. Photography as a means of self-expression has gained a foothold.

In 1978 Otmar Thormann exhibited photographs that related strongly to his childhood memories. He makes highly personal pictures, often of arranged still lifes, with painstaking exactness, and has carefully developed the relationship of the tone and texture of his photographic materials to the subject matter. At Stockholm's Photography Museum, Gunnar Smoliansky displayed his intimate still lifes as part of the 1978 group exhibition *Through Swedish Eyes*. Some were in platinum; others were toned with gold.

One of the most respected portrait and fashion photographers in the Swedish capital from the 1940s to his death in 1968 was Rolf Winquist. Several of his assistants later became prominent Swedish photographers. One of them was Hans Gedda, whose portraits of the 1970s are stylistically akin to those of Richard Avedon and Diane Arbus. Gedda's more recent work includes experimental landscape photography.

In the spring of 1981 Petter Antonisen exhibited a series of photographs of details of canvas tents, which were considerably more formalistic than is generally the case in Swedish photography. Several of the pictures were in a subtle range of color. Otherwise, color photography is rather neglected in Scandinavia. Only a few photographers have worked seriously with it, and then apparently most often in the southern countries where the colors of nature are more dramatic than those in the northern climate.

Conceptual photography, which is so prevalent in nearby Poland, has not appeared in Scandinavia to any extent. In Oslo the work of Dag Alveng is one exception, however: in some instances, he combines two to six similar photographs in series to make a dramatic statement. In Iceland a number of young artists inspired by Dieter Rot, a conceptual artist and part-time resident, use the camera to record their performances, painting and sculpture.

Lennart Olson
Emilia Romagna II 1962/1981
combination gum print
9¼ x 11½
23.5 x 29.2
Courtesy Camera Obscura, Stockholm

Gudmundur Ingólfsson
My New Balcony 1980
gelatin silver print
11¼ x 11¼
28.6 x 28.6
Collection the artist, Reykjavík

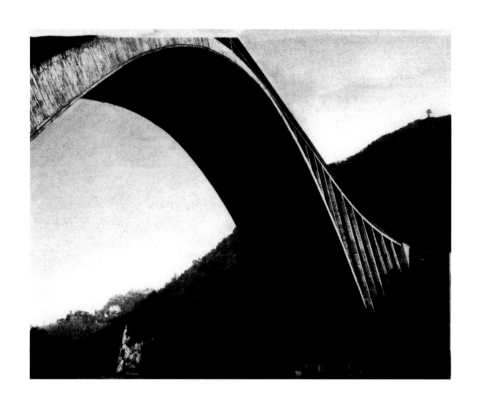

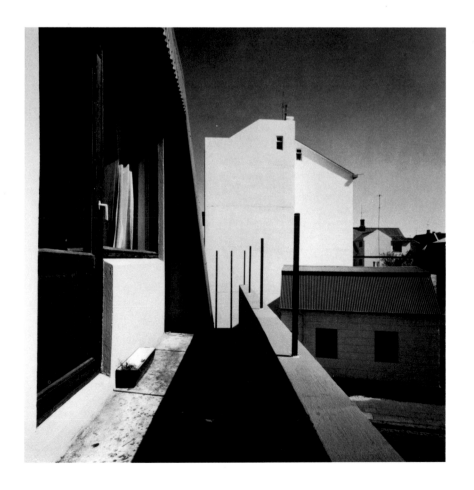

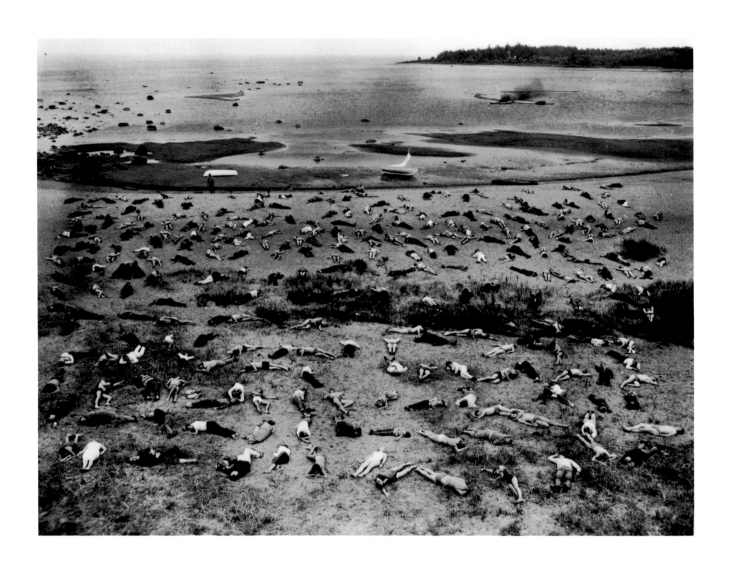

Bertil Stilling
Drowning Death 1967
gelatin silver print
14¾ x 20
37.5 x 50.8
Collection the artist, Stockholm

We have been hung up on photography and are faced with the necessity of freeing ourselves from it. We must use the camera to supersede the camera. We must work toward no longer being slaves of photography but becoming masters of it. Photography must be transformed from being used for purely reporting and become a tool for artistic inspiration; the business of direct observation should be handed over to the sight-seeing sections of the newsreels.

Carl Theodore Dreyer, *Dreyer in Double Reflection*, 1940

A more traditional yet personal approach characterizes the photography of Tom Sandberg. His unusually composed photographs with their large dark areas are powerful, personal images. Jim Bengston, also active in Oslo, uses his family and close friends as subject matter for his highly stylized photographs. A fishing trip or an outing to the beach can be the point of departure for one of his allusive, charged images created with a skilled, straightforward photographic technique.

Several young Norwegian photographers are interested in landscape photography, a popular and obvious subject for the nature-loving Scandinavians. Documentary and journalistic photography is also pursued by the new generation, but with a more mature vision than that of five to ten years ago when reportage was most popular. This documentation coexists with today's more private form of photography: the former developed mainly in response to local conditions with relatively little outside influence; the latter is clearly responsive to American and European versions.

In November 1977 three exhibitions in Stockholm firmly established the growing interest in a new artistic form of photography. Works by Henri Cartier-Bresson were exhibited at Fotograficentrum, by Ansel Adams at the Photography Museum and by Irving Penn at Camera Obscura, which opened that year. A growing interest in photography was ignited—previously there had rarely been one exhibition a year of any magnitude. The mass media began to review photography exhibitions seriously. Museums and libraries throughout Scandinavia began to exhibit photography and shows began to circulate widely. For example, Hans Gedda's popular portraits traveled to eight locations in Sweden in one year. This has accelerated photography's development in all forms in Scandinavia today. The Scandinavians do not, however, appear to take their cues from one another or from their own photographic traditions. Instead, Nordic photographers have drawn nearer their peers in foreign countries as a more international kind of photography has begun to emerge.

Lennart Durehed, a photographer, is the co-founder and manager of the Camera Obscura Gallery in Stockholm, the first gallery in Scandinavia dedicated solely to photography. (Translation by Alison Durehed.)

157

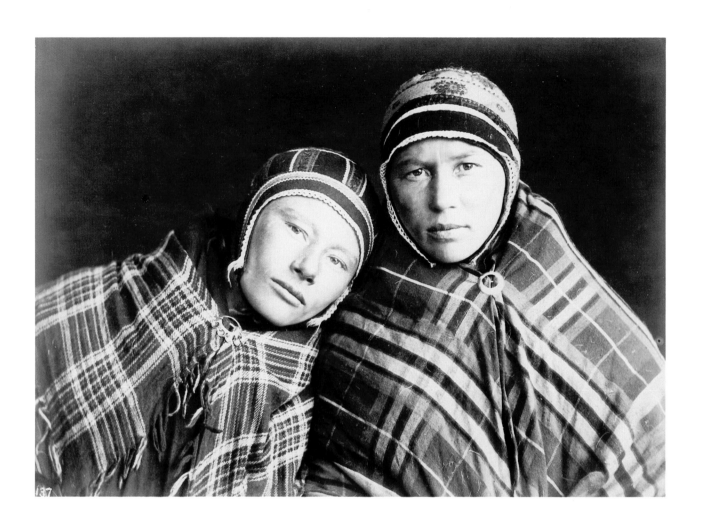

Sophus Tromholt
Anna Aslaksdatter Gaup and
Anna Jonsdatter Somby, Koutakaeino,
Norway 1883
albumen print
$4^{5}/_{8}$ x $6^{5}/_{8}$
11.7 x 16.8
Collection Universitetsbiblioteket i Bergen

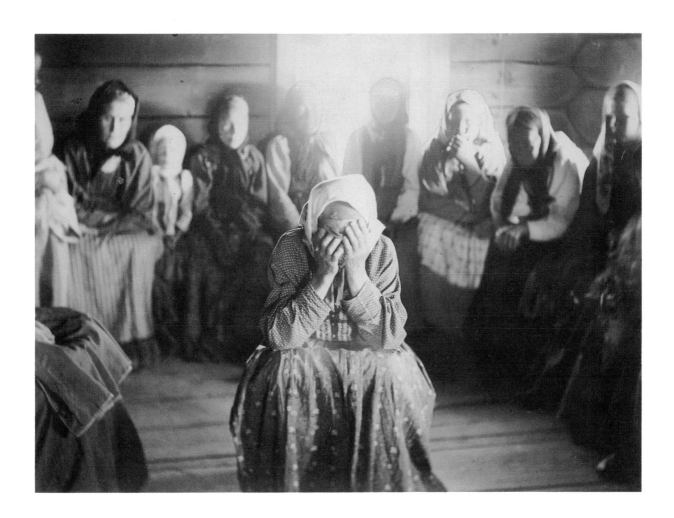

Into Konrad Inha
Mother's lament at a wedding, Jyvoalahti,
Archangel 1894
albumen print
6⅝ x 9
16.8 x 22.9
Collection Museovirasto, Helsinki

front

back

Unknown photographers
Fan with photographs, autographs,
drawings and bon mots by artists
(among them is the Danish composer
Carl Nielsen) 1909–27
wood, gelatin silver prints, ink, graphite, oil
paint, fabric ribbon in gold-painted wood,
gesso and glass case
fan dimensions: 12 x 23
30.5 x 58.4
case dimensions: 18 x 26½ x 2
45.7 x 67.3 x 5.1
Collection Københavns Bymuseum

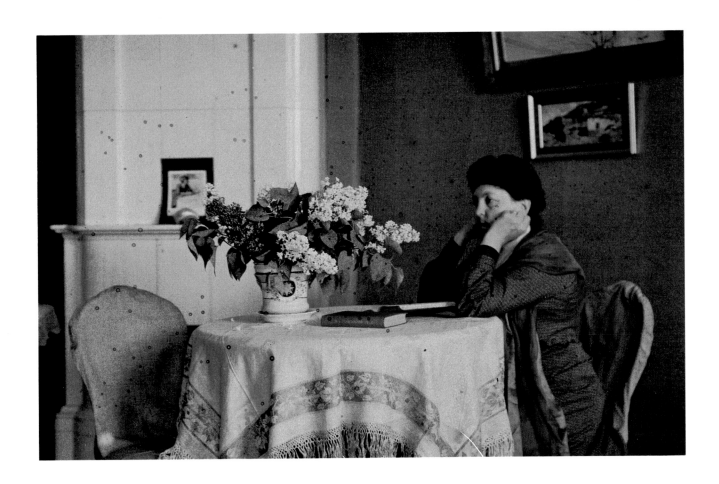

Wladimir Schohin
At home ca. 1907
modern Cibachrome print
from original autochrome
6⅝ x 9⅞
16.8 x 25.1
Collection Amatörfotografklubben,
Helsinki

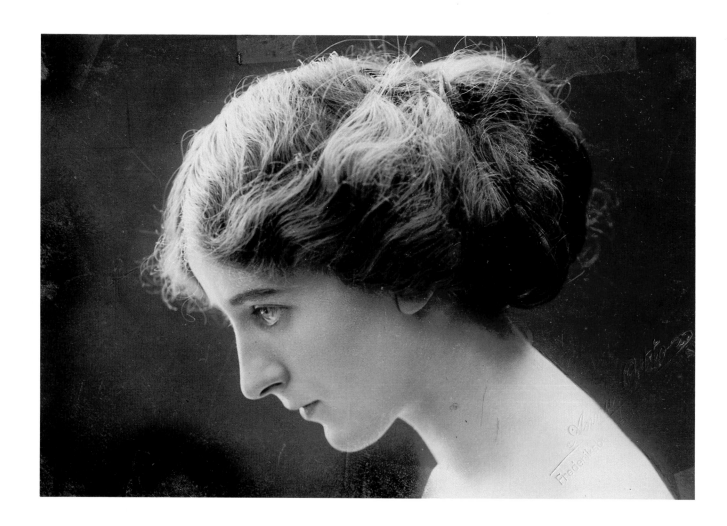

Anna Otto
Zanny Petersen, the actress ca. 1912
gelatin silver print
3⅜ x 5
8.6 x 12.7
Collection Det Kongelige Bibliotek,
Copenhagen

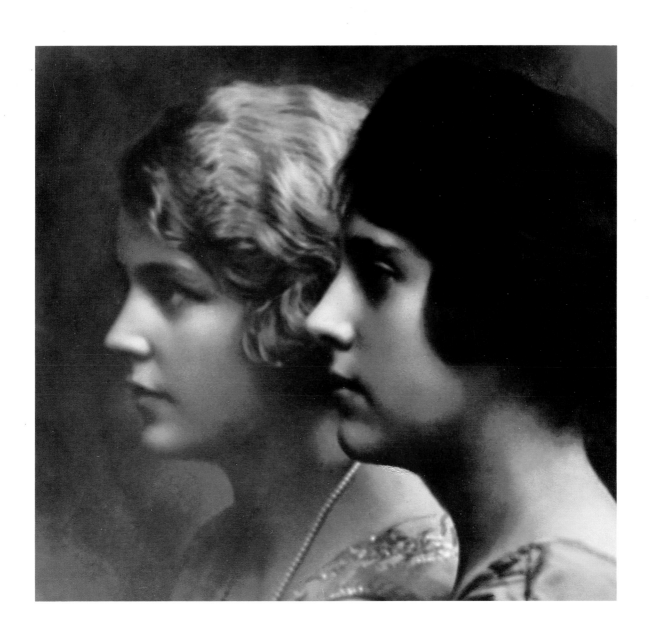

Jon Kaldal
Two girls ca. 1930
gelatin silver print
6¾ x 7½
17.1 x 19.1
Collection Ingiborg Kaldal, Reykjavík

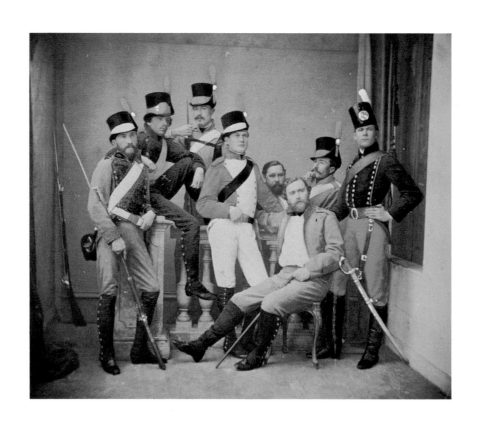

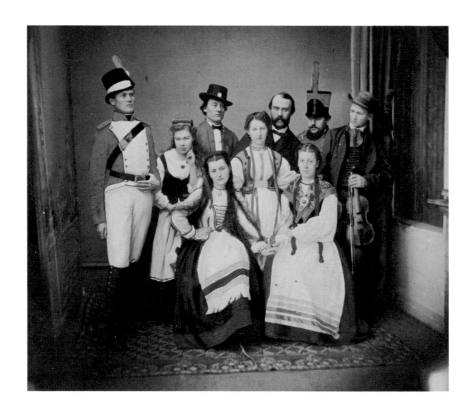

Carl Adolph Hårdh
Finnish Artists' Society 5 February 1866
hand-colored *cartes-de-visite*
4 x 5 each
10.2 x 12.7
Collection Helsingin Kaupunginmuseo,
Helsinki

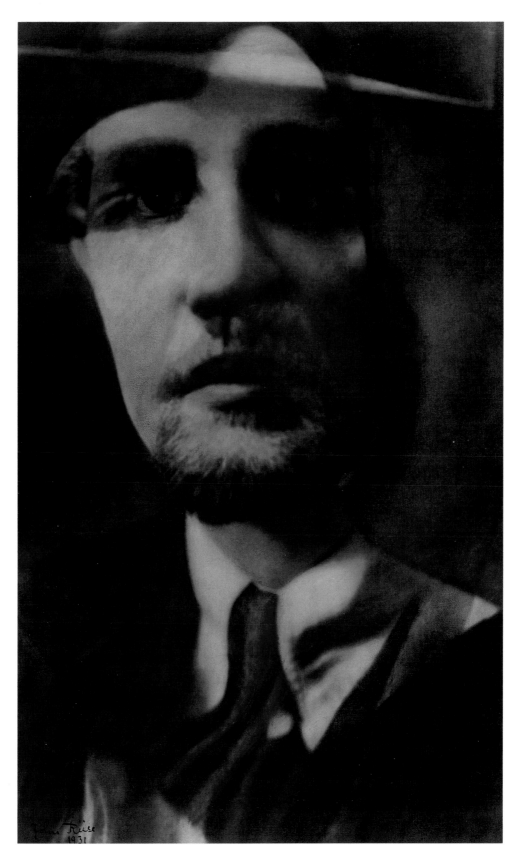

John Riise
Portrait of a young man ca. 1931
hand-colored gelatin silver print
14⅝ x 9
37.1 x 22.9
Collection Sonja Henie-Niels Onstad
Foundations, Høvikodden, Norway;
Deposited by Statens Håndverks og
Kunstindustriskole, Oslo

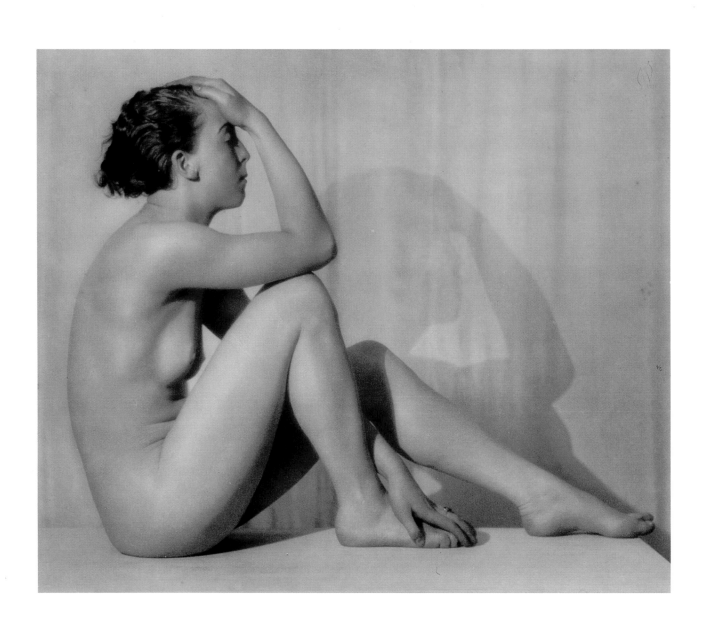

Arne Wahlberg
Rhythm 1930
gelatin silver print
10⅞ x 13¼
27.6 x 33.7
Collection Fotografiska Museet, Stockholm

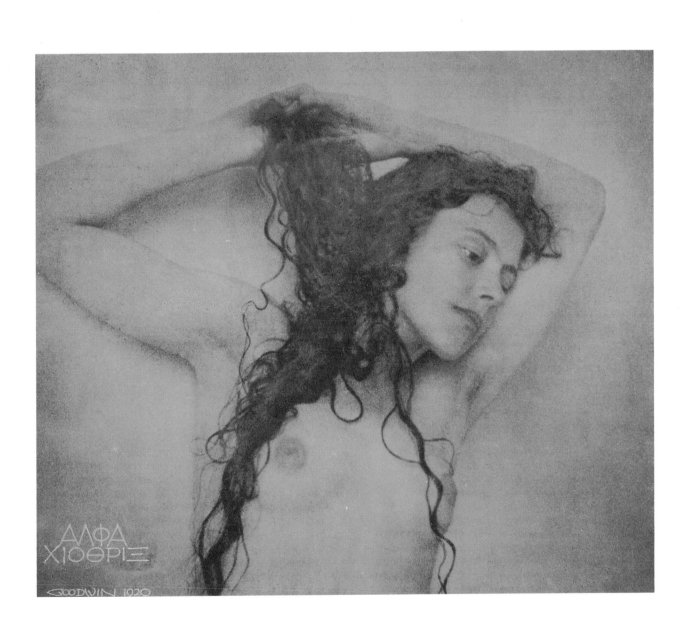

Henry B. Goodwin
Carin B. 1920
gum print
8½ x 9¾
21.6 x 24.8
Collection Kungliga Biblioteket, Stockholm

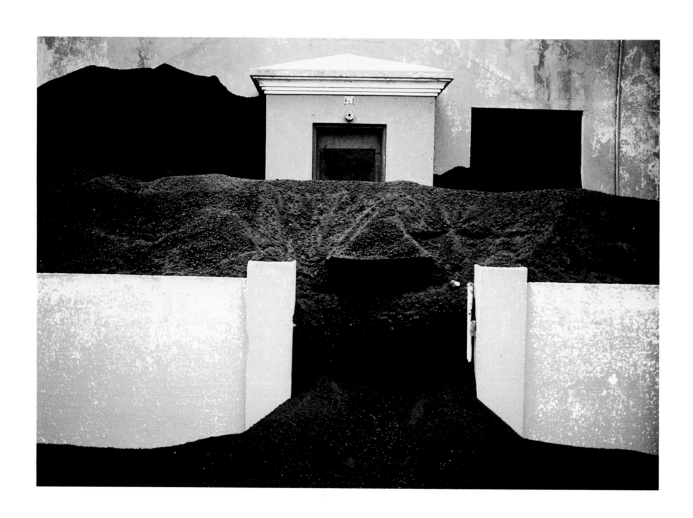

Jan Landfeldt
Untitled 1973
color-coupler print
16 x 20
40.6 x 50.8
Collection the artist, Stockholm

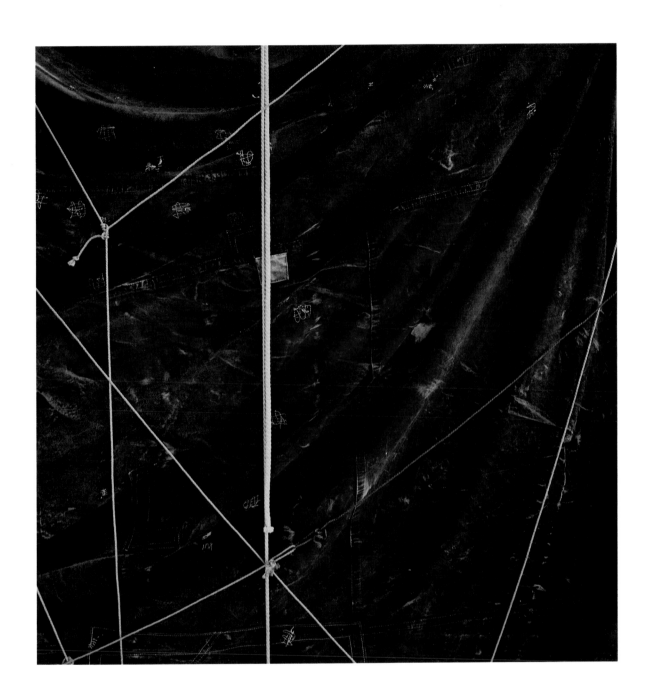

Petter Antonisen
Untitled 1980
dye transfer color print
14½ x 13
36.8 x 33
Courtesy Camera Obscura, Stockholm

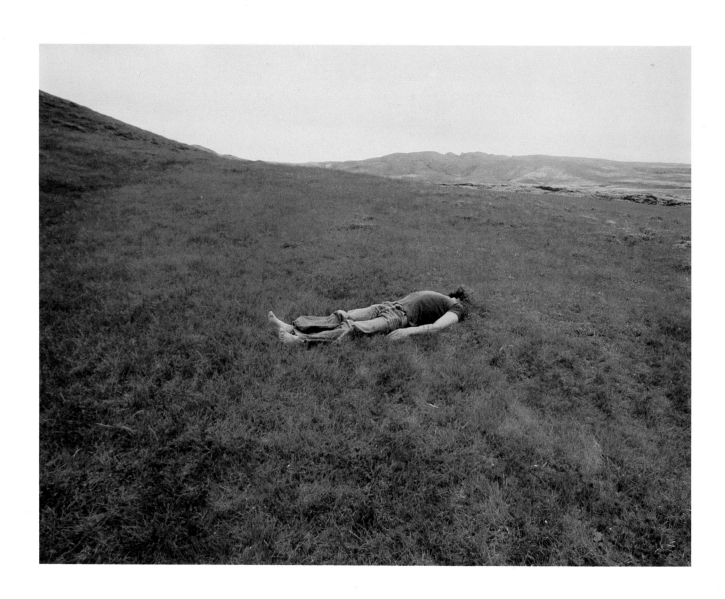

Ólafur Lárusson
Attempt to Get Rid of Mystery 1976
color-coupler print and text
9 x 12
22.9 x 30.5
Collection the artist, Reykjavík

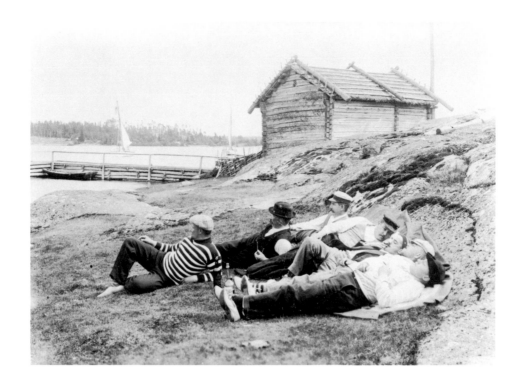

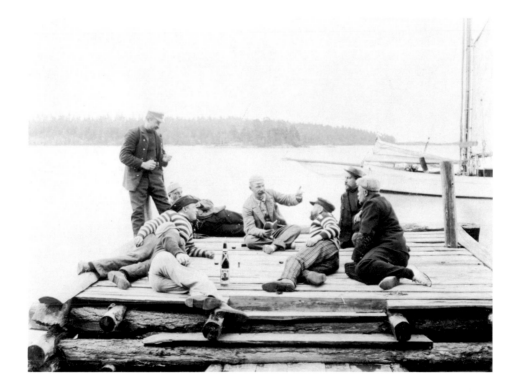

Unknown photographer
Yacht Club, Korpo 1895
gelatin silver prints
4¾ x 6⅜ each
12.1 x 16.2
Collection Åbo Akademis Bildsamlinger

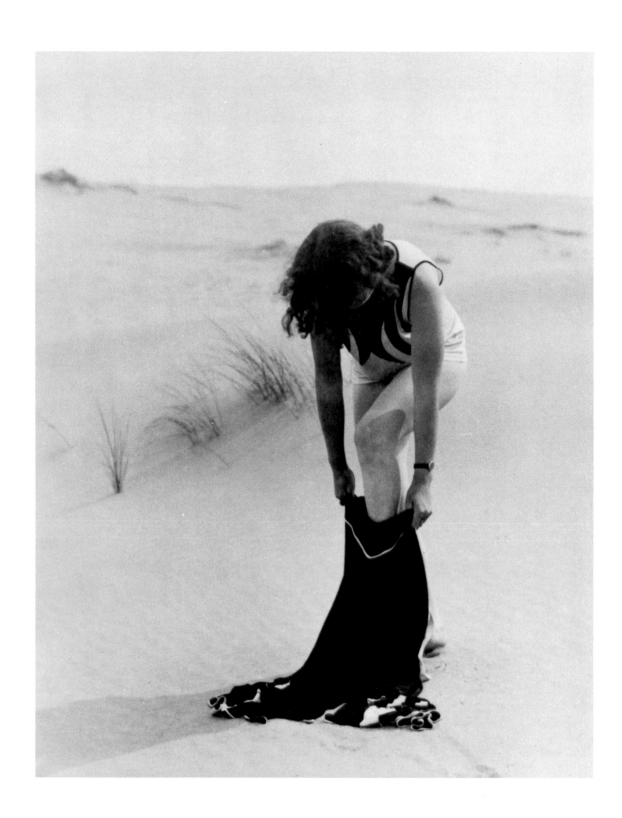

Rolf Ødegaard
Summer 1931
gelatin silver print
11½ x 9⅛
29.2 x 23.2
Collection Robert Meyer, Oslo

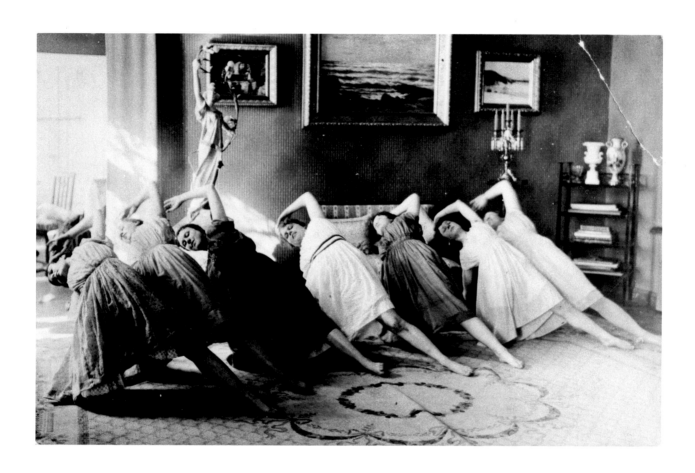

Unknown photographer
Dancing lesson 1917
gelatin silver print
3⅜ x 5⅜
8.6 x 13.7
Collection Åbo Akademis Bildsamlinger

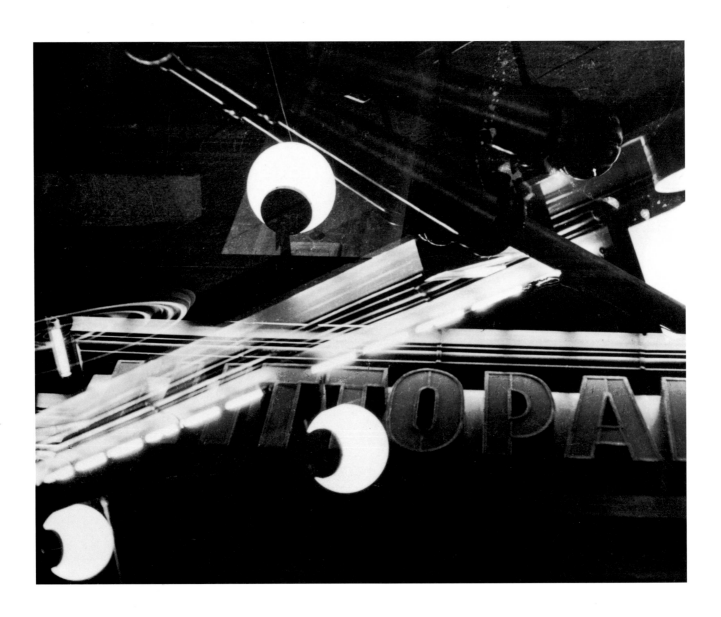

Eino Mäkinen
Street light studies ca. 1925
gelatin silver print
9¼ x 11⅝
23.5 x 29.6
Collection Suomen Valokuvataiteen
Museon Säätiö, Helsinki

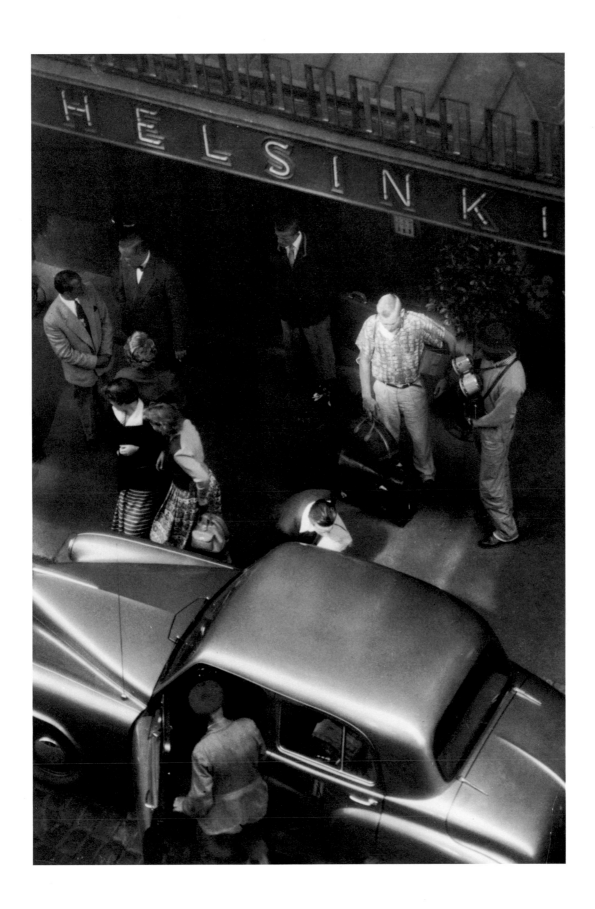

Matti A. Pitkanen
Helsinki Hotel entrance 1953
gelatin silver print
14¾ x 10¼
37.5 x 26
Collection Suomen Valokuvataiteen
Museon Säätiö, Helsinki

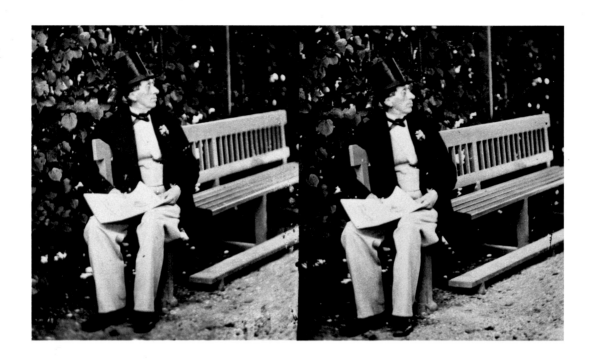

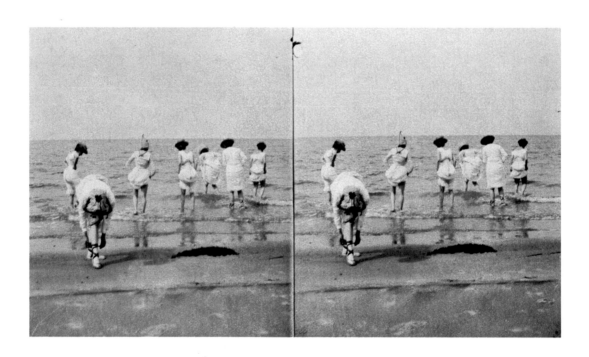

Israel B. Melchior
Hans Christian Andersen 1867
gelatin silver print, stereo card
3³/₁₆ x 5⅝
8.1 x 14.3
Collection Det Kongelige Bibliotek,
Copenhagen

Peter L. Petersen
(1901 adopted pseudonym Peter Elfelt)
Beach scene 1901
gelatin silver print, stereo card
3¼ x 5⅝
8.3 x 14.3
Collection Det Kongelige Bibliotek,
Copenhagen

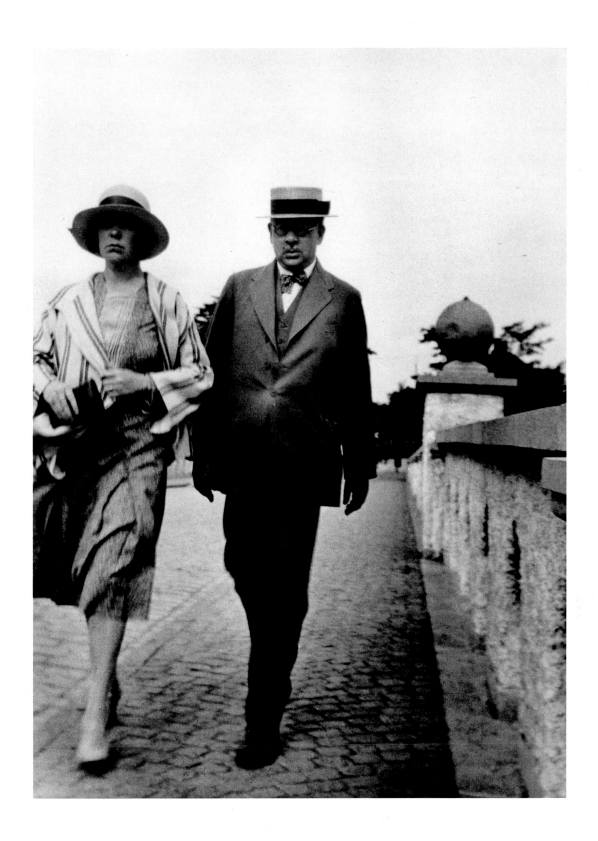

Patrik Johnson
Mr. E.D. Arnell and his wife Signe,
Falkenberg, Sweden 1931
modern gelatin silver print
from original negative
16 x 11⅞
40.6 x 30.2
Collection Falkenbergs sparbank

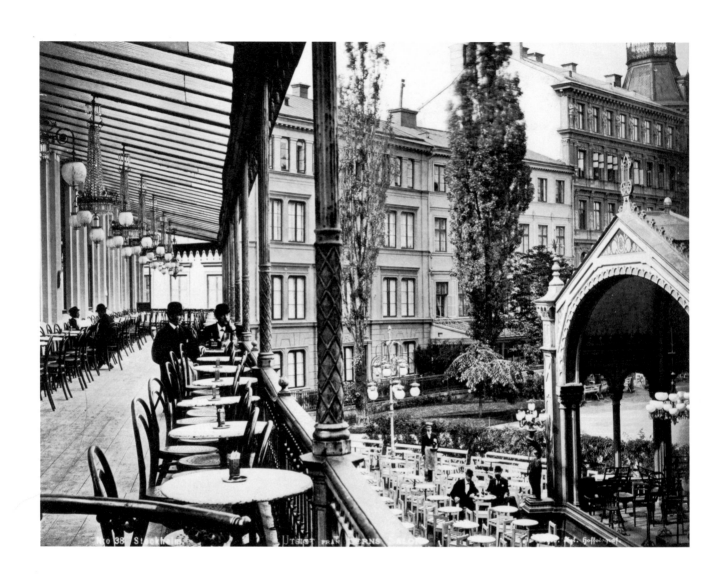

Johannes Jaeger
Berns Restaurant, Stockholm ca. 1870
collotype
7$\frac{5}{16}$ x 5$\frac{3}{4}$
18.6 x 14.6
Collection Fotografiska Museet, Stockholm

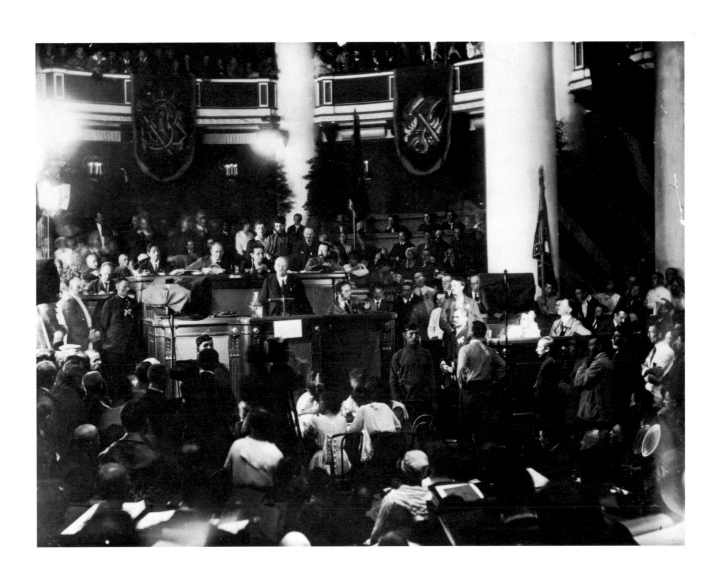

Unknown photographer
Lenin, 2nd Congress of Communist
International, Moscow 1920
gelatin silver print
6¾ x 9
17.1 x 22.9
Collection Arbeiderbevegelsens Arkiv og
Bibliotek, Oslo

and an extraordinary population growth. After 1860 relief for the strains this placed on the agrarian economies of Scandinavia came through emigration to America and industrialization at home. Denmark, with her greater initial level of urbanization and economic development, led the way in industrialization after 1865, followed by Norway and Sweden in the 1870s and 1880s, and by Finland, whose industrialization started later and stretched well into the 20th century. Mass emigration to North America was led by the Norwegians and Swedes in the late 1860s, while the rate of Danish emigration picked up in the 1870s and the Finns began to follow their neighbors in the 1880s.

With the growth of modern factories and communications came urbanization and increasing political awareness. Voluntary associations such as nonconformist religious societies, temperance groups and trade unions—as well as the correspondence from friends and relatives who had emigrated to the United States—further raised the political consciousness of the broader masses, and pressure grew on the political elites to accept universal suffrage and the concept of parliamentary government. Both of these goals were fully realized by 1920. The shift from an overwhelmingly agrarian society in the 1850s to a balanced agrarian-industrial society by 1914 (with Finland and Iceland still remaining predominantly agrarian), enhanced material well-being and produced a vital city life: within this broader framework, Scandinavians were encouraged to greater partici- pation in the mainstream of European economic as well as artistic and literary development.

The very speed of this growth caused problems. Strains in Norwegian-Swedish relations within their monarchical union led to a Norwegian plebiscite in 1905 that resulted in Norway's complete independence from Sweden and in the election of Haakon VII as King of Norway. This move was inspired by Norway's heightened sense of pride, which came, among other things, from the growth of Norwegian arts and letters and from the internationally recognized accomplishments of explorers such as Fritiof Nansen and Roald Amundsen. There were similar contributing factors to Finland's emergence as a completely independent state, of course, but the Finnish declaration of inde- pendence from Russia of December 1917 was spurred by much more serious socio-economic pressures at home and, even more importantly, by the Bolshevik Revolution of November 1917. The establishment of nationhood was far more wrenching for Finland than for Norway: Finland's declaration of independence was immediately followed by a bloody three months of civil war that would divide the nation into socialist and non-socialist camps for decades to come. Finally, Iceland was granted autonomous self-rule under the Danish monarchy in 1918, and it at last achieved complete independence and sovereignty in the June 1944 proclamation of the Republic of Iceland.

During the interwar period, the cultural and political community of the Scandinavian countries manifested itself in one important,

A S
Sca
His

Micha

188

although indirect way. Each of the four independent states had weak governments based on slim parliamentary backing in the 1920s, and each of them met the threat of Fascism in the 1930s by making explicit or implicit accommodations across the traditional socialist, non-socialist dividing line. While the threat of Fascism was external and still nebulous in Denmark and Sweden, it was alive in Norway in the 1930s, and it was blatantly manifest in Finland's so-called Lapua Movement, which threatened the government itself in 1932. It was the Danes and the Swedes who led the way in finding compromises between the traditionally hostile agrarian and social democratic parties in 1933, and the Norwegians and Finns were to follow suit in 1935 and 1937. Not only did the Scandinavian societies thus succeed in bridging the serious gap between agricultural and industrial sectors of their economies, but these "red-green" agreements also created the political basis for the social welfare policies that excited the world's imagination even before the end of the 1930s.

In World War II the geopolitical situations and experiences of the Scandinavian countries differed radically. Denmark and Norway were occupied by Germany; Iceland served as voluntary host first to the British and then to the American forces; Finland first defended herself heroically against Soviet aggression and then joined with Germany in co-belligerency against the Soviet Union; and Sweden survived the war as a heavily armed neutral island in a German-dominated region. Understandably, during the postwar period the Scandinavian countries chose very different security and defense strategies. Denmark, Iceland and Norway all became members of NATO, while Sweden continued her long-established tradition of neutrality and Finland adopted a position of neutrality compatible with her Treaty of Friendship, Cooperation and Mutual Assistance with the Soviet Union. Yet, in the realms of economic and cultural affairs, all five countries have been very active in promoting Scandinavian integration through the institution of the Nordic Council, which held its first annual meeting in 1953 and which has since reached a series of impressive agreements: for example, the creation of a common Nordic labor market in 1954; the extension in 1955 of eligibility for social welfare benefits to all Nordic citizens, benefits transferable with residence in any of the five countries; and ventures in cultural cooperation such as the joint sponsorship of "Scandinavia Today" in 1982–83.

Having shared many common experiences over the centuries, and having achieved in the decades since World War II a communal identity based on political, economic and cultural factors, the Scandinavian nations still retain their distinctive and intriguing individuality. While the fertile Danish farmlands and Denmark's immediate proximity to the Continent have created a comfortable and friendly society, the harsh agricultural climates of most of Finland, Iceland, Norway and Sweden have kept the inhabitants of vast reaches of these countries dependent upon a more rough-hewn and untamed nature— whether the sea or the forest—for a significant part of their

livelihood. Thus, the characteristics of a sedentary peasantry were always supplemented or moderated by a compelling relationship with the wilderness, and these people retain a relationship with the sea, the forest and the mountains that reflects—if ever more dimly—that past reality.

Culturally, the peoples of the five nations also present important differences. While the Danes and the Swedes, independent peoples for centuries past, have had less need to emphasize their uniqueness in the community of nations, in Finland and Norway self-awareness grew strong, these people asserting themselves as separate and richly endowed in the 19th and 20th centuries. Icelandic society always retained its separateness through the vigorous and almost doctrinaire preservation of the old Icelandic language, which has descended almost unaltered from the Viking Age, and the Swedish-speaking minority in Finland has struggled to retain its cultural individuality. In recent decades, the Scandinavians, concerned for the plight of indigenous peoples around the world, have increasingly recognized the cultural identity of another ancient people—the Sami (or Lapps) of Finland, Norway and Sweden. In their international contacts, too, the Scandinavian peoples have, for a variety of historical reasons, kept channels open in different directions. Norway and Iceland have had strong ties to England, while Denmark's links have been equally strong to England and Germany. Sweden's strongest cultural and economic ties outside of Scandinavia have been with France, Germany and England successively and in varying degrees, but her foreign policy has traditionally attempted to strike a balance between Germany to the south and Russia to the east. Finally, Finland has transformed her 19th-century experience as an autonomous part of the Russian Empire into a special relationship of mutual respect and trust with the Soviet Union, while maintaining strong economic, cultural and political ties with the nations of Western Europe.

Today, the Scandinavian countries present a striking example of strong regional cooperation paired with distinct national development. This harmony between the national and the international reflects a strong balance between the perception of the present and the received perceptions of the past, as well as a strong moral sense of compatibility between national and international concerns and goals in the late 20th century. The Scandinavian self-image has changed in the past and will undoubtedly change in the future, but if ever that self-image was one of community, it is now.

Michael F. Metcalf, Associate Professor of Scandinavian History at the University of Minnesota, is the author of several studies of 18th-century Swedish party politics and of a ten-part television program on modern Scandinavian history broadcast in Minnesota in 1981.

Chronology

Information in this chronology was gathered from a number of sources. Most significant were data compiled by historian Michael Metcalf for this publication; Beaumont Newhall's *The History of Photography* (New York: The Museum of Modern Art, 1964); and Lee D. Witkin and Barbara London, *The Photograph Collector's Guide* (New York: New York Graphic Society, 1979). Additional information was provided by the staff of the International Center of Photography.

1839 – Present
Scandinavian Political, Social and Cultural History

1839 – 59
Emergence of capitalism and industrialization in Denmark, Norway, Sweden. Mechanization introduced to agriculture and practices of collective village replaced by individually owned farm.

Folk high school movement brings political and cultural education to the agricultural community.

1848
Ivar Aasen, *Grammar of Norwegian Popular Speech* published.

1849
Elias Lönnrot, *Kalevala* published.

Constitutional monarchy and freedom of the presses established in Denmark.

1851
Marcus Thrane's political reform movement fails in Norway.

1854
Norwegian painter Hans Fredrik Gude teaches in Düsseldorf to 1862 (in Karlsruhe in 1860s, Berlin in 1880s).

1860 – 79
Producers' and consumers' cooperative movements take hold in Nordic countries.

Population explosion leads to flood of emigration from Scandinavia by 1870.

1839 – Present
Worldwide Photography

1839
Daguerreotype published.

Sir John Herschel finds that hypo will fix image; initiates terms *positive* and *negative*.

1840 – 44
Excursions daguerriennes published.

1841
Calotype patented by William Henry Fox Talbot.

Danish born Han Thøger Winther introduces calotype in Oslo.

1844
Johan Wilhelm Bergström makes daguerreotypes in Stockholm.

1847
Albumen plates discovery communicated by Niépce to the Académie des Sciences.

1849
Stereoscopic viewer manufactured.

1851
Frederick Scott Archer invents collodion wet-plate process.

1853
Photographic Society of Great Britain founded.

1854
Ambrotype patented.

1855
Roger Fenton photographs Crimean War to 1857.

1856
Lewis Carroll photographs Alice Liddell who inspires *Alice's Adventures in Wonderland.*

1857
Oscar Rejlander's composite print, *The Two Ways of Life,* shown at Manchester Art Treasures exhibition.

1858
Nadar takes aerial photographs from balloon.

1860
Word "snapshot" coined.

Principles of three-color photography demonstrated.

1863
Finnish language edict by Finnish government (formerly Swedish was Finland's sole official language).

1864
Schleswig-Holstein lost to Germany in Dano-Prussian War.

1866
Henrik Ibsen, *Brand* published.

Swedish bicameral parliament established.

1869
Norwegian parliament begins to meet on annual basis.

1872
Danish liberal party gains majority.

1873
Scandinavian Ethnographic Collection, Stockholm (renamed Nordic Museum, 1880).

1874
Icelandic constitution granted under Danish supervision.

1876
Sweden creates office of prime minister.

1877
Henrik Ibsen, *Peer Gynt* published.

1878
Finnish Conscription Act establishes Finnish army (Russian Imperial forces previously provided defense from 1808).

1879
August Strindberg, *The Red Room* published.

Henrik Ibsen, *A Doll's House* published.

1880–99
Denmark, Norway, Sweden transformed from agrarian to industrial societies. Traditional hierarchy of social classes challenged by new urbanization. Political parties develop calling for universal suffrage and parliamentary majorities.

1884
Henrik Ibsen, *The Wild Duck* published.

1884–89
Norwegian liberals establish principle of majority government.

1888
Edvard Grieg's piano concerto performed in London.

1861–65
Mathew Brady documents United States Civil War.

1865
Miniature camera developed. Leads to dry plates and hand-held cameras with negatives meant for enlargement.

1866
Johannes Jaeger credited with having produced the first documentary photograph made in Sweden.

1870
William Henry Jackson's 20 x 24 inch wet plates of Rocky Mountains.

1871
Gelatin emulsion invented.

1873
Orthochromatic emulsion invented.

1878
Eadweard Muybridge, *The Horse in Motion* published.

1880
Eadweard Muybridge projects moving pictures.

First newspaper half-tone published.

Platinum paper on market.

1885
Gustaf Adolf Berggren photographs Constantinople.

1887
Stieglitz receives international recognition.

1888
Kodak camera available.

Swedish Society of Amateur Photographers founded.

1889
Sweden's Social Democratic party founded.

Kaiser Wilhelm's annual visits to Norway spur German tourism.

1890
Knut Hamsun, *Hunger* published.

1889
Transparent, flexible film, hand-held camera available.

Amateur Photographers' Club of Helsinki founded.

1890
Jacob Riis, *How the Other Half Lives* published.

1891
Lippman interference color process invented.

1893
The Linked Ring founded in London.

Pictorialism spreads.

Velox paper available.

1894
Edison's kinetoscope invented.

1895
Lumière's cinematograph invented.

1897
August Strindberg, *Inferno* published.

1898
Nearly universal male suffrage in Norway.

1899
Jean Sibelius, *Finlandia* composed.

Nicholas II abolishes Finnish legislature with February Manifesto, inaugurating first period of Russian repression.

Trade union movement born and gains significant strength in Denmark, Norway, Sweden with court of labor arbitration in Denmark.

1900
Gallen-Kallela paints frescoes for the Finnish pavilion at the Paris World Exhibition.

1901
Nobel Prize established in Sweden/Norway.

Parliamentary government in Denmark.

Copenhagen City Museum founded.

1902
Edvard Munch, *Frieze of Life;* Berlin exhibition a sensation.

1904
Russian governor-general assassinated in Helsinki.

Icelandic home rule under Danish sovereignty.

1898
Eugène Atget begins 30-year project to photograph Paris and environs.

Gunnar Malmberg travels to Berlin to attend a course in reproduction technique and practical photography.

1902
Edward Weston begins career.

Photo-Secession and *Camera Work* founded by Stieglitz.

1905
Dispute over foreign trade leads to dissolution of Norwegian-Swedish union.

General strike in Finland.

1906
Finnish parliament established as concession by Nicholas II of Russia.

1907 – 13
Female suffrage in Norway.

1908
Russification resumed in Finland.

1909
Male suffrage in Sweden.

State Academy of Art established in Norway.

Selma Lagerlöf, Nobel Prize in Literature.

Painters' group "The Young Ones" exhibits in Stockholm.

1915
Universal suffrage in Denmark, Iceland.

1917
Majority government principle and practice established in Sweden.

"November Group" of painters founded in Sweden.

Scandinavian countries non-belligerents in World War I. Finland declares independence from Russia and "whites" victorious in 1918 civil war.

1918
Icelandic independence under Danish-Icelandic monarchy.

1918 – 21
Female suffrage in Sweden.

1919
Republican constitution adopted in Finland.

Norwegian Viking Eggeling works on avant-garde films with Hans Richter, Berlin.

1920
Niels Bohr establishes Institute of Physics in Denmark.

Northern Schleswig recovered from Germany by Denmark.

Finnish Treaty of Dorpat establishes Finnish independence from Russia.

1905
Lewis Hine begins career.

1907
Autochrome plates manufactured by Lumière Brothers.

Bromoil process introduced.

Edward Curtis's American Indians project funded by J.P. Morgan.

1909
Greater Copenhagen published in two volumes.

1913
Perscheid lectures in Stockholm on his special portrait method at the invitation of the Swedish Photographers Association.

Prof. Helmer Bäckström publishes the first essay in his series "Collections for the Swedish History of the Camera and Photography." Series continues until 1944.

1916
Paul Strand's photographs published in *Camera Work*.

1918
August Sander begins social documentation, Germany.

1920 – 22
Sigrid Undset, *Kristen Lavransdotter*
published.

1924
Social Democratic government in
Denmark.

1925
Greta Garbo debut.

1929 – 32
Fascist-inspired Lapua group in Finland
harasses political opponents, finally kidnaps
former president of the Republic.

1930
"Oslo Group," European neutral nations.

1931
Great Depression in Sweden.

First exhibition of modern French painting
at the National Museum in Stockholm.

1932
Swedish Social Democratic government
begins 44 years of power.

Alvar Aalto's first "functional" building.

Nordic countries plagued with depressions.
Europe under threat of Fascism. Social
Democratic-agrarian alliances in Denmark,
Norway, Sweden, Finland by 1937.

Finns repress Lapua.

1933
Danes adopt and implement broad social
reforms.

Sweden establishes social welfare state.

Vidkin Quisling founds fascist party,
Norway.

1935
Labor government in Norway.

1938
Picasso's *Guernica* shown in Stockholm.

1939 – 40
Finno-Soviet Winter War won by Russia.

1921
Man Ray, "Rayographs."

Moholy-Nagy, "photograms."

Christiania Camera Club founded.

1923
Steichen joins Condé Nast.

1925
Leica and Ermanox cameras available.

1928
Berenice Abbott preserves Atget negatives.

1930
"Candid" pictures by Erich Salomon.

1931
Photo-electric exposure meter available.

Arne Wahlberg visits Hugo Erfurth and
Franc Fiedler in Germany.

1932
Cartier-Bresson begins career.

Walker Evans, *Front Street* published.

f64 group founded.

1935
Farm Security Administration photo
project.

1936
Kodachrome marketed.

Life magazine appears.

1938
Walker Evans, *American Photographs*
published.

1939
Det nya ögat-Fotografien 100 ar exhibition in
Sweden.

1940
Germans occupy Denmark, Norway.

The "Saltsjo-Duvnas" group formed in Sweden (painters).

1941
Finland joins Germany in invasion of Soviet Union.

Sweden neutral, World War II.

American forces replace British under United States-Icelandic agreement.

1944
Icelandic Independent Republic.

Finland defeated by Russia.

Ingmar Bergman makes first film.

1945
Norway elects labor government.

German occupation of Denmark and Norway ends with German defeat.

Social welfare state concept embraced by all Scandinavian majorities.

1947
"Young Art" exhibition of new generation of painters in Stockholm.

1948
Thor Heyerdahl, Kon-Tiki expedition.

Finns sign mutual assistance pact with Soviet Union.

1949
Norway, Denmark, Iceland join NATO.

1949−56
Vilhelm Moberg, trilogy on emigration.

Inter-Nordic cooperation grows.

1951
United States airbase in Iceland.

1953
Nordic Council established.

1958
First Icelandic "Cod War" with Great Britain.

1959
Treaty of Stockholm creates European Free Trade Association.

1940
The Museum of Modern Art, New York, initiates department of photography.

1942
Color negative film invented.

1944
Modern svensk fotokonst exhibition at the Nationalmuseum in Stockholm.

1947
Land camera, Polaroid film invented.

1948
Gunnar Lundh publishes *Tenant Farm Laborers in Pictures* in Stockholm.

1949
The International Museum of Photography, George Eastman House opened.

1949−56
Young Photographers exhibition, Stockholm.

1952
Aperture magazine founded.

1955
Family of Man exhibition.

1956
Agfa 66 automatic camera available.

1958
Robert Frank, *The Americans* published.

Tio Fotografer cooperative founded in Sweden.

1959
Foundation of Forbundet Frie Fotografer in Norway.

1961
Karl Sandels founds *Fotonyheterna* magazine in Sweden.

1962
Strömholm founds the Fotoskolen, Stockholm (to 1972).

1963
Polacolor dye-diffusion instant color film.

1965
Labor government falls in Norway to non-socialist coalition.

1965
Swedish State purchases the Bäckström collection of photography.

1966
First photograph of planet Earth from moon.

1970
Many new books appear on photography. New interest in collecting photographs, in educating photographers and historians of photography. Princeton University creates first endowed professorship in history of photography.

1971
Sweden replaces bicameral with unicameral parliament.

1972
Last issue of weekly *Life* magazine.

Diane Arbus, first photographer from U.S. to be shown at Venice Biennale.

1973
Denmark joins European Common Market.

Oil crisis and international trade crisis lead to inflation and weakened markets. With the North Sea oil exception in Norway, Nordic countries unable to further social programs; current program levels require rising taxation.

1974
Norway enters oil age: Statoil formed.

1975
Helsinki accords on European security.

1976
Non-socialist government formed in Sweden.

1982
The Frozen Image: Scandinavian Photography exhibition organized as part of "Scandinavia Today" celebration.

Selected Bibliography

Books

Alland, Alexander. *Heinrich Tønnies Cartes-de-Visite Photographer Extraordinaire.* New York: Camera Graphics Press, 1978.

Bergengren, Kurt; Jonsson, Rune and Westman, Lars. *Hans Malmberg-bild-reportern.* Stockholm: Fotograficentrums Bildtidning, 1980.

Bo, Morten. *Alarm.* Copenhagen: Informations Forlag, 1978.

Clement, Krass. *Skygger af øjeblikke.* Copenhagen: Christian Erichsens Forlag, 1978.

Erichsen, John. *Et andet København: Sociale fotografier fra århundredskiftet.* Copenhagen: Gyldendal, 1978.

Haestrup, Jørgen. *Panorama Denmark. From Occupied to Ally: Denmark's Fight for Freedom 1940–1945.* Copenhagen: Ministry of Foreign Affairs, The Press and Information Department, n.d.

Hassner, Rune. *Bilder för miljoner.* Stockholm: Sveriges Radio/Rabén & Sjögren, 1977.

Hirn, Sven. *Ateljeesta luontoon: Valokuvaus ja valokuvaajat Suomessa 1871–1900.* Helsinki: Suomen Valokuvataiteen Museon Säätiö, 1977.

Jansson, Ingvar, editor. *Jämten 1981: Heimbygdas årsbok årgång 74.* Östersund: Jämtlands läns Museum, 1980. (Articles about Nils Thomasson).

Johansson, Sven and Hassner, Rune. *Lima bortom mannaminne.* Stockholm: Rabén & Sjögren, 1977.

Lehtinen, Iidikó and Kukkonen, Jukka. *Karhu: The Great Bear: Old Photographs of the Volga-Finnic, Permian Finnic and Ob-Ugrian Peoples.* Helsinki: Suomalaisen Kirjallisuuden Seura/Museovirasto, 1980.

Magnússon, Thór. *Ljósmyndir Sigfúsar Eymundssonar.* Reykjavík: Almenna bókafelagid, 1976.

Miller, Russell and the editors of Time-Life Books. *The Resistance.* Alexandria, VA: Time-Life Books, 1979.

Norsk Kulturråd. *Fotoregister og kortfattet fotoleksikon.* Oslo: Norsk Kulturråd, 1973.

Ochsner, Bjørn. *Fotografiet i Danmark 1840–1980.* Copenhagen: Forum, 1974.

_____. *Fotografer i og fra Danmark indtil år 1900.* Copenhagen: Det Kongelige Bibliotek, 1969.

Paulaharju, Samuli. *Lapsia: Children.* Edited by Kimmo Paulaharju. Helsinki: Suomalaisen Kirjallisuuden Seura, 1975.

Sidwall, Åke and Wigh, Leif. *Bäckströms Bilder!* Stockholm: Fotografiska Museet, 1980.

Söderberg, Rolf. *Frans G. Klemming.* Stockholm: Stockholms Stadsmuseum, 1975.

_____. *Anton Blomberg.* Stockholm: Stockholms Stadsmuseum, 1980.

Söderström, Göran; Rangström, Ture and Pasche, Wolfgang. *Der andere Strindberg.* Frankfurt am Main: Insel Verlag, 1981.

Sollied, Ragna; Bonge, Susanne and Nordhagen, Per Jonas. *Photograf M. Selmers Bergensbilleder.* Bergen: Ed. B. Giertsens Forlag, 1974.

Sundman, Per Olof. *The Flight of the Eagle.* Translated by Mary Sandbach. New York: Pantheon Books, 1970.

Tio Fotografer: Sten Didrik Bellander, Harry Dittmer, Sven Gillsäter, Hans Hammarskiöld, Rune Hassner, Tore Johnson, Hans Malmberg, Pål-Nils Nilsson, George Oddner, Lennart Olson. Stockholm: Tio Fotografer, n.d.

Vuorenmaa, Tuomo-Juhani and Kajander, Ismo. *I. K. Inha: valokuvaaja 1865–1930.* Porvoo, Helsinki, Juva: Werner Söderström Osakeyhtiö, 1981.

Articles

Askholm, Børge. "Aage Remfeldt, dansk fotografis 'Grand old man'," *Kreativ Fotografi,* No. 2, 1981, p 38.

Bergengren, Kurt. "Adress Rosenlund," *Fotografiskt Album,* No. 3, June–September 1980, pp 4–23.

Bonge, S. "Photographer K. Knudsens pictures at the Picture-collection, Library of the Bergen University," *Nye foto,* No. 4, December 1976, pp 4–13.

Carpelan, Bert. "Wladimir Schohin—värivalokuvauksen uranuurtaja," *Valokuvauksen vuosikirja 1973.* Helsinki: Suomen Valokuvataiteen Museon Säätiö, 1973.

Dölle, Sirkku (text) and Paulaharju, Samuli (photos). "Vaeltaja Samuli Paulaharju," *Valokuva,* No. 12, 1975, pp 14–17.

Hassner, Rune. "Kort återblick på 'De Unga'," *Fotografiskt Album,* No. 3, June–September 1980, pp 25–31.

Holter, Tore. "Tom Sandberg: Jeg savner personlighet blant norske fotografer," *Fotoforum,* No. 1, 1980, pp 6–10.

Kajander, Ismo. "Portsa," *Valokuva,* No. 10, 1978, pp 18–23.

Kukkonen, Jakka. "Ugrien kuvat," *Valokuva,* No. 9, 1979, pp 5–27.

Preus, Leif. "Edvards fotografiapparat," *Fotoforum,* No. 2, 1980, pp 40–42.

Exhibition Catalogues

Alveng, Dag. *54 Mayo Road.* Oslo: Ikaros Forlag, n.d.

Bengston, Jim. *Jim Bengston Photographs/ fotografier.* Høvikodden: Henie-Onstad Kunstsenter, 1981.

Bergman, Ulla and Sidwall, Åke, editors. *Fotografer: Emil Heilborn, Sven Järlås, Gunnar Sundgren, Arne Wahlberg.* Stockholm: Moderna Museet/Fotografiska Museet, 1977.

Bergman, Ulla, Sidwall, Åke and Wigh, Leif, editors. *Fotografer: Curt Götlin, Anna Riwkin, Karl Sandels.* Stockholm: Moderna Museet/Fotografiska Museet, 1977.

Dawidsson, Björn. *20 fotografier av Dawid.* Foreword by Jan-Gunnar Sjölin. Stockholm: Camera Obscura, 1980.

Hall, Lars. *Hans Gedda: fotografier av kända och okända på Galleri Camera Obscura mellan den 28 januari till den 5 mars 1978.* Stockholm: Camera Obscura, 1979.

Hall, Lars and Hård af Segerstad, Ulf. *Ett Glas vatten av 25 svenska fotografer.* Stockholm: Camera Obscura, n.d.

Hassner, Rune. *Rolf Winquist.* Stockholm: Liljevalchs Konsthall, 1970.

Helgi Thorgils Fridjónsson, Ólafur Lárusson, Níels Hafstein, Thór Vigfússon, Rúri. Sýning/ Exhibition June 1977. Norraena Húsid, Reykjavík.

Jonsson, Rune. *Hans Hammarskiöld.* Helsingborg: Aktuell Fotolitteratur/Fyra Förläggare AB, 1979.

Meyer, Robert. *Rolf Ødegaard.* Oslo: Ikaros Forlag, 1980.

Nykvist, Ralph. *I Sverige.* Helsingborg: Aktuell Fotolitteratur/Frya Förläggare AB, 1979.

Petersen, Ad. *Sigurdur Gudmundsson: Situaties.* Amsterdam: Stedelijk Museum, 1980.

Strömholm, Christer. *Privata Bilder.* Stockholm: Camera Obscura, 1978.

Thormann, Otmar. *Otmar Thormann.* Stockholm: Camera Obscura, 1979.

Photographers in the Exhibition

Each photographer's name is followed by birthplace; dates of birth and death; country in which principal work was accomplished.

Heikki Aho
Hausjärvi, Finland
1895–1961
Finland

L.O. Akerman
Lima, Sweden
1861–1935
Sweden

B. Allwin
birthplace and
dates unknown
Sweden

Dag Alveng
Oslo, Norway
1953
Norway

Roald Amundsen
Sarpsborg, Norway
1872–1928
Norway

Brossen Andersson
birthplace and
dates unknown
Sweden

Hans Andersson
Falun, Sweden
1944
Sweden

Petter Antonisen
Bergen, Norway
1953
Sweden

Jón J. Árnason
Krossastadir, Iceland
1853–1927
Iceland

Ole Jonsen Aune
Bynäset, Norway
1837–1909
Finland

Sten Didrik Bellander
Stockholm, Sweden
1921
Sweden

Jim Bengston
Evanston, Illinois
1942
Norway

Fritz Benzen
Copenhagen, Denmark
1864–1945
Denmark

Johan Bülow Birk
Ålborg, Denmark
1819–58
Denmark

Lars Björk
Borlänge, Sweden
1937
Iceland

Anton Blomberg
Gothenburg, Sweden
1862–1936
Sweden

Morten Bo
Copenhagen, Denmark
1945
Denmark

Emil Boehm
Sortavala, Finland
1856–1919
Finland

Jorgen Borg
Risskov, Denmark
1945
Denmark

Pietro Th. Boyesen
Copenhagen, Denmark
1819–82
Denmark

Signe Brander
Parkano, Finland
1869–1942
Finland

Björn Breitholtz
Umeå, Sweden
1938
Sweden

Conrad M. Bringe
birthplace unknown
1901
Norway

Pétur Brynjólfsson
Heidi, Mýrdalur, Iceland
1882–1930
Iceland

Nanna Büchert
Copenhagen, Denmark
1937
Denmark

Ferdinand Cammer
Copenhagen, Denmark
1821–88
Denmark

Krass Clement
Copenhagen, Denmark
1946
Denmark

Henrik Cronström
Petolahti, Finland
1879–1958
Finland

Carl Curman
Skänninge, Sweden
1833–1913
Sweden

Gustaf Alfred Johannes Dahllöf
birthplace unknown
1841–1908
Sweden

Jón J. Dahlmann
Reykjavík, Iceland
1873–1949
Iceland

Holger Damgaard
Ribe, Denmark
1870–1945
Denmark

Björn Dawidsson
Örebro, Sweden
1949
Sweden

Ditlev Duckert
Copenhagen, Denmark
1885–1976
Denmark

Lennart Durehed
Gothenburg, Sweden
1950
Sweden

John Englund
Stockholm, Sweden
1870–1929
Finland

Frans Henry Engström
(Atelier Imatra)
Sweden
1873–1930
Finland

Thure Eson
Stockholm, Sweden
1903–79
Sweden

Sigfús Eymundsson
Borgir, Vopnafjördur, Iceland
1837–1911
Iceland

Finnur P. Fródason
Copenhagen, Denmark
1946
Iceland

Palle From
Odense, Denmark
1935
Denmark

Hans Gedda
Stockholm, Sweden
1942
Sweden

Henry B. Goodwin
Munich, Germany
1878–1931
Sweden

Sigurdur Gudmundsson
Reykjavík, Iceland
1942
The Netherlands

Loftur Gudmundsson
Reykjavík, Iceland
1892–1952
Iceland

Hans Hammarskiöld
Stockholm, Sweden
1925
Sweden

Georg E. Hansen
Næstved, Denmark
1833–91
Denmark

Jørgen Hansen
Copenhagen, Denmark
1944
Denmark

Carl Adolph Hårdh
Stockholm, Sweden
1835–75
Finland

Evald Hemmert
Copenhagen, Denmark
1866–1944
Iceland

John Hertzberg
Norrköping, Sweden
1871–1935
Sweden

Harry Hintze
Helsinki, Finland
1863–1952
Finland

Bo Holst
New York, New York
1930
Sweden

Frederick W. Warbreck Howell
England
1857–1901
Iceland

Kristian Hude
Roskilde, Denmark
1864–1929
Denmark

Gudmundur Ingólfsson
Reykjavík, Iceland
1946
Iceland

Into Konrad Inha
Virrat, Finland
1865–1930
Finland

Johannes Jaeger
Berlin, Germany
1832–1908
Sweden

Per Bak Jensen
Copenhagen, Denmark
1949
Denmark

Patrik Johnson
Falkenberg, Sweden
1876–1971
Sweden

Aron Jonason
Sweden
1838–1914
Sweden

Jon Kaldal
Hunavatnssýsla, Iceland
1896–1981
Iceland

Anton Kalland
Bergen, Norway
1856–1933
Norway

Jørgen Anker Kierkegaard
(Studio Vrønding and Kierkegaard)
Ålborg, Denmark
1895–1975
Denmark

Vihtori Kilpinen
birthplace and
dates unknown
Finland

Halvard Kjærvik
Trondheim, Norway
1946
Norway

Frans G. Klemming
Ulriksdal, Sweden
1859–1922
Sweden

Knud Knudsen
Odda, Norway
1832–1915
Norway

Alfred Koller
Gran, Hadeland, Norway
1878–1951
Norway

Thomas Neergaard Krabbe
Kirke-Hvalsø, Denmark
1861–1936
Denmark

Jan Landfeldt
Stockholm, Sweden
1951
Sweden

Lars Larsson
Västra Bodarna, Sweden
1858–unknown
Sweden

Ólafur Lárusson
Reykjavík, Iceland
1951
Iceland

Jouko Leskelä
Kajaani, Finland
1956
Finland

Mauritz Levin
birthplace and
dates unknown
Finland

Axel Lindahl
Gothenburg, Sweden
1842–1907
Sweden/Norway

Bertil Ludvigsson
Norra Råda, Sweden
1937
Sweden

Peter P. Lundh
Kullabygden, Sweden
1865–1943
Sweden

Birger Lundsten
Laukkaa, Finland
1898–1977
Finland

Tue Lütken
Næstved, Denmark
1948
Denmark

Olafur Magnússon
Reykjavík, Iceland
1889–1954
Iceland

Skúli Thor Magnússon
Reykjavík, Iceland
1946
Iceland

Eino Mäkinen
Helsinki, Finland
1908
Finland

Hans Malmberg
Stockholm, Sweden
1927–77
Sweden

Israel B. Melchoir
Copenhagen, Denmark
1827–93
Denmark

Borg Mesch
Kiruna, Sweden
1870–1956
Sweden

Erkki Mikkola
Ikaalinen, Finland
1904–40
Finland

Odd Moe
Oslo, Norway
1944
Denmark

Rolf Mortenson
Oslo, Norway
1900–75
Norway

Budtz Müller
(Budtz Müller & Co.)
Mariager, Denmark
1837–84
Denmark

Edvard Munch
Løten, Hedmark, Norway
1863–1944
Norway

Christian Neuhaus
Copenhagen, Denmark
1833–1907
Denmark

Severin Nilson
Halland, Sweden
1846–1918
Sweden

Pål-Nils Nilsson
Rome, Italy
1907
Sweden

Karl Nordgaard
Örebro, Sweden
1887–1963
Sweden

Alfred Nybom
Helsinki, Finland
1879–1963
Finland

Ralph Nykvist
Landskrona, Sweden
1944
Sweden

Rolf Ødegaard
Oslo, Norway
1884–1959
Norway

Magnús Ólafsson
Stykkishólmur, Iceland
1862–1937
Iceland

Lennart Olson
Gothenburg, Sweden
1925
Sweden

Anna Otto
birthplace unknown
1878–unknown
Denmark

Sakari Pälsi
Loppi, Finland
1882–1965
Finland

Jamie Parslow
Inglewood, California
1943
Norway

Samuli Paulaharju
Kurikka, Finland
1875–1944
Finland

Per Persson
Malung, Sweden
1860–1940
Sweden

Peter L. Petersen
(pseudonym 1901 Peter Elfelt)
Elsinore, Denmark
1866–1931
Denmark

Einar Pétursson
Reykjavík, Iceland
1958
Iceland

Arne Pietinen
Säkkijärvi, Finland
1884–1946
Finland

Wilhelm Piro
Oslo, Norway
1909
Norway

Matti A. Pitkanen
Helsinki, Finland
1930
Finland

Eli Ponsaing
Copenhagen, Denmark
1922
Denmark

Tage Poulsen
Hjorthshøj, Denmark
1935
Denmark

Queen Viktoria of Sweden
(Queen to Gustaf V)
Karlsruhe, Baden, Germany
1862–1930
Sweden

Aage Remfeldt
Havdrup, Denmark
1889
Denmark/Norway

Georg Renström
Lima, Sweden
1892–1950
Sweden

N.O. Reppen
Sogndal, Norway
1856–95
Norway

John Riise
Hareide, Norway
1885–1978
Norway

Anna Riwkin
Russia
1908–70
Sweden

C.G. Rosenberg
Paris, France
1883–1957
Sweden

Harald Rosenberg
Helsinki, Finland
1883–1931
Finland

Wilhelm Roth
Austria
dates unknown
Norway

Axel Rydin
Norrköping, Sweden
1837–1912
Sweden

Pentti Sammallahti
Helsinki, Finland
1950
Finland

Tom Sandberg
Narvik, Norway
1953
Norway

Sixten Sandell
Bro, Sweden
1908
Sweden

Karl Sandels
Stockholm, Sweden
1909
Sweden

Jonas Albert Sandman
Haapavesi, Finland
1866–1947
Finland

Wladimir Schohin
Helsinki, Finland
1862–1934
Finland

Hilma Selin
birthplace and
dates unknown
Sweden

Marcus Selmer
Randers, Denmark
1819–1900
Norway

Vilho Setälä
Helsinki, Finland
1892
Finland

Sigurgeir Sigurjónsson
Reykjavík, Iceland
1948
Iceland

Ulf Simonsson
Stockholm, Sweden
1944
Sweden

U.T. Sirelius
Jaaski, Finland
1872–1929
Finland

Gunnar Smoliansky
Visby, Sweden
1933
Sweden

John Stenersen
Oslo, Norway
1957
Norway

Bertil Stilling
Stockholm, Sweden
1924
Sweden

Bertil Strandell
Stockholm, Sweden
1950
Sweden

August Strindberg
Stockholm, Sweden
1849–1912
Sweden

Nils Strindberg
birthplace unknown
1872–97
Sweden

Christer Strömholm
Stockholm, Sweden
1918
Sweden

Ingimundur Sveinsson
Efriey, Medalland, Iceland
1873–1926
Iceland

Herrman Sylwander
Karlskrona, Sweden
1883–1948
Sweden

L. Szacinski
Suwalki, Poland
1844–94
Sweden

Nils Thomasson
Myssjö, Jämtland, Sweden
1880–1975
Sweden

Otmar Thormann
Graz, Austria
1944
Sweden

Carl Kristian Thorncliff
birthplace unknown
1865–unknown
Sweden

Gunhild Thorsteinsson
Isafjördur, Iceland
1878–1948
Iceland

Vilhelm Tillge
Copenhagen, Denmark
1843–96
Denmark

Emil Tønnies
Ålborg, Denmark
1860–1923
Denmark

Heinrich Tønnies
Grünenplan, Braunschweig,
Germany
1825–1903
Denmark

Sophus Tromholt
Husum, Denmark
1851–96
Norway

William Truelsen
Copenhagen, Denmark
1865–1927
Denmark

Pekka Turunen
Joensuu, Finland
1958
Finland

Armas Otto Väisänen
Savonranta, Finland
1890–1969
Finland

Poul Erik Veigaard
Åbyhøj, Denmark
1948
Denmark

Timo Viljakainen
Varkaus, Finland
1951
Finland

Lennart Wängestam
Korsberga, Sweden
1929
Sweden

Arne Wahlberg
Örebro, Sweden
1905
Sweden

L. Walter
Kniphagen at Eutin, Holstein,
Germany
1811–78
Denmark

Carl Wessel
Copenhagen, Denmark
1867–1946
Denmark

Ellisif Wessel
Gausdal, Norway
1866–1949
Norway

Anders Beer Wilse
Flekkefjord, Norway
1865–1949
Norway

Peder Winge
Copenhagen, Denmark
1941
Denmark

Rolf Winquist
Gothenburg, Sweden
1910–68
Sweden

Sigridur Zoëga
Reykjavík, Iceland
1889–1968
Iceland

Acknowledgments

For the opportunity to organize this exhibition and produce this publication, the Walker Art Center is indebted to many individuals and institutions in Scandinavia and in this country.

It is a pleasure, first, to acknowledge the catalytic role of The American-Scandinavian Foundation in New York, who together with the Nordic Council of Ministers invited us to organize this exhibition. Our initial contact was with David Swickard, then the Foundation's President. During preparation of the exhibition we had invaluable help from Brooke Lappin, its resourceful National Program Director of "Scandinavia Today," and from his assistant Bruce Kellerhouse, National Program Coordinator, "Scandinavia Today." Patricia McFate, now the President of The American-Scandinavian Foundation, also gave her support to this project.

The Secretariat for Nordic Cultural Cooperation of the Nordic Council of Ministers made travel arrangements in Scandinavia and contacted lending institutions on our behalf. In this formidable task, Niels Toft—then Secretary General of "Scandinavia Today"—gave us invaluable support. His able successor, Carl Tomas Edam, brought considerable energy to coordinating our efforts in Scandinavia. His understanding of our artistic objectives and his diplomatic skills helped make the exhibition a reality.

To those contemporary Scandinavian photographers whose images are represented in this exhibition, our special thanks. They are individually credited, along with the many museums, libraries and other institutions that so generously permitted us to show photographs from their collections. In each Scandinavian country an official representative appointed by the Nordic Council served as our liaison and oversaw logistics of our visits. Through these representatives we maintained contact with the many people involved with preparing the exhibition and this book. In Denmark we had the privilege of working with Bjørn Ochsner who was Librarian of Det Kongelige Bibliotek from 1944 to 1980 and is a much respected authority on the Danish photography scene. Because of his great knowledge of the history of Scandinavian photography he was a frequently consulted resource. In Denmark we also had the assistance of Tage Poulsen, who helped us pursue an active schedule of visits to collections. Ritva Keski-Korhonen, Director of the Suomen Valokuvataiteen Museon Säätiö (The Photographic Museum) in Helsinki, assisted us with our Finnish research. In Reykjavík, the diligent efforts of Leifur Thorsteinsson helped uncover important Icelandic photographic material. The Director of the Sonja Henie-Niels Onstad Foundations, Per Hovdenakk, with his knowledge of the contemporary photography scene in Norway, brought important work to our attention. With the assistance of the Svenska Institutet in Stockholm we began our exploration of the historical and contemporary photography situation in Sweden. Initially, Hans Hammarskiöld was our guide to collections; later we had excellent support from two Svenska Institutet officials, Sonja Martinson and Christina Hamacher.

To the many Walker Art Center staff members associated with this project, my warm thanks. Special mention must be made of the efforts of Mildred Friedman, Design Curator, and Gwen Bitz, Associate Registrar, who worked on many aspects of the exhibition, including the selection process. Ms. Friedman was the design and editorial coordinator for this book and Ms. Bitz assisted with basic research on Scandinavian photography collections and with registration duties related to documenting, collecting and transporting the photographs. The fourth member of our group, William Ewing, Director of Exhibitions, International Center of Photography, New York, was a congenial and knowledgeable participant in our photograph selection process. This publication was designed by Robert Jensen. Walker Art Center staff members who assisted with this project are listed on page 207.

Thanks are due Michael Metcalf, Associate Professor, University of Minnesota Department of History, for his expertise and contribution of an essay, and to Philip R. Anderson for locating the quotations from Scandinavian authors, poets and philosophers that appear in this book. We are grateful to Tage Poussette, Consul General of Sweden in Minneapolis, for his help in our communications with our Scandinavian colleagues; in that office, Irene Anderson, Consul, and Mmes. May Söderström and Kerstin Johnson rendered valuable assistance. To Anne Hoene Hoy go special thanks for her thorough editing of the contributions of the Scandinavian writers and for her perceptive comments on my essays. Her knowledge of the history of photography and penchant for clear expression were matched by her dedication to this project.

MF

Lenders to the Exhibition

Aarhus Kunstmuseum, Århus, Denmark
Åbo Akademis Bildsamlinger, Åbo, Finland
Dag Alveng, Oslo, Norway
Amatörfotografklubben, Helsinki, Finland
Antikvarisk-Topografiska arkiven, Riksantikvarieämbetet, Stockholm, Sweden
Arbeiderbevegelsens Arkiv og Bibliotek, Oslo, Norway
Jim Bengston, Oslo, Norway
Bernadottebiblioteket, Kungliga Slottet, Stockholm, Sweden
Lars Björk, Reykjavík, Iceland
Morten Bo, Copenhagen, Denmark
Jørgen Borg, Tim, Denmark
Nanna Büchert, Allerød, Denmark
Camera Obscura, Stockholm, Sweden
Krass Clement, Copenhagen, Denmark
Björn Dawidsson, known as "Dawid," Stockholm, Sweden
Det Kongelige Bibliotek, Copenhagen, Denmark
Falkenbergs sparbank, Falkenberg, Sweden
Forsvarsmuseet, Oslo, Norway
Fotografiska Museet, Stockholm, Sweden
Fritids-och Kulturnämnden, Kiruna, Sweden
Finnur P. Fródason, Reykjavík, Iceland
Palle From, Odense, Denmark
Kees van Gelder, Amsterdam, The Netherlands
Göteborgs Konstmuseum, Gothenburg, Sweden
Sigurdur Gudmundsson, Amsterdam, The Netherlands
Hedmarksmuseet og Domkirkeodden, Hamar, Norway
Helsingin Kaupunginmuseo, Helsinki, Finland
Margrét Hemmert, Reykjavík, Iceland
Höganäs Museum, Höganäs, Sweden
Bo Holst, Aftonbladet, Malmö, Sweden
Image Center for Fotografi, Århus, Denmark
Gudmundur Ingólfsson, Reykjavík, Iceland
Jämtlands Läns Museum, Östersund, Sweden
Per Bak Jensen, Copenhagen, Denmark
Sven Johansson, Stockholm, Sweden
Ingiborg Kaldal, Reykjavík, Iceland
Halvard Kjærvik, Kabelvåg, Norway
Københavns Bymuseum, Copenhagen, Denmark
Kungliga Biblioteket, Stockholm, Sweden
Jan Landfeldt, Stockholm, Sweden
Landsbókasafn Islands, Reykjavík, Iceland
Ólafur Lárusson, Reykjavík, Iceland
Jouko Leskelä, Helsinki, Finland
Lokalhistorisk arkiv for Aalborg kommune, Ålborg, Denmark
Bertil Ludvigsson, Karlstad, Sweden
Peter Lundsten, Turku, Finland
Tue Lütken, Copenhagen, Denmark
Skúli Thor Magnússon, Reykjavík, Iceland
Robert Meyer, Oslo, Norway
Museet for Danmarks Frihedskamp, Copenhagen, Denmark
Museovirasto, Helsinki, Finland
Nordiska museet, Stockholm, Sweden

Norsk Folkemuseum, Oslo, Norway
Norsk Polarinstitutt, Oslo, Norway
Ralph Nykvist, Helsingborg, Sweden
Oslo Kommunes Kunstsamlinger Munch-museet, Oslo, Norway
Jamie Parslow, Oslo, Norway
Einar Pétursson, Reykjavík, Iceland
Eli Ponsaing, Lyngby, Denmark
Tage Poulsen, Copenhagen, Denmark
Preus Fotomuseum, Horten, Norway
Pentti Sammallahti, Helsinki, Finland
Tom Sandberg, Oslo, Norway
Sixten Sandell, Gothenburg, Sweden
Satakunnan Museo, Pori, Finland
Vilho Setälä, Espoo, Finland
Sigurgeir Sigurjónsson, Reykjavík, Iceland
Ulf Simonsson, Lidingö, Sweden
Sonja Henie-Niels Onstad Foundations, Høvikodden, Norway
Sør-Varanger Museum, Svanvik, Norway
Sotamuseo, Helsinki, Finland
John Stenersen, Oslo, Norway
Bertil Stilling, Stockholm, Sweden
Stockholms Stadsmuseum, Stockholm, Sweden
Suomalaisen Kirjallisuuden Seura, Helsinki, Finland
Suomen Valokuvataiteen Museon Säätiö, Helsinki, Finland
Svenska Filminstitutet, Stockholm, Sweden
Tekniska museet, Stockholm, Sweden
Thjódminjasafn Íslands, Reykjavík, Iceland
Tio Fotografer, Stockholm, Sweden
Pekka Turunen, Helsinki, Finland
Universitetets Etnografiske Museum, Oslo, Norway
Universitetsbiblioteket i Bergen, Bergen, Norway
Timo Viljakainen, Helsinki, Finland
Lennart Wängestam, Karlstad, Sweden
Peder Winge, Copenhagen, Denmark
Sigridur Zoëga, Reykjavík, Iceland

Reproduction Credits and Quotation Credits

All prints for reproduction in this book were made by Walker Art Center staff photographers Glenn Halvorson and Donald Neal from original or duplicate negatives. New prints of photographs for this book, where original prints were not available, were made by accomplished printers in Scandinavia and at Walker Art Center who made every effort to duplicate the original material. The printer's name precedes that of the photographer.

Nils Andersson for Wladimir Schohin: pp 121, 123, 165

Nils Andersson for Atelier Imatra, probable photographer Frans Henry Engström: pp 6–7

Jerker Ekström for Anton Blomberg: pp 79, 80

Jerker Ekström for Patrik Johnson: p 185

Jerker Ekström for Frans G. Klemming: pp 66–67, 77

Jerker Ekström for Peter P. Lundh: pp 83, 84, 85

Jerker Ekström for August Strindberg: p 111

Gudmundur Ingólfsson for Pétur Brynjólfsson: p 64

Gudmundur Ingólfsson for Jón J. Dahlmann: p 89

Gudmundur Ingólfsson for Sigfús Eymundsson: pp 61, 62, 63

Gudmundur Ingólfsson for Olafur Magnússon: p 9

Museet for Danmarks Frihedskamp: pp 124–125, 139, 142

Walker Art Center for Anton Blomberg: p 69

Walker Art Center for Carl Curman: cover, pp 29, 31, 33

Walker Art Center for Edvard Munch: pp 102–103, 112

Walker Art Center for Samuli Paulaharju: pp 49, 59

Walker Art Center for Heinrich Tønnies: pp 93, 94, 97

p 20: From Henrik Ibsen, *Peer Gynt,* trans. Michael Meyer © 1963 by Michael Meyer. Reprinted by permission of Harold Ober Associates, Inc.

pp 40, 42: *Andrée's Story: The Complete Record of His Polar Flight,* 1897. Translated from the Swedish by Edward A. Ray. © 1930 by The Viking Press Inc. Copyright renewed 1958 by The Viking Press Inc. Reprinted by permission of Viking Penguin Inc.

p 45: Reprinted from Roald Amundsen, *My Life as an Explorer* (Garden City, New York: Doubleday, Doran & Co., 1928), pp 236–237.

p 50: Reprinted from Knut Hamsun, *The Road Leads On,* trans. Eugene Gay-Tifft (New York: Coward-McCann Inc., 1934), p 23.

p 65: Reprinted from "The Wonder Pony," a story by Halldór Laxness in *Paradise Reclaimed,* trans. Magnus Magnusson (London: Methuen & Co., Ltd., 1962), p 7.

pp 95, 96: From *Six Plays by Strindberg,* trans. Elizabeth Sprigge. © 1955 by Elizabeth Sprigge. Reprinted by permission of the Estate of Elizabeth Sprigge.

p 114: Reprinted from *Edvard Munch: Symbols and Images,* introduction by Robert Rosenblum (Washington, D.C.: National Gallery of Art, 1978), p 209.

p 157: Reprinted by permission of E.P. Dutton Inc. From *Dreyer in Double Reflection.* © 1973 by Donald Skoller.